*A Camera
in the Garden*

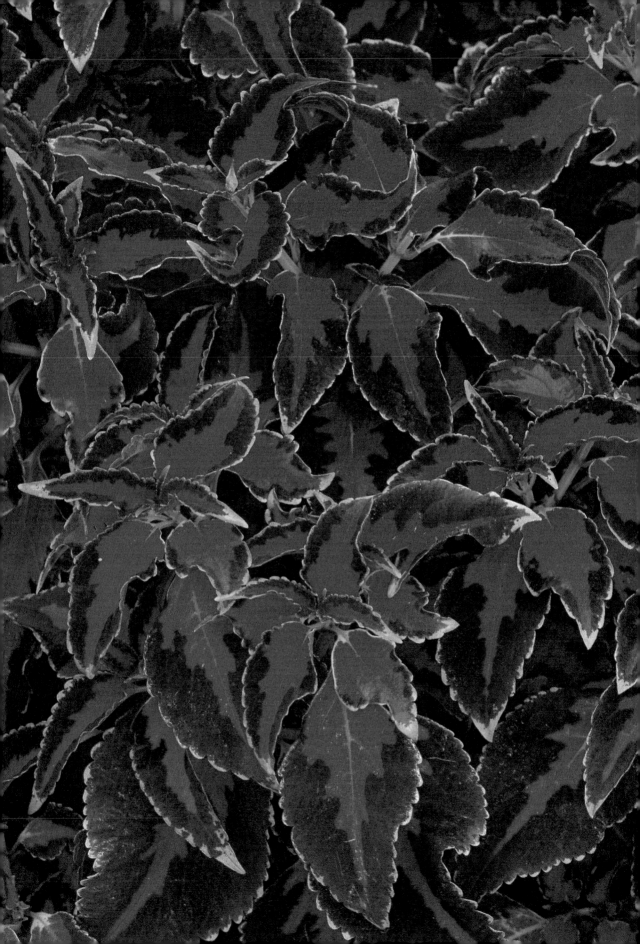

A Camera in the Garden

HEATHER ANGEL

Quiller Press
London

For Martin and Giles with love

Published by
Quiller Press Limited,
50 Albemarle Street,
London W1X 4BD

First published 1984

ISBN 0 907621 34 1

Designed by Ron Jones

Design and production in association with
Book Production Consultants, Cambridge

Typeset by Cambridge Photosetting Services
and The Granta Press, Bottisham, Cambridge

Illustrations originated by Cambridge Litho, Milton,
Cambs.

Printed and bound by Hazell, Watson and Viney,
Aylesbury, Bucks.

Acknowledgements

Heather Angel would like to thank everyone who so
willingly gave their time to answer her queries. In
particular, the Royal Horticultural Society's staff at Wisley
Garden and at the Lindley Library, the Royal Botanic
Gardens Kew, the Royal Botanic Garden Edinburgh,
Cambridge University Botanic Garden, the University of
Liverpool Botanic Gardens at Ness, Harlow Car Gardens,
the National Trust, Cambridge University Library, Kodak
Photo Information Service, Bath City Council (Department
of Leisure and Tourist Services), Chester Zoological
Gardens, the National Gardens Scheme, the Keep Britain
Tidy Group, TV Man Union (Tokyo), the Alexander
Turnbull Library (Wellington, New Zealand), and the
National Trust of Australia were especially helpful.

Many individuals were also a tremendous help,
suggesting contacts and gardens, or supplying information,
notably: Mavis Batey, Caroline Boisset, Brinsley Burbidge,
Dr. June Chatfield, Duncan Donald (NCCPG), Joan
Edwards, Charles Funke, Mr Hopkins (Head Gardener at
Chatworth), Dr. Sylvia Landsberg, Joy Larkham, Michael
Lear, Alan Mitchell, Philippa Rakusen, Marion Thompson,
and Basil Williams.

Special thanks go to everyone who kindly allowed me to
photograph their gardens or who escorted me round them –
Mr Rupert Milward (Alton Towers Ltd.), Bowood Estate, Joe
and Frieda Brown, Beth Chatto, Chelsea Physic Garden,
C.I.E. Construction Management Ltd, Mr and Mrs Gerald
Coke, Sir Francis Dashwood (West Wycombe Park), Mr W S
Garstone, Mr Alan Gloak of 'The Brighter Kensington and
Chelsea Scheme', Roy and Pat Grimes (Duke of
Marlborough Inn, Nr Woodstock), Hever Castle Ltd
Edenbridge Kent, Holly Gate Cactus Nursery, Mr Robin
Loder (Leonardslee), Gwyn Miles, the National Trust
Regional Offices, the Painshill Trust, Prior Park College,
Frances Pumphrey, Mr Michael Hornby (Pusey House), Mrs
J H Robinson (Denmans), Tyninghame, The University of
Bristol and the Warden of Goldney House, Rosemary Verey,
Victoria Wakefield, Wellington Enterprises, Mr Colin Wells-
Brown, and also the owners of many private gardens.

Heather Angel would especially like to thank her mother,
Hazel Le Rougetel, for constructive criticism of the whole
text and for useful suggestions about roses; Colour
Processing Laboratories Ltd for their efficient film
processing service; Sally Smallwood for designing the
dummy book; Julie Burchett, Cynthia Pearce, Julie Short
and Kate West for their speedy typing; Lucy Bonner for her
enthusiastic researching; Janet Atkins and Romilly Lockyer
for general assistance and Jan McLachlan for editing. Above
all, I thank my husband, Martin Angel, for originally
suggesting the idea and for his constant help and
encouragement.

Contents

Introduction

On a fine summer's day, people with cameras of all shapes and sizes invade gardens, to record living tapestries created by dedicated gardeners over many years. Yet I wonder how many people stop to think twice about where the best viewpoint is or whether they should wait for better light? Today the mechanics of taking a photograph are easy; perhaps too easy. The exposure is automatically controlled on many cameras, and some models even have automatic focusing. All this may help to ensure a higher percentage success rate, but it inevitably means that the camera dictates the end result instead of the photographer experimenting and building on experience.

From the many comments and queries I have had whilst working in gardens all over the world, I know visitors are so often disappointed that their photos do not capture the essence of the particular garden as they saw it. One feature may merge in with another, vertical lines of a gate or a building may lean, the colours may not be faithfully reproduced. With care, however, these faults can be remedied.

This book aims to provide both inspiration from the photographs and also tips and guidelines on how to get the best out of a camera. This is not simply another book on photography; it is specifically written for gardeners, horiculturalists and garden lovers whose main interest and knowledge evolves around all aspects of gardening – without dwelling on photographic technicalities. Certain aspects of photography *are* highly scientific: optics, physics of light, the chemistry of film emulsions, to name but a few. But photography is also an exciting overlap between science and art; of learning to use a medium for expression.

Internationally famous gardens have already been illustrated in many books, so I make no apologies about excluding them. However, the techniques described in this book can be applied to gardens anywhere in the world. Here in Britain we are spoilt by the wealth of gardens open to the public, only a small fraction of which are illustrated in this book. Wherever possible, the garden is identified in each caption (with the exception of private gardens which are not open to the public) and its location can be found via the index in Appendix 7.

A single visit can never do justice to a garden. Each time you return some new delight will be found. It also does not matter how many times someone else has photographed a garden before you, something will have changed – most notably the light. Even in one afternoon, no two people will take an identical picture. This fact was proved to me when I took 20 people into a deer park and saw the results of their photographs. Much to my surprise none were duplicated. Each person had chosen their own viewpoint and some selected a different lens so that the proportion of the

sky varied. Different emphasis was placed on the trees; in some pictures they featured strongly in the foreground, in others incidentally in the background.

Throughout, the approach is directed solely to colour photography, because this is what appeals to the majority today. However, from the feedback I have had from horticultural colleges and students, some guidance on monochrome garden photography is needed and this is briefly covered in a separate appendix.

Each chapter is written so that anyone with little previous knowledge of photography can follow through with reference, if necessary, to the words in bold type which are defined in the photographic glossary on page 146. The most common faults and how to remedy them are listed on page 149. All references to focal length of the lens refer to the 35mm format.

As I travelled in search of pictures for this book, I appreciated how much we owe to generations of dedicated gardeners. Today's harsh economic climate was repeatedly brought home to me when I visited gardens which only a few years previously had been written up with ecstatic reverence. All too often I found yesterday's glories had faded into disordered array. On the other hand there were bonuses as I discovered gems of town gardens, skilfully embellished patios and eye-catching window boxes.

Many of the gardens in which I photographed have been omitted from the final selection simply because each picture has to illustrate a specific photographic point; none the less I extend my thanks to everyone who so kindly allowed me to visit their garden with a camera.

One spin-off from my concentrated look at gardens whilst working on this book is that I have plunged into an enthusiastic revamping of our own over-mature garden. Plants from many gardens have found a home here, chosen for the texture or pattern of their leaves, for the juxtaposition of colour against another plant, for their exquisite beauty in close-up or simply to remind us of the first time we found and photographed them in their natural habitat abroad.

One of the best ways of improving your photography is to work with subjects you know well. I can think of no better way to enjoy photography than to combine it with a love of plants and gardens. As with gardening itself, there will inevitably be frustrations, but successful pictures will make failures fade into insignificance.

Farnham
31 December 1983

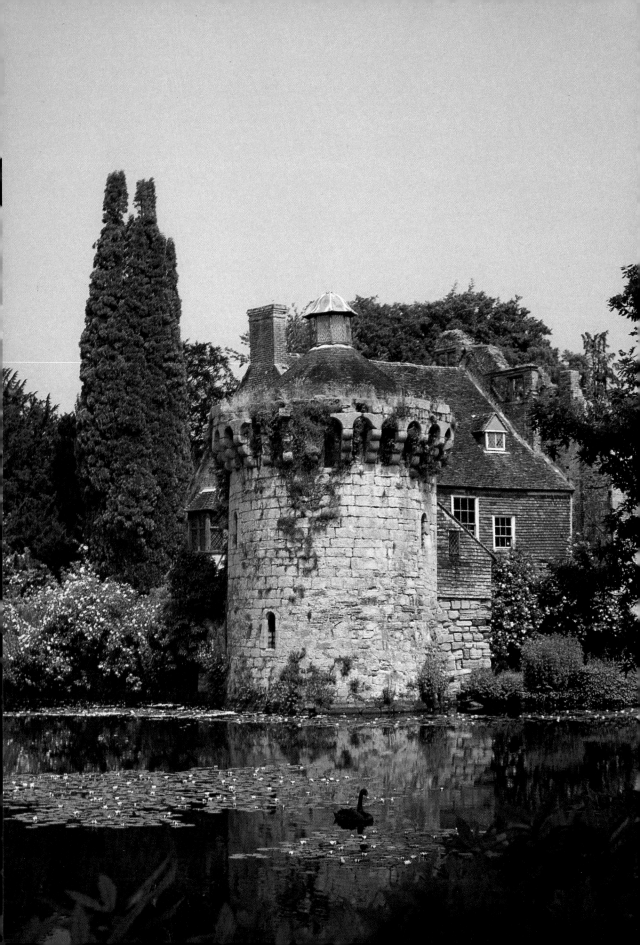

1 Setting the Scene

Gardens – like natural habitats – are dynamic. As the species interact with one another, the whole make-up of the community evolves. A garden is created by artificially mixing annuals, biennials, herbs, shrubs and trees from different countries of origin. No two species favour identical conditions, so that without constant care and attention, a garden quickly reverts into an overgrown jungle where vigorous species swamp slow-growing plants.

Even in the relatively short time span of a year, the colour and mood of a garden will perceptibly change; within a single day, the vagaries of the weather can dramatically transform a peaceful scene into a wind-swept landscape set against a stormy backcloth.

A photograph records a precise moment in time – a moment which can be recalled with pleasure and nostalgia at a later date. More importantly, old dated photographs of gardens depicting the design and planting at that time, are invaluable records for garden historians and landscape architects. The collection of monochrome plates reproduced in Alastair Forsyth's book, *Yesterday's Gardens,* from the photographic archives of the National Monuments Record, provides an interesting record of Victorian and Edwardian gardens. Such photographs serve not only as comparisons with those gardens still in existence; but can also be used to help assess the historic value of a garden when decisions have to be made on whether or not it is worth restoring to its former glory. If the original plans are missing, photographs can be used as the basis for recreating an original garden design. Photographs of a nineteenth-century house and garden destroyed in the horrific bush fires which swept through South Australia on the fateful 1983 Ash Wednesday, have aided the reconstruction of both house and garden.

As some plants become popular with gardeners, so the popularity of others begins to wane. The British National Council for the Conservation of Plants and Gardens (NCCPG) was set up in 1978 to ensure that plants which are now rare in gardens will not be lost from cultivation. Specialist plant collections have been designated as National Collections, so that a gene bank can be built up of rare and uncommon plants. These Collections are by no means restricted to botanical and large public gardens; many are in private gardens. Apart from alerting the Council's attention to rare plants, photography can play an important role in recording accurate details of scarce plants – especially cultivars.

Gertrude Jekyll's (1843–1932) informal approach to planting revolutionised gardening in Britain around the turn of the last century. Trained originally as an artist, she took up garden design when her eyesight failed. Her photographs of gardens used to illustrate articles and

The well-preserved ruins of old Scotney Castle, Kent bedecked with roses and surrounded by the moat present an idyllic summer scene. To reduce the sheen from the lily pads, I used a polarising filter and waited for the black swan to swim into the picture.

9

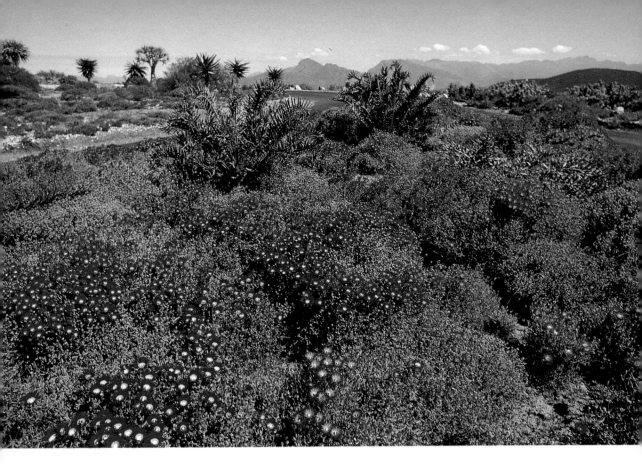

books, confirm her observant eye and her understanding of light and shadow. Miss Jekyll clearly appreciated the value of photography as a medium for communication to others, for in the preface of her book *Wall and Water Gardens* published in 1901 she writes '. . . illustrations are of distinct educational value, in that they present aspects of things beautiful, or of matters desirable for practice, much more vividly than can be done by unpictured text.' Gertrude Jekyll's example was followed by Edna Walling, a garden designer who illustrated her books published in Australia in the 1940s with telling monochrome photographs.

These two ladies used photography to inspire and enlighten their readers, but most often garden photographs are taken solely for personal enjoyment, in which case what better place to start than in your own garden? Here, a permanent record can be made of how it develops from early beginnings passing through seasonal changes. Familiar views along well-worn paths will ensure the best time of day is chosen for photographing each one. Photographs taken in other people's gardens can provide a pleasurable reminder of a day's outing. They can also serve as a valuable visual notebook: to recall interesting garden features or plant associations when making plans for your own garden, or as an *aide memoire* to a later artistic impression.

The reason for taking a photograph of a garden will vary. It may be purely for pleasure, for tempting people to visit a garden, or for recording its design and form; but the starting point is inevitably a garden vista. Given good light, bold lines and shapes, scenes can be taken with a simple camera such as a disc or compact, without any accessories. However, the more versatile **single lens reflex (SLR)** camera will enable pictures to be

This colourful array of flowering succulents can be seen in the Karoo Gardens at Worcester in South Africa. A wide angle lens provides foreground emphasis and a low viewpoint has helped to disguise the tarmac roads.

taken in almost any weather conditions. Such cameras are also preferable for taking close-ups (page 44).

Whatever camera is used for garden scenes, some thought should be given to the lighting and the composition if the end result is to be pleasing to the eye. When experimenting with new ideas – especially if the subject is taken in different ways – it is well worth keeping notes as a reminder after the film has been processed.

Composing the picture

In the same way that an artist has to decide on the boundaries for his picture, so the photographer has to make a conscious decision how best to frame a garden scene. Whenever a 35mm camera is used, the first consideration should be which format most suits the subject: horizontal (landscape) or vertical (portrait).

The most natural way of bringing a 35mm camera up to the eye is by holding it horizontally, so it is not surprising that the majority of pictures are taken this way. It seems to require a special effort to turn the camera through 90°! How do you choose which way to hold the camera? The subject itself often dictates the format, for example a linear lake suggests a horizontal picture whereas a columnar Lombardy poplar is an obvious vertical subject.

Remember that when you look at a garden, your binocular vision allows you to see it as a three-dimensional creation, whereas a still photograph reproduces it in two dimensions. Try to create a feeling of depth to a picture by leading the eye from the front to the back. Ideas can often be gleaned by looking at other people's pictures. A glance through any gardening book illustrated with good quality plates will reveal the way in which gates, arches or trees are used to frame a picture; a path is used to lead the eye into the scene or even to invite beyond it; trees or architectural features are mirrored in a lake; foreground interest is created for example, by a clump of lush green ferns, a cluster of roses or a statue.

Lighting landscapes

Since the following chapter concentrates on lighting, only brief mention will be made here about the points which are especially relevant to garden views. Close-up subjects in dull places can be lit by using **flash** but views can be lit only by ambient light. Care must be taken however, when metering the light in a garden view which includes a large expanse of sky (page 23). The extreme contrast between a colourless sky and a garden scene can be reduced by using a **graduated filter**, although care needs to be taken that the tinted strip on the filter is not a completely unnatural sky colour. For this reason, I prefer to use a grey, rather than a tobacco or a pink graduated filter.

Weather cannot be controlled, but it can be selected for optimum effect. Strong direct sunlight is not suitable lighting for all subjects (page 38), but sun and shade can provide more impact for bold landscapes than the soft light filtering through a cloud-covered sky. Perhaps the best of both worlds is experienced on a day when clouds racing across the sky results in bright sunny intervals interspersed with periods when the lighting is soft and indirect. When photographing while the sun is shining, remember that the

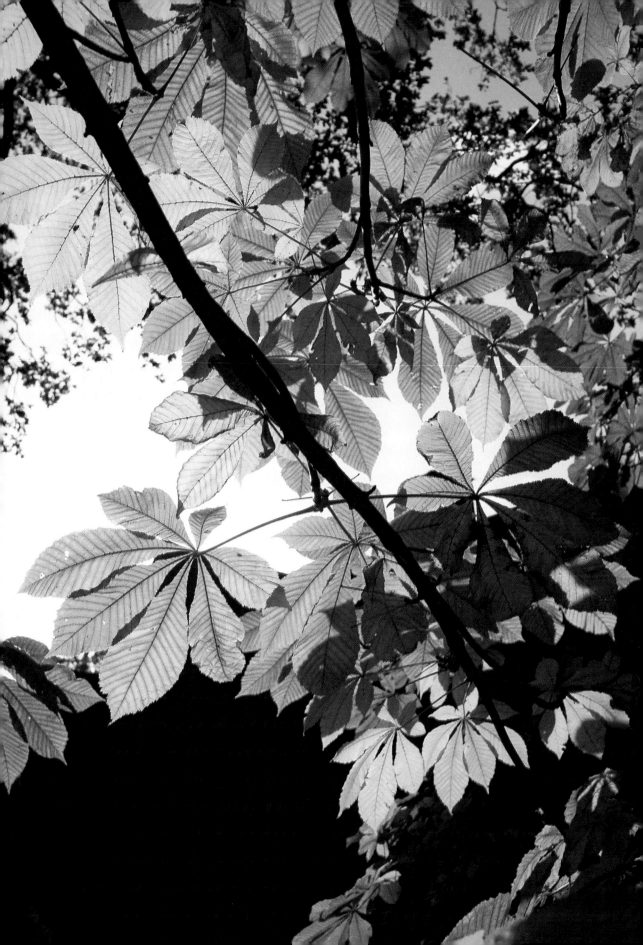

direction of the light falling on the subject (front, side or back) creates a totally different mood in each picture.

The time of day is also important, since an overhead sun casts short shadows which increase in length as the sun sinks lower in the sky in late afternoon or shorten as it rises early in the morning; while some flowers open their petals only when the sun is shining. A safe way to light a view is to stand with the sun behind the camera so that the front of the scene is lit. Front lighting, however, is uncreative, since shadows cast by trees, arches and walls will fall *behind* the objects and therefore not be visible in the picture. Side or cross lighting, on the other hand, helps to create a three-dimensional image by casting shadows *across* the photograph. When the sun is in this position – to the left or right of the subject – the intensity of blue sky, as well as the contrast between clouds and sky, can be increased by attaching a **polarising filter** to the front of the lens on an SLR camera. The effect of such a filter can be seen by holding it up to your eye and rotating it in front of the sky.

Pointing the camera into or against the sun so that the view is lit from behind can produce some dramatic and creative results with shadows extending *forwards* from the objects and so appearing to reach towards the camera. **Contre jour** photography is not always easy and many a time when I have had my camera set up on a **tripod**, helpful advice has been proferred by a passer-by such as: 'You know it won't come out if you face the sun'! With care it will, although you should never look directly at the sun through a camera, since this can hurt your eyes. Secondly, if the sun's rays strike the front element of the lens either the picture will appear hazy with muted colours, or else ghostly bright spots of light – the shape of the **iris diaphragm** – will tend to spoil the view.

Pictorial photographers may induce such **flare** intentionally to their pictures for effect, and it is a technique often used in television advertisements. The **viewfinder** of an SLR camera sees precisely the view the lens will take, so any flare will be seen simply by looking through the camera and **stopping down** the lens to the selected **aperture**. Unwanted flare can be reduced by using a **lens hood**, or by simply shading the lens with a hand, making sure it does not encroach into the edge of the picture. Modern lenses of SLR cameras have a special coating which reduces the problem of flare when shooting into the light. Flare can, of course, be eliminated altogether quite simply by altering the camera position.

Choosing the viewpoint

It is easy and convenient to use the camera at normal eye level, yet this may not always be the best viewpoint. Grabbing the camera and taking a hurried snap is certainly not the best way to compose a picture. Quite small changes in the camera position – a few degrees to the left or right, up or down – can change the perspective of a picture quite dramatically.

A tripod is not only useful for steadying the camera and preventing a blurred image from hand shake, it also allows you time to compose and **focus** a picture. When it is mounted on a tripod, the best viewpoint can be found by **panning** the camera from side to side or by tilting it up and down. Permission is required to use a tripod in some gardens; this I found to be particularly true in Japan. Some gardens in the old capital, Kyoto,

The rich colours of these horse chestnut *Aesculus hippocastanum* leaves are a good example of how back-lighting can dramatise a picture. The camera position was carefully chosen to make sure the direct rays of the sun were masked by the leaves.

required me to pay a nominal fee for using a tripod; one requested a fee equivalent to several hundred pounds and another confiscated my tripod saying I could take 'snaps' (this turned out to be hand-held pictures) but not 'photographies' (with a tripod!). Maybe I would have fared better with an interpreter.

Even when taking general garden scenes, with or without a tripod, be sure to focus the camera lens on the main point of interest. When the lens is fully open the **depth of field** is limited so the camera can be selectively focused. As the lens is stopped down, so the depth of field increases – not equally on both sides of the plane of focus (as for close-ups page 46) – but one-third in front and two-thirds behind. The scale printed on the focusing ring of the lens shows how far the depth of field extends in front and behind the focused distance, according to which aperture is selected. For example, the depth of field scale on my 50mm **standard lens** spans from infinity (∞) to 4 metres when the lens is focused at a distance of 10 metres and the aperture is set to f11.

The creator of the garden, or in the case of old gardens, the current gardener, will know the prime viewpoints and the optimum time of day to record them. Famous vistas in landscaped gardens as at Stourhead, Chatsworth and Blenheim Palace which have been extensively painted and photographed are obvious choices for successful scenic pictures.

Artists though, may interpret the landscape instead of faithfully reproducing it; for instance, they may paint a much broader sweep on their canvas than can be seen through the viewfinder of a basic fixed-lens camera. However, a camera which allows the lens to be changed can have the standard lens (50mm) substituted with a **wide angle lens** (such as a 35mm or even a 24mm lens). These wide angle lenses will include not only much more of the garden itself, but also a larger area of sky. At the same time, the size of the individual features in the garden will be reduced. Watch out for your own shadow impinging on the picture if you use a wide angle lens early or late in the day with the sun behind you. Conversely, a **long focus lens**, also known as a **telephoto lens**, has a narrow **angle of view** and will concentrate attention on a more distant point of interest. For example, by using a 200mm lens from the same viewpoint as a standard 50mm lens, the scene will be enlarged four times and so only the central portion will be seen in the viewfinder.

Often a slightly higher viewpoint will provide a good view of a garden design, but with the exception of knot gardens (page 81) this is not usually the prime viewpoint envisaged by the designer. It is well-worth climbing up a flight of steps or onto the brow of a hillock to compare the view with one from ground level. I have had the roof rack of my four-wheel drive estate completely boarded over so I can use it as a photographic platform for taking flat, low-level natural habitats – especially wetlands. On rare occasions I can use it for garden photography when, for example, a drive overlooks an interesting part of the garden. I also carry a small step-ladder in the car, which I often use for gaining an extra metre or so in height.

Appraising the background

Once the vista has been found, a picture should not be taken until a careful check has been made to see that there is nothing in the background which will spoil the photograph. It is all too easy to be captivated by strong colour

The only way the varied facets of this Leeds garden could be included was to climb onto the flat roof of a garden shed. How well it illustrates the potential of a narrow suburban garden.

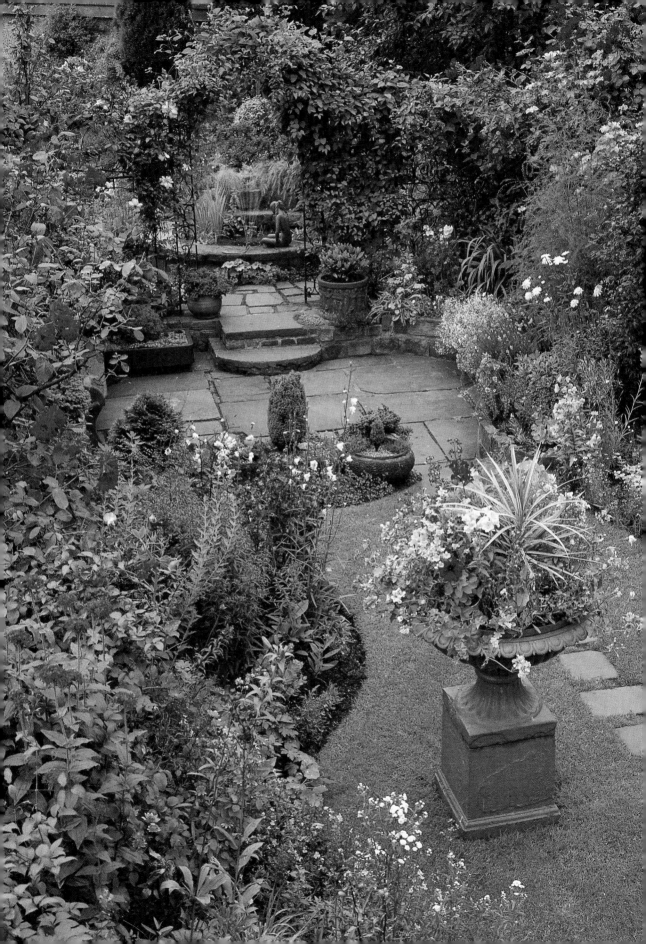

or shape in the foreground or middle distance and not to notice some unsightly objects until after the film has been processed. Look out for hoses snaking across the lawn, washing on a line, telegraph wires or vapour trails criss-crossing a blue sky.

Even daisies on a lawn can be distracting. One photographer I know will never take a picture of a garden unless the lawn has been mown and all daisy flowers removed. Personally, I feel it is a matter of relative scale; daisies are frankly not going to be visible in a wide angle view of a landscaped garden, whereas in a small garden they may compete for attention with flowers in an adjacent bed. I realised after having removed all the daisies from a patch of lawn immediately behind a low stone ornament, and on another occasion all flowering dandelions from behind a cluster of apples growing in an orchard, that it was time well spent. The removal of unwanted and conflicting plant material – such as dry bracken stems or twigs – before a picture is taken, is common practice among natural history photographers, who refer to it as 'gardening'!

Using a low viewpoint to isolate flowers against the sky is discussed on page 46 and this approach may also be useful for photographing a feature on raised ground. For example, a clump of trees will be more clearly defined when taken against sky, rather than against a background of other trees. Initially, statues will be sited so they can be viewed from normal eye level against a harmonious background; but backgrounds can change. Portions of walls, trees or paths directly behind a statue will make its form difficult to interpret, in which case a slightly lower camera angle may simplify the background with a uniform sky.

Autumnal misty mornings not only create atmosphere in a landscape, but they also blot out unsightly buildings or other conflicting parts of a background scene. Bonfire smoke can also help to mask annoying distractions in the background.

Framing the picture

When composing a garden vista, search for a strong foreground element to frame the picture and give it some depth. Many gardeners deliberately create frames so as to lead the eye on through the garden. Unadorned, inanimate frames such as archways, gateways, pillars and pergolas can be used at any time of year, as can wrought iron gates, which should be photographed slightly ajar. A wall opening can be used to frame a photograph (page 123) and in this way Far Eastern gardens provide endless opportunities for a camera enthusiast.

Frameworks which are festooned with climbers will look their best for a limited spell only. Similarly, live features such as rose arches, tree tunnels or even windows in pleached hedges, make attractive frames when they are leafing out or in flower. These frames can be used both to strengthen the design of pictures and to give them greater depth.

In large gardens, with a variety of trees, look for a solid trunk of a mature clean-boled tree – such as an oak or a beech – with a horizontal branch to form the framework. Even a branch on its own can help to break up a large expanse of solid blue or grey sky. Where columnar conifers have been planted as sentinels, they make strong vertical frames for a colourful border or shrubbery.

The rose archway both adds foreground interest and frames the openwork arbour in the Secret Garden at Tyninghame in Scotland. Late afternoon sun breaks up the uniform grassy path by casting obvious cross shadows.

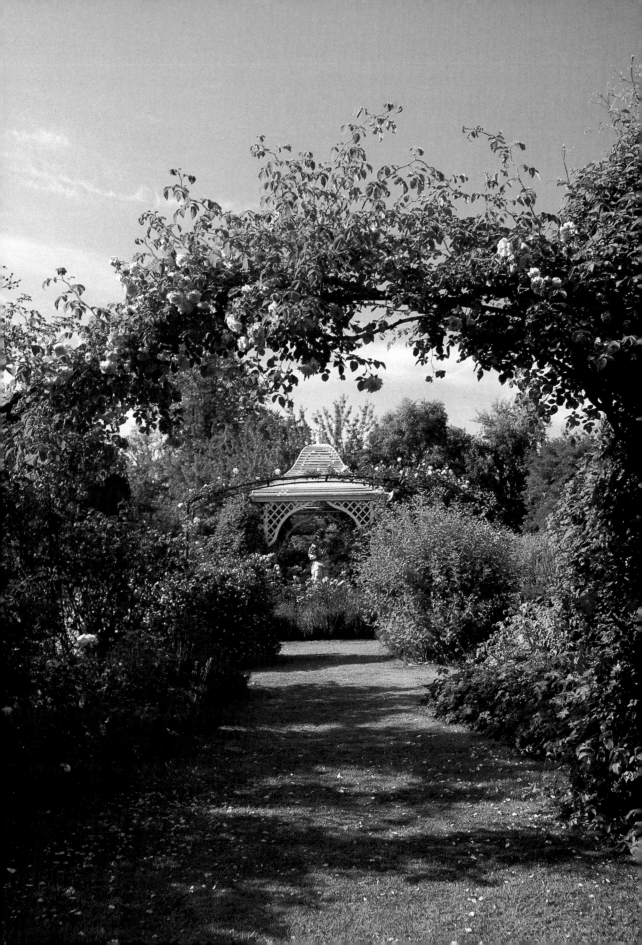

Adding foreground interest

A sombre scene – lit by soft diffuse light – can be enlivened by introducing colour or shape to the foreground. A clump of flowers or a spray of autumnal leaves will add that touch of vitality to what otherwise might be a rather lifeless or 'flat' picture, but care must be taken to see that the foreground does not dominate the picture or mask the view behind. Even a small area of red, for instance, automatically leads the eye away from the rest of the picture. It takes only a few moments to walk on past a view, turn round and approach it from the opposite direction, or to move a few paces backwards or forwards to assess the best picture. The view of the bridge framed by a colourful acer tree reproduced on page 64, was seen only after I had walked over the bridge, paused to pack up my cameras and turned round to pick up my tripod. Plants grown in mobile containers on patios

The obvious way to photograph Lady Emily's Garden at Pusey House Gardens in Oxfordshire is to look along one of the paths. Instead, I stood on a log to give a slightly higher viewpoint and used the flowering *Verbascum* to provide foreground interest.

and terraces often can be conveniently moved to give foreground interest. However I would not go so far as to advise the emulation of a landscape photographer who transported potted rhododendrons in his estate car so he could position them to provide instant – and unnatural – colour to all his scenic views!

Introducing foreground interest is most effectively done when using a wide-angle lens. Then it is possible to focus sharply on a clump of flowers in the foreground, yet still show them in a recognisable garden setting. I often take wild flowers in their natural habitat this way – especially alpines against a mountainous backcloth (page 114) or cliff-top plants against a seascape or emergent plants beside a river. Whatever the subject, when taking a view with foreground interest it is important to get as much as possible sharply in focus. By focusing on the foreground plants I note the minimum focusing distance required. I then focus the lens beyond this distance so that when the lens is stopped down to a small aperture this will provide sufficient depth of field to get both the background and foreground in focus. For example, if a spray of roses is 2 metres away from the camera, I would focus a 35mm wide angle lens on 7 metres and with an aperture of f11 I would be able to get both the roses and the garden landscape in focus.

Taking a panorama

From a high vantage point, we can enjoy an extensive panorama across the landscape, but as soon as we hold a camera up to the eye, we feel cheated when the camera sees only a portion of the view. Even a wide angle lens may not encompass the whole scene. However, it is possible to compose a panoramic mosaic print by taking a series of pictures so that each slightly overlaps the previous view. In this case, a standard lens is more suitable than a wide angle lens. Unless a tripod is used it will be difficult to keep the horizon level. When using negative film, the final mosaic is made by carefully trimming and matching the horizons on each print. This is best viewed by displaying the long composite picture in a gentle concave. The audio-visual enthusiast may like to attempt a garden panorama on slide film so that the complete vista is viewed using several projectors. Then, the amount of overlap between each frame needs to be minimal. After processing, each slide should be mounted in a soft edge mask so that the image fades gently into the neighbouring ones.

The success of any panoramic series clearly depends on careful framing and also maintaining a constant exposure. There are special panoramic cameras which record a view through 180° onto a single long negative or transparency either by means of the lens or the whole camera rotating.

Having set your scene, then start to consider how best to emphasise a particular aspect, noting especially the primary importance of light.

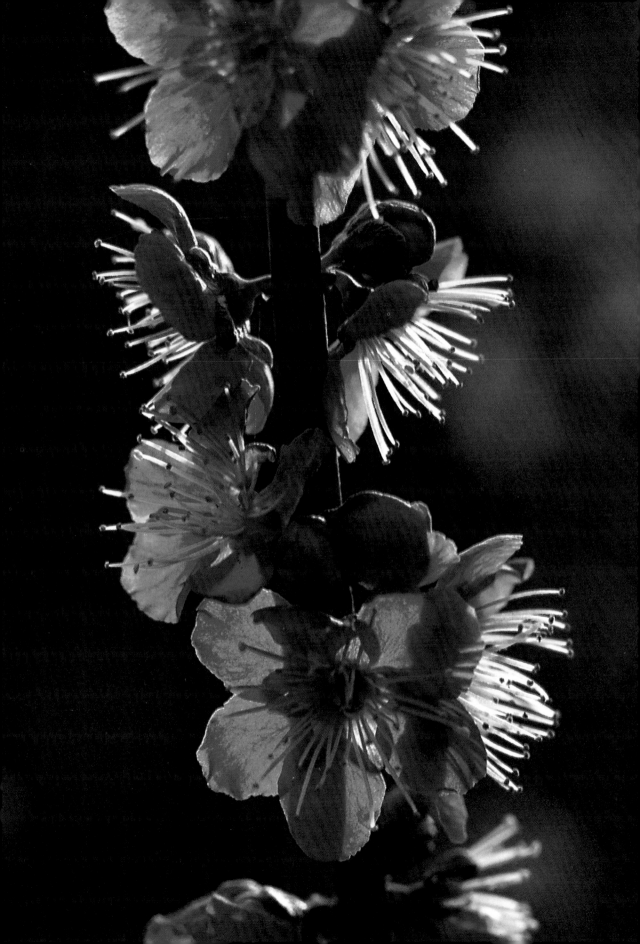

2 Looking at Light

To the photographer, light is of vital importance: it sculpts shape, reveals texture, highlights wet and shiny surfaces and casts shadows. The direction of natural light from the sun cannot, of course, be moved at will, but it can be used to optimum advantage and even modified by using a **filter** or **diffuser**.

The nature of light

The direction and intensity of the lighting can make or mar a photograph. The majority of garden photographs are taken using daylight, yet this is the most variable of all light sources, changing throughout the day and even in the middle of a long **exposure**. Depending on the time of day and the weather conditions, daylight can emphasise or mask detail and can enrich, suppress, or change colours. This can be seen most obviously when a white building or statue is photographed at dawn, at noon and at dusk.

The most dramatic changes in the colour of natural light occur at dawn and dusk, when the light from the low-angled sun passes through a thick atmospheric layer. This layer absorbs the blue light so that garden scenes lit at these times of day tend to be rendered with a warm reddish cast. This shift in the colour balance is most obvious with pastel-coloured flowers which have their natural colours masked by a reddish-orange glow.

Daylight colour films are designed to give their best colour rendering when the sun is shining at mid-day; the one time of the day when no self-respecting landscape photographer would choose to work, because the light is harsh and the high-angled sun casts stunted shadows. For all practical purposes, colour films will give a perfectly acceptable colour rendering if they are exposed within the period from two hours after sunrise to a couple of hours before sunset on a clear day. They may, however, give an unnatural colour reproduction on completely overcast days when the red light tends to be absorbed so that the scene is lit with a bluish cast. This is why snow scenes photographed on a dull day appear blue instead of pure white.

Sunlight usually appears uncoloured to our eyes, but when it is refracted by water drops (by rain or a garden spray) the component colours appear as a rainbow. The different coloured wavelengths – ranging from long red to short blue – can be seen in this spectrum. We see objects as distinct colours because their surfaces selectively absorb some coloured wavelengths and reflect others. A red rose, for example, appears red because it reflects red wavelengths and absorbs other colours. Berries and leaves which appear shiny reflect some white light. The proportion of light which is reflected depends on the tone and texture of the surface. Under identical lighting conditions, dark peaty soil, for instance, will reflect much

Sunlight behind the flowers of Japanese apricot *Prunus mume* 'Kyokkoh' at the Royal Botanic Gardens, Kew highlights the stamens. I used a 105mm macro lens so that just a few flowers filled the frame.

less light than a white wall or wet paving stones. Similarly, rough or hairy leaves will reflect less light than smooth, shiny leaves which have a lively appearance (page 103).

Choosing the film

From the wide range of colour films now available, how can the most suitable one be selected? The first decision to be made is whether slide or print film is required. The former gives transparencies for projection (or reproduction in books such as this one) while the latter is a negative film from which colour prints can be made. The relative sensitivity of a film to light is denoted by the **film speed**. For taking outdoor pictures with plenty of light, a film with a speed of 64 **ASA** or 100 ASA will do. In low light or in dark woodland gardens however, a film as fast as 400 ASA or even 1000 ASA may be necessary when working without flash. Having selected a film, make sure you set the correct speed on the film speed dial and keep it set for the entire film.

The rich colours of sugar maple *Acer saccharum* leaves in the New England fall, are enhanced by the dark unlit trunk. This sort of picture, with great contrast between the leaves and the trunk, needs careful metering of the leaves. I used a tripod for a long exposure with a 64 ASA film.

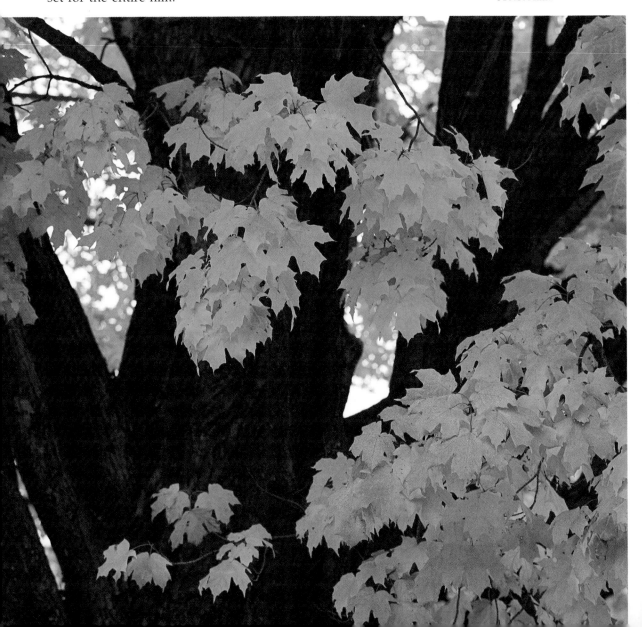

Metering light

A film will be correctly exposed only when there is enough light to reproduce full detail and true colours in the illuminated parts of the picture. If insufficient light reaches the film, the picture – whether slide or print – will appear dark through **under-exposure**, whereas if too much light reaches the film, the picture will appear pale or washed out through **over-exposure**.

Basic cameras which have no controls for adjusting the amount of light reaching the film are designed to be used in average light conditions when the whole frame is evenly lit without much contrast between highlights and shadows. Cameras with a built-in light meter which automatically adjusts and varies the exposure depending on the amount of light available, are not nearly so versatile as the SLR camera with variable aperture and **shutter speed** controls.

A correct exposure is derived by a combination of the intensity of light entering the camera via the lens opening or aperture, and the length of time the shutter is open. Therefore, a film can be correctly exposed either by strong sunlight for a short time (say 1/250 second) or by hazy light for a longer time (say 1/30 second). However, since not all films are equally sensitive to light there can be no single 'correct' exposure for a given subject at a given time. This is why I fail to see any benefit in quoting the precise exposure used to take the picture, since there is no guarantee that identical lighting conditions will prevail on another occasion.

Most modern cameras have a built-in metering system which means a separate light meter is not essential and the majority of SLR cameras with through the lens (**TTL**) metering take a **reflected light** reading of the subject. This gives good results for most evenly lit pictures without large areas of bright sky or dark shadow. A more accurate way of metering light in tricky situations, such as when a thin grass stem is backlit against a dark tree trunk or a coloured flower nestles against a white-washed wall, is to measure the **incident light** falling on the subject. The cheapest way of doing this is to insert a translucent white plastic disc – known as a Meter-mate – into the front of the camera lens. Instead of pointing the camera towards the subject, turn and hold the camera in such a way as to meter the light falling on the subject. For taking close-ups this means the camera is held beside the subject at 180° to the chosen picture viewpoint. This can also be done using a hand-held light meter with a white plastic diffuser over the light window.

A common cause of incorrect exposure of garden scenes arises when a camera with a TTL meter is imprecisely directed towards the garden scene. If the camera points up towards the sky a high and therefore erroneous reading will be obtained for the garden itself. The correct exposure for the garden can be found by pointing the camera towards the ground when metering. Before taking a picture a decision must be made concerning which part of the scene needs to be correctly exposed. If an accurate reading of a distant object cannot be obtained, meter from a nearby similar-toned object which is lit in the same way. When a view has two quite different tones or colours, yet detail needs to be shown in both areas, take separate readings and use an exposure mid-way between the two.

One way of coping with tricky exposures is to take several pictures of the

same subject but varying either the shutter speed or the aperture by half-stop intervals. Known as **bracketing**, this technique is clearly wasteful of film, since only one frame of a series will be correctly exposed. However, it is worth doing when taking a picture which is likely to be unrepeatable.

A manual metering system clearly indicates when the exposure is correct. A recording of under- or over-exposure can be corrected by changing either the lens aperture or the shutter speed. A hand-held camera used for taking only garden views may be set at a shutter speed of 1/125 second so that only the aperture needs to be changed. However, when taking close-ups of a flower, it is better to use a tripod. Slow shutter speeds can then be used, enabling the lens to be stopped down so that more of the subject will be in focus.

Automatic cameras tend to have an aperture-priority metering system, which allows the lens aperture to be selected and the camera then sets the shutter speed for the correct exposure. For static subjects this approach is ideal, but for moving subjects the shutter speed may not be fast enough to freeze the movement. This is where the alternative shutter-priority system, present on some cameras, is preferable; once the shutter speed has been selected, the meter sets the aperture.

Daylight

In temperate latitudes the proportion of hours of daylight to hours of darkness varies with the seasons, whereas in tropical regions the day length varies comparatively little throughout the year. It is therefore fortunate that during the temperate summer, when most gardens are at their peak, there are more potential hours for garden photography than at any other time of year.

When there is a clear sky, direct low-angled sunlight creates deep, sharply defined shadows. As soon as clouds roll across the sky blanketing the sun, diffuse light shines down from the whole sky making shadows less definite. In fact, they will disappear altogether against darker backgrounds, giving pictures a more restful feel.

The brightness of the background is not only an important factor in achieving a pleasant composition, but it can also affect the exposure of the whole picture. For example, on sunny days it is impossible to photograph a climber with coloured flowers growing on a white wall, so that both are correctly exposed on colour film. Therefore, it is necessary either to wait for a cloud to cover the sun, or else to return on an overcast day. Direct sunlight, however, can help increase the colour saturation or intensity of reds and oranges, especially when shining from the side or, in the case of translucent petals or leaves, from behind.

Rarely are solid black **silhouettes** seen in any gardening book. This is not surprising for silhouettes give no information about colour or surface texture. However, the simplicity of this kind of photograph reinforces outline shape and, in the case of leaves, reveals the way in which each species displays a distinct leaf mosaic. Taken against the light without sun shining through them, large pine needles with cone clusters make a striking picture and photographs of silhouetted deciduous trees in winter clearly reveal their branching patterns – a valuable aid for identification.

To give additional background colour interest, tree silhouettes may be taken against a dawn or dusk sky or through a fine mist as the autumn sun

Rosa 'Raubritter' growing beside the pool in the National Trust rose garden at Mottisfont Abbey in Hampshire, provides a colourful foreground. A threatening sky not only adds colour to the top of this picture, but also reduces the contrast between the sky and the rose.

begins to shine. For a totally black silhouette, deliberately under-expose the tree by metering the camera against the sky but do not point it directly into the sun as this can harm your eyes.

Direct side lighting will inevitably cast strong shadows in a picture which can make a close-up of a plant with upright leaves rather sombre. Localised shadows can be softened by holding a **reflector** directly opposite to the sun's rays so they bounce into the shadow areas. For colour film I use a gold reflector which often helps to reduce any blueness in green areas and hence to warm-up the greens. Aluminium cooking foil wrapped around a piece of cardboard or even a notebook can be almost as effective, although it will reflect a somewhat bluer, colder light. Even a white board will reflect some additional light. Reflectors are also invaluable for throwing a shaft of sunlight onto a shady spot in a woodland garden.

Exposure problems are also experienced when direct sunlight shines on pastel-coloured flowers. For example, a white rose tends to appear over-exposed when the surrounding green leaves are correctly exposed, while a correctly exposed flower will result in under-exposed leaves. If there are no imminent clouds in the sky, a localised cloud blanket can be created by using a diffuser to soften the harsh sunlight and shadows. Plain muslin curtaining makes a simple and cheap diffuser, although it is difficult to control single-handed, without an assistant. However, if it is stretched over a square bamboo or a circular wire framework it will not flap around in the breeze. There are also circular white nylon diffusers, available from photographic shops, which fold away into a small pouch by a simple twist of the wrists.

Mixing flash with daylight

When conditions are unfavourable for outside photography, the available light can be improved by balancing it with flash, and although this is not a difficult technique, **fill-in flash** needs to be carried out with care. It is particularly useful for taking plants in localised shady positions with surrounding brighter patches and for lighting up shadows in recessed areas, at the same time keeping colour in the background. This is preferable to using flash as the main light source, when a distant unlit black background resembles a nocturnal flash picture.

There are three basic steps to remember when taking a fill-in flash picture. Firstly, after taking a light reading, make sure to select a shutter speed which synchronises with the electronic flash. This may be 1/60 or 1/125 second, and is often painted red on the shutter speed dial. Secondly, set the aperture which will give the correct daylight exposure with the selected shutter speed. Finally, using the **guide number** of the flash, and the aperture you have set, calculate the flash-to-subject distance.

Potted coppery-leaved cordylines decorate Mrs. Winthrop's Garden at Hidcote Manor in Gloucestershire. I waited for two hours until the sun cast a symmetrical shadow on the brickwork, thereby repeating the distinctive shape of the entire plant.

Flash can be coupled with daylight to light up or fill-in harsh shadows in a close shot. For example, if a clump of flowers is taken without flash against a sunset, either the flowers will appear silhouetted against a dusk sky, or else the flowers will be correctly exposed and the sky over-exposed. By using flash, however, both the flowers and the sky can be correctly exposed. This kind of picture will look better if the flash output is slightly reduced because some daylight will contribute to the exposure. Reduce the flash output by adjusting the ASA setting *on the flash* by 1 stop, for example from 64 ASA to 125 ASA.

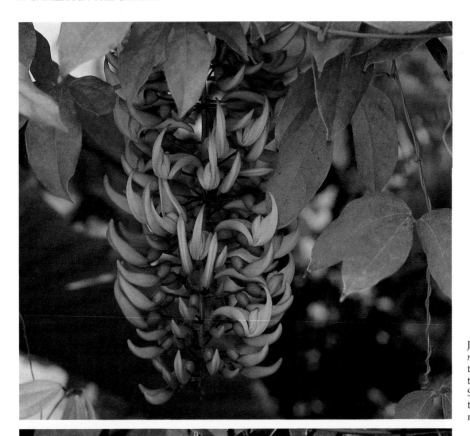

Jade vine *Strongylodon macrobotrys* flowers were taken inside a glass-house at the RHS Gardens, Wisley in Surrey using a gold reflector to boost the overhead natural light.

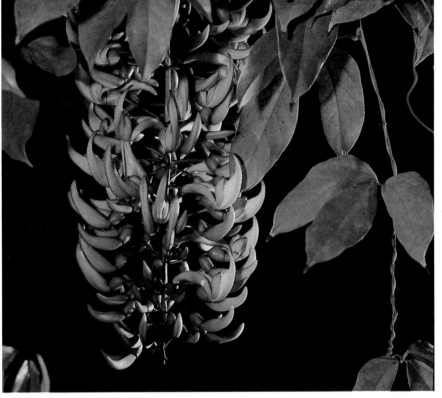

Two flashes have produced a more accurate colour reproduction of the exquisite turquoise jade vine flowers than the natural light picture. The flashes have also isolated the flowers from the unlit background.

Using flash

In the main, a flash is not essential for garden photography, although it is useful for taking plants or statues in dark situations, when working in grottos or for stopping the movement of active insects. Judging by the number of flashes I have seen going off when general garden scenes are being photographed, not everyone appreciates that a flash will be unable to illuminate a complete garden. Before using flash to light a plant, pause for a moment to consider if it is really necessary. If the light is poor and the subject is static, a slower shutter speed may be a better alternative to using a flash to boost the light.

I do not favour using a single flash for lighting plants, since a full-frontal blast of light from a flash-on-camera could never be classed as creative. However, if a flash is moved off the camera to one side, or even to a position behind the plant, it can emphasise hairy or spiny stems or leaves. Even if there is only a hot shoe flash attachment on the camera, it *is* possible to move the flash away from the camera by using a hot shoe-to-flash adapter. As with sunlight, a single direct flash can cast harsh shadows. They can be reduced by using a reflector, or by placing a piece of white translucent acetate sheet over the flash window as a diffuser. If a flash is pointed onto a white card or white umbrella held above the plant, indirect **bounced lighting** will give soft shadowless lighting. Multiple flash can be used either by connecting each flash head to a multiple adapter on the camera or by firing each secondary flash with a remote **slave** trigger.

For backlighting a plant with flash, either use a small tripod or a clamp to support the flash, or get someone else to hold it in position. As when photographing into the sun, make sure the flash does not shine directly into the camera lens, since this will result in flare.

When a flash lights up wet surfaces or shiny fruit, it will be reflected back as a bright highlighted area. This also happens when sun shines on such objects, but then the position of the highlights can be seen, and, if necessary, the camera position adjusted. With a flash, however, you can only guess where they will appear in the frame – an impossible task with moving water. Taping a torch to the flash may help and it will also aid focusing the camera in poor light.

Artificial light

Only on rare occasions will artificial continuous lighting be used to illuminate a garden picture, but I have included it here because it does present different problems from all other types of lighting covered in this chapter. Floodlit gardens and illuminated fountains are clearly nocturnal subjects so they are covered on page 31.

When working in a garden room or a greenhouse in fading light, it would seem logical to boost the ambient light with tungsten or fluorescent lights. Unfortunately this will give unnatural colour casts to plants, since daylight colour film is designed to be used only in daylight *or* with electronic flash. If this film is used with any tungsten lighting (which includes household electric bulbs) the pictures will have a yellow cast. There are special **artificial light films** available for use with tungsten lights, but if there is also some daylight present, the pictures will have a blue cast. So the most important thing to remember is, if authentic colours

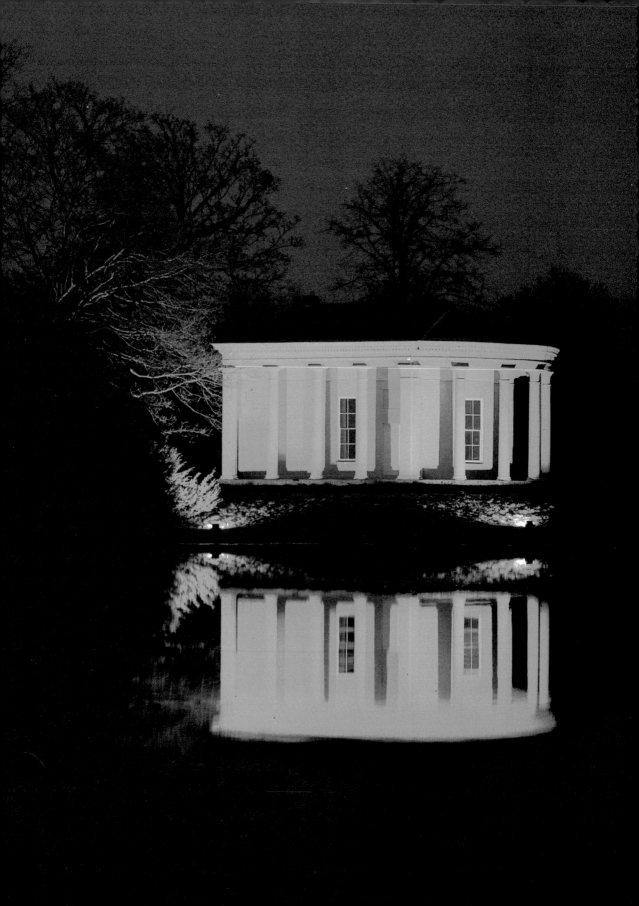

Spot-lit at night, the Music Temple is reflected in the lake of West Wycombe Park, Buckinghamshire. Compare this scene with the one taken several hours earlier, reproduced on page 84. For the night picture I used a 6-second exposure.

are required, *never* mix light sources. If only a few pictures of plants are to be taken lit by tungsten light, a daylight colour film can be used, providing a **colour conversion filter** such as a blue (80A) is placed over the camera lens to correct the yellow cast.

Fluorescent lights may look like daylight, but they produce a yellow–green cast with daylight colour film unless a FL-D (fluorescent-to-day) correction filter is used.

Night photography

When a full moon shines on snow the garden appears brilliantly lit because the snow is acting like a huge reflector carpeting the ground. Compared with sunlight though, this source is so weak that long exposures of several minutes will be required if any garden features are to be distinguished. When using a camera with TTL metering the exposure will have to be guessed at because the meter is not sensitive to such a low light intensity. However, there are a few hand-held meters which will give a reading in moonlight. In Japan, moon viewing – enjoyed for centuries by aristocrats – has now become a popular pastime. White sand creations in gardens reflect the moonlight in the same way as a snow blanket. Within the fifteenth-century Japanese garden of Ginkakuji created by Yoshimasa, are two piles of white river sand which do not harmonise with the rest of the garden when viewed by day, but under the light of the moon they exhibit an aesthetic beauty. If attempting to photograph a moonlit scene, using a long exposure, try not to include the moon in the picture because it will be reproduced as a blurred streak as it moves across the sky.

Other nocturnal garden subjects are plants which flower only at night – flowers such as the Nottingham catchfly *Silene nutans* and the queen of the night cactus *Selenicereus pteranthus (Cereus nycticalus)*. The flowers of the night cactus – like all night bloomers – open when the light intensity decreases and by the morning they have withered. Perfect flowers of these plants will therefore have to be photographed using a flash at night. Unless the camera is set up on a tripod and prefocused in daylight, a continuous light source will be required to focus the camera before taking the picture.

An evening primrose cultivated in China is known there as the moon or dinner flower because the flowers suddenly open at dusk when hosts take their dinner guests outside to view the spectacle. First the sepals spring back, then the four large yellow petals rapidly untwist and open out to emit a delicate scent. Different phases of the flower opening can be captured by using a flash, but the magical rapid transformation from a tight pointed bud to an open flower can only be relived by recording the sequence on film or video.

Use your own garden to look critically at lighting, to see the way it changes during the day. This will help you to gain a clearer understanding of the crucial part it plays in the successful photography of all subjects, in any situation. Having spent time creating a garden, it is also worth spending a little time waiting for the optimum lighting which will show it off to the best advantage.

3 Colour Appreciation

Colour is fundamental to all gardens, whether they display a gaudy patchwork of flowering plants or the harmonious tones of more subtle foliage. Black and white photographs therefore cannot be expected to convey the beauty of a garden scene; instead they concentrate attention on light and shadow, on shape and form, or on texture. It is for this reason that colour photographs have been used throughout the book, although colour as we see it may not always correspond with the way a colour film reproduces it. Multi-coloured images usually have no obvious focal point and so can be disturbing to the eye. The best colour pictures – of any subject – are generally simple images with only a few colours.

The great English landscape gardens are typically lacking bright colours – sombre green tones of lawns and trees are broken only by stonework and water. Modern garden colour is more arresting – beds and borders may be planted to produce a riot of colours throughout summer, or simply to echo shades of a single colour over a longer period. Colour can be found in winter too, when it often appears more conspicuous in stark contrast to bare earth and leafless branches, although some bare branches themselves contribute to winter colour. Among some of the most spectacular coloured barks are the red-stemmed white willow, *Salix alba* 'Chermesina' the purple osier, *Salix purpurea* and the red-barked dogwood *Cornus alba* 'Sibirica' – all of which need to be regularly pruned because it is the bark of young branches which colours up best. Other trees noted for their striking bark are listed on page 63. Persistent fruits (brilliant orange of stinking iris or reds of cotoneasters), winter flowering shrubs (yellow racemes of *Mahonia*, pink and red camellias or various shades of *Hamamelis*) and winter bulbs (cyclamens, nerines or winter aconites) all bring welcome splashes of colour to a winter garden.

The nature of colour

The variety of hues displayed by plants is governed by the pigments contained within the plant cells. The yellow and orange colour of flowers such as *Viola, Forsythia, Cytisus* and *Tropaeolum,* of carrot root, and the red of hips, haws and tomatoes arise from minute particles of colour pigments. Sometimes, as in the case of the tomato which changes from green to red, the colour develops as the cells lose their chlorophyll. Green leaves turn yellow in autumn as the green chlorophyll is broken down, revealing the yellow carotenoid pigments, previously masked.

Blue, violet and reddish-purple flowers and fruits, as well as red autumnal leaves, develop as a result of water-soluble anthocyanin pigments present in the cell sap. Among the most important of these pigments are the red cyanidin (found in *Centaurea, Pulmonaria, Rosa* and

The Winter Garden in Cambridge University Botanic Garden photographed in January proves how colour need not be restricted to the spring and summer months. Here, red-stemmed *Cornus alba* 'Sibirica' are backed by *Chamaecyparis lawsoniana* 'Winston Churchill'.

33

red cabbage leaves), blue delphinidin (found in *Delphinium* and *Malva*) and the salmon-coloured pelargonidin (found in *Pelargonium* and *Dahlia*). However, the colour of these pigments can be affected by the acidity of the cell sap; for example, pink hydrangea flowers can be transformed to blue flowers by feeding the plant with aluminium salts. Some of the colours caused by anthocyanin pigments are especially difficult to faithfully reproduce on colour film (page 39).

White flowers owe their colour to the internal structure of their petals, not to a pigment. Layers of air between the cells totally reflect or scatter light so that none of the spectral colours are seen. Any damage to a white petal removes air, thereby rendering it transparent.

Understanding colour

The way in which we see and appreciate colour is briefly covered on page 21. Within the visible spectrum are seven hues: red, orange, yellow, green, blue, indigo and violet. More simply, three main colours – blue, green and red – each cover about one-third of the spectrum and together make white light. This can be demonstrated by filtering light from three torches so that one appears red, one blue and one green. When the three lights are superimposed, white light is formed from these three primary colours. All this may seem rather academic and irrelevant to appreciating colour in the garden, but an understanding of colour is important if harmonious colour combinations are to be achieved.

Harmony and contrast

Gertrude Jekyll knew and understood the principles of colour association as laid down by Michel Chevreul, in his detailed 1854 report entitled *The Principles of Harmony and Contrast of Colours and their Application to the Arts*, edited by Faber Birren in a 1967 edition. Chevreul illustrated his theories by painting the spectral colours as a series of consecutive segments in his *circle chromatique*. Neighbouring colours in Chevreul's colour circle such as red, orange and yellow are harmonious with each other, while colours on opposite sides of the circle contrast. Thus, red and green show maximum contrast and are known as **complementary colours**. When a coloured filter is used on a camera, it transmits light of its own colour and absorbs light of the complementary colour. The bizarre colours seen in a colour negative are complementary of those in the original scene and therefore the true colours reproduced in the final print are the complements of the negative colours. Warm colours such as yellows, oranges and reds are strong and dynamic, whereas blues and greens are passive, cool colours. Each colour also has a range of tints or tones produced by the addition of white or black.

Miss Jekyll planted her borders as drifts of colour with white or grey separated from a strong colour by a tint or a tone. The herbaceous border in her Munstead Wood garden was 61 metres (200 feet) long by 4 metres (14 feet) wide. At the front, grey foliage plants – *Stachys*, *Santolina* and *Cineraria maritima* (now *Senecio bicolor cineraria*) – were planted as ground cover. At the western end were drifts of blue, grey-blue, pale yellow and pale pink flowers placed adjacent to strong yellows, oranges and reds in the centre. Moving eastwards from the centre the colour receded through orange and

Colour negative film (above) and colour slide film (below) of a pot plant collection show how the negative film colours are complementary of the slide film colours. Thus green leaves appear red, red *Poinsettia* bracts appear green, yellow *Primula* appears blue, blue *Cineraria* appears yellow and orange *Solanum* appears turquoise. Both pictures were taken in a sun-room using natural light.

deep yellow to pale yellow, white and blue-grey foliage, with purples and lilacs at the extreme east end. The whole border was designed as a complete picture, with cool ends and a warm centre.

With individual plants, effective colour contrast is equally important and roses grown as shrubs can be taken as an example. Silver foliage appropriately sets off the regal purple, crimson and maroon tones of many summer-flowering old roses. Acid green provides a cooler scene: in my mother's Hampshire garden, an underplanting of lady's mantle, hostas and ferns set off pale pink 'Fantin Latour'. At Greatham Mill, also in Hampshire, the golden glow of 'Buff Beauty' associates with a rich purple-leaved berberis to present a more vibrant picture, while not far away, in Gilbert White's garden – The Wakes at Selborne – large bushes of pale old rose flowers are well displayed against a dark yew hedge. All these are good examples of carefully chosen colour contrasts worthy of a colour picture.

We see plants as having distinct colours because each reflects different coloured wavelengths. Green leaves, trees and grass, for example, appear green because they absorb all wavelengths except green ones. However, it is not as simple as that, for in addition to the hue (actual colour) there are other qualities to consider; the green of a lawn is not the same as the green of a Douglas fir. The tone of a colour is determined by the intensity and the brightness; an intense colour is well saturated while a pale colour is desaturated. In bright sunlight, colours appear brighter because they are reflecting more light and the colour of a flower will appear stronger if a close-up is taken to exclude weaker surrounding colours. Using a polarising filter on a camera lens can help to increase the colour saturation by removing wavelengths which produce reflections on shiny leaves or fruits (page 103). Texture also influences colour intensity. When a glossy red fruit is compared with a matt red petunia or rose the fruit will appear much richer in colour than the flowers.

The same effect can be seen by comparing glossy and matt photographic prints of the same subject. Providing it does not reflect a highlight from a direct spotlight, the gloss print will appear much richer. This is why colour plates in top quality books are often printed on glossy art paper in preference to a matt surface which reflects some white light. Care must therefore be taken when copying a matt colour print, to ensure that reflections from the tiny raised portions of the print do not result in a noticeable loss of colour in the dark areas. If the print is laid face upwards on a table for copying from above, reflections can be eliminated by placing a truncated cone of translucent white paper around the print so the light is diffused from all directions. The camera looks down onto the print through the upper end of the cone.

Colours evoke distinct moods: muted tones are much more subtle and romantic than fully saturated ones. Hazy light produced by fog or smoke scatters light waves so that colours are softened. A similar effect, combined with a softly defined image can be achieved by breathing on the lens – a technique often used by portrait photographers – or by attaching a **soft focus lens** to the camera.

By resisting the temptation to crop in tightly on flowering Primula japonica and Dodecatheon sp. at Harlow Car Gardens in Yorkshire, the flowers are shown off to better advantage by being completely surrounded with green leaves. Notice how the plantings of the upper primula bed repeat the foreground colour.

Single-colour borders

The popularity today of gardens, or borders, devoted to a single colour

originates from Gertrude Jekyll who, through her perceptive painter's eye, created borders of restricted, but harmonious, colours. She understood that to stick rigidly to a single colour might not create the best visual effect: blue flowers, for example, can be shown to greater advantage by judicious planting with white or even their complementary colour, yellow. In her book *Colour Schemes for the Flower Garden* (recently reprinted), she also described and drew plans for a grey, a gold, a blue and a green garden.

Compared with other colours, a green garden or border never makes quite the same impact, because green is so widespread in any garden. However, it can look most attractive when it is planted beside a red brick path much mellowed with age.

The wealth of grey foliage plants available today has ensured that grey borders remain fashionable. However, this colour – especially if the individual plants have filigree foliage – looks disappointing in a photograph of a whole border, unless there are splashes of harmonious pink, lilac or purple. If, however, grey foliage plants with yellow flowers such as *Senecio greyi* and *Helichrysum angustifolium,* are allowed to flower in a grey border, although not too conspicuous in reality, they will be all too apparent in a photograph. A fastidious gardener will anticipate this discord by nipping out all the buds before the colour breaks.

A natural extension of the pure grey border is a white one – perhaps one of the most popular of all single-colour borders today, with grey used to soften the contrast between white and dark green. One of the most famous of all white gardens was designed by Vita Sackville-West at Sissinghurst where collections of plants are contained by low box hedges and where various shades of green and grey intermingle with the white inflorescences. Other white gardens can be seen at Hidcote and at Grey's Court.

White gardens present problems for photography on a sunny day if the white flowers are interspersed with green foliage since the contrast between them will be too great for colour film to expose both correctly. Nothing looks worse then over-exposed white flowers lacking any petal detail. It is therefore necessary to correctly expose for the white flowers even if this means the greens will then appear too dark. It is for this reason that I much prefer to photograph a white border on an overcast day.

A gold border or garden on the other hand, especially if the plants have bold leaf shapes, is easier to photograph. On a sunny day they positively radiate colour, while on a dull day, the yellows and golds are strong enough to stand out against a green hedge. The golden rose garden at Chartwell originates from a presentation made by the family to Sir Winston and Lady Churchill for their golden jubilee in 1958 and contains 32 different kinds of yellow and gold roses.

Red, being such a strong colour, is perhaps the most difficult to use as the prime colour for a border. In fact, the red borders at Hidcote include many red flowering plants which have green foliage for much of the year, in addition to purple-leaved Norway maple, berberis and prunus. In spring, crown imperial fritillaries, red-flowered rhubarb and geums provide early red flowers, while in summer red-flowering dahlias and salvias produce a good show. These borders are best seen in strong sunlight, for on a dull day the dark red foliage plants, in particular, can look very sombre and uninteresting.

In September, the Red Borders at Hidcote Manor in Gloucestershire include red-flowering begonias, dahlias and sweet peas, as well as plants with coppery foliage. These strong colours need bright sunlight for the camera to do them justice.

Reproducing authentic colours

More colour film is wasted in an attempt to reproduce blue flowers as we see them, than on any other garden subject. Time and time again, beautiful blue *Ipomoea* flowers come out as magenta, bluebells appear as 'pink' bells, and purple buddleia flowers are rendered a harsh red. I have a picture of a formal bedding scheme incorporating red and white fibrous-rooted begonias with blue ageratums, which is completely unusable because the red, white and blue design appears red, white and magenta.

The reason why these flowers appear the 'wrong' colour to our eyes in a photograph is that, in common with many other blue and also magenta flowers, they contain pigments which reflect some far red and infra-red wavelengths, invisible to our eyes, but detectable by the film **emulsion**. Colour films therefore reproduce some blues with overtones of red, instead of as pure blues.

For many years I have advocated two ways of counteracting this unnatural colour. Firstly, the effect is much less noticeable on an overcast day than on a sunny day. Secondly, a pale blue **colour compensating (CC) filter**, such as a CC 20B or a CC 30B, will help to increase the blueness of flowers – as well as any adjacent green leaves – by absorbing light of the complementary colour (yellow) and transmitting blue light. The filter remedy therefore only works if the frame is filled with blue flowers alone, since it 'blues' up the whole scene. The loss of light with such a blue CC filter is negligible – ⅓ or ½ stop – and this will be detected by a TTL meter.

Kodak have published several papers and leaflets on the so-called 'Ageratum effect', and they recommended using a filter pack made up of no less than five filters! However, this is hardly practical for use outside in a garden on a breezy day when the light loss can be as much as five stops! While I was working on this book in 1983, Kodak launched their range of Kodacolor VR films, known in the trade as 'short red' films, meaning they have a rapid fall-off in the sensitivity at the far red end of the spectrum. Having tried both Kodacolor 100 and 200 on a wide range of problem blue flowers, I have found that the colour reproduction is consistently good and much more acceptable than with Kodachrome slide film. Kodacolor,

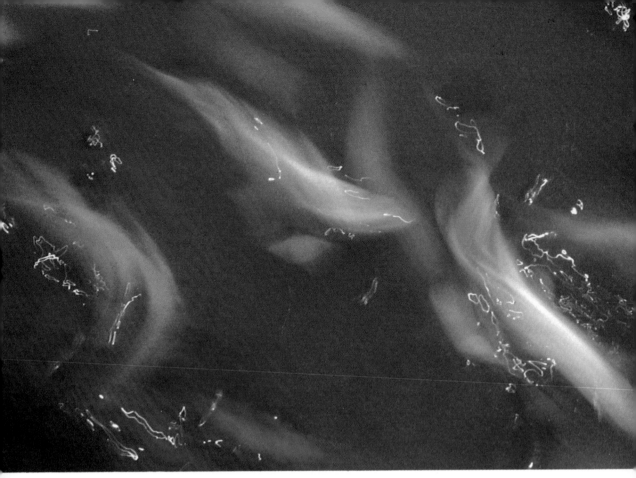

however, is a colour negative film, so that if a colour transparency is required, the negative has to be copied by a colour processing laboratory onto Vericolor slide film, which in 1983 cost 60 pence per frame.

A useful indication as to whether or not a blue flower will reflect red light and will therefore be a problem, is to view it indoors under tungsten light. Since this contains more red light than daylight it will exaggerate the effect. There is a tendency for species within the same genus to follow a colour trend which is not surprising since the colour of their flowers arises from the pigments in the cell sap (page 33).

It is clearly important to a plant breeder that the colour of any new cultivar should be reproduced authentically in a catalogue. Fortunately, it is possible for a printer to correct any colour before the picture appears on the printed page.

Abstract colour

The usual approach to garden photography is to reproduce the scene or the plant as naturally as possible, with authentic colour and identifiable shape. This is certainly my chief aim and is borne out by looking through the photographs in this book. However, an alternative approach is to take abstract representations. Most simply, the image can be defocused, so that individual soft-edged patches of colour appear against a muted background, reminiscent of a Monet landscape. The precise effect can be seen through an SLR camera, but remember to use a wide aperture, since a small one will increase the sharpness of the image. If a moving subject is photographed using a slow shutter speed of ½ or even 1 second, the

A 1-second exposure creates an abstract impression of the shapes and colours of Koi carp swimming in a pool in Japan. The changing positions of the highlights are recorded as a fine white tracery.

40

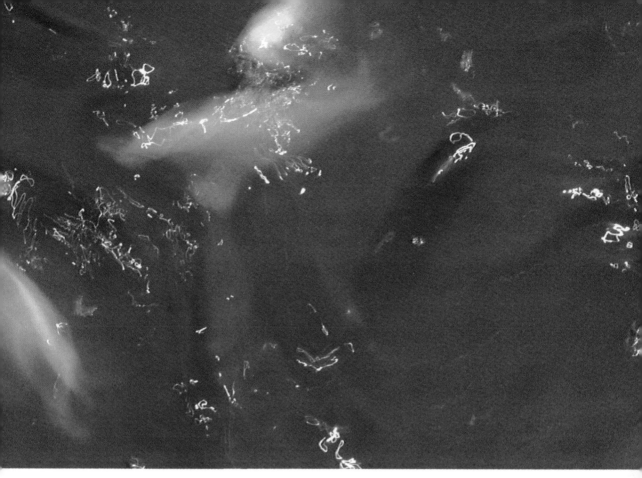

natural form becomes abstracted, although it is quite impossible to view the final effect. My first reaction when I saw some Koi carp swimming around in a deep pool in the garden of a Japanese restaurant, was to abandon all thought of a picture. Then I realised it would be interesting to try a long exposure and the result, seen here, shows streaks of colour with smaller streaks of light as the highlights on the water surface moved during the exposure.

Such a deliberate use of **blur** to abstract an image can extend or mix colours across the frame. A similar effect can be gained by photographing long-stalked flowers blowing in the breeze. Even static subjects can be abstracted by panning the camera from side to side during the exposure. Another way of creating an impression of movement of static subjects is by using a **zoom lens** and adjusting the focal length during a long exposure to produce coloured lines radiating out from the centre of the picture. A perceptive eye will always find abstract coloured shapes in a garden, which may need to be isolated from confusing surroundings by using a long focus lens. The interplay of light and shadow on water offers plenty of scope for abstract photographs.

Colour is an exciting medium, but it is often misused. The aim when using colour films should not always be to record dynamic reds on a summer's day since the subtle colours of a winter scene can be just as evocative, as is shown in the picture of the fountain playing reproduced on page 86. Mention has already been made of how colours relate to moods, so that any collector of garden photographs should strive to vary the mood, by including both vibrant and muted images.

4 Flowers and Fruits

More photographs are taken of flowers than of any other garden subject, and a glance back in winter at pictures taken during the previous spring and summer reminds us of the pleasures ahead when hibernating gardens will once again burst forth into a glorious kaleidoscope of colour. The colours, shapes and sometimes scent of many flowers (true species, not cultivars) have evolved in parallel to their natural animal pollinators. Pansies and irises have obvious honey guides on their petals to lure insects dusted with pollen from one flower to another of the same species, thereby bringing about cross-pollination. Many single-coloured flowers also have honey guides which are invisible to us, but not to insects. These **ultra-violet light** patterns can be found by lighting the flowers with an ultra-violet light source and taking a photograph through a special filter as I illustrated in *The Book of Nature Photography*. In temperate regions, insects are important pollinators not only of ornamental flowers, but also of fruit and vegetable crops. In the tropics, birds and bats also pollinate flowers; the long-billed hummingbird is a superb example of a bird adapted for the collection of nectar but which incidentally transfers pollen from one flower to another.

The fact that many of the animal-pollinated flowers give untold pleasure to gardeners and photographers is of secondary importance to the plant – or is it? Plants with highly attractive flowers are most likely to be propagated and conserved by man, although he may wish to 'improve' on nature and breed larger or more elaborate cultivars.

Colour and smell also attract animals to the fruits of some plants, which are then eaten and their seeds thus dispersed. It is therefore not surprising that people too are attracted to animal-pollinated flowers and animal-dispersed fruits and they are therefore more frequently photographed than the smaller and more insignificant wind-pollinated flowers.

There are two distinct approaches to photographing the flowers and fruits of garden plants. They can be taken *en masse* in their natural surroundings or as detailed close-ups, to show not only their colour, but also their structure and form. As flowers and fruits are covered in separate chapters on beds and borders, and on trees and shrubs, this chapter will concentrate on taking close-ups, which can be attempted in any garden, whatever the size. More distant general shots should not be neglected though, since close-ups on their own cannot give information about the way in which a plant grows.

Taking close-up photographs of flowers or fruits requires careful focusing on the subject, and thus the differences between one flower and another are better appreciated. It is like going round a garden looking at plants through a hand lens. A photograph is said to be a close-up when the

A close-up lens was used to take this harmonious planting of yellow nasturtiums and *Lonicera japonica* 'Aureoreticulata' covering the wall of a cottage garden in the South Wales village of St. Florence.

magnification of the subject on the film (negative or transparency) is one-tenth or more of its life size. Put another way, it means that a photograph of a spray of flowers which is 35cm across will be considered a close-up when it just fills a 35mm frame. Such a magnification is not going to be particularly impressive because it will not reveal any more than can be seen with the naked eye.

However, if a single flower or fruit is photographed at life size so that a 35mm-long subject fills the frame and is blown up many times larger than life size on a print or a screen, then this is much more exciting. Photographs can be taken in the garden at magnifications of greater than life size, but to do this a tripod and a **cable release** are essential and an electronic flash useful. Larger than life-size close-ups are often referred to as macrophotographs, but this is a misnomer since it translates literally as large photographs! A more precise word is **photomacrograph**, which is comparable with a photomicrograph – a picture taken several times larger than life size through a microscope.

Getting in close

The **definition** of a photograph depends on several factors: the film speed, the lens quality and the contrast of the subject. Movement of the camera while using a slow shutter speed, or careless focusing will produce a blurred image. To get a well-defined close-up, as much enlargement as

The soft early morning light was exactly right for this still-life picture of grapes growing in the Dordogne, France. At this time of day in autumn, dew is often present on fruit.

possible must be done in the camera because enlarging a small part of a negative or a transparency taken with a standard lens will never give such a clear image as a carefully focused close-up. The easiest (and cheapest) way of getting in close – with any type of camera – is simply to attach a **close-up lens** to the front of the camera. The strength of a close-up lens is quoted in **dioptres**. The main advantage of using a close-up lens is that it does not reduce the amount of light reaching the film. An SLR camera is ideal for taking close-ups because unlike non-reflex and **twin lens reflex (TLR)** cameras the image seen through the viewfinder is precisely the same as in the final photograph. This discrepancy between the viewfinder image or the upper lens image of TLR cameras and the film image is known as **parallax. Extension tubes** or **bellows** can be inserted between a standard lens and an SLR camera body to enable photographs to be taken at a much closer range than with a close-up lens. The more extension used, the greater the magnification.

For anyone who wants to specialise in taking close-ups though, I would strongly recommend getting a **macro lens** with its own built-in extension. The most popular macro lens for plant photography is the 50 or 55mm macro which can be focused continuously at any distance between infinity and 25 centimetres. Without any extension tubes it usually gives a magnification of half life size, and by using tubes or bellows up to life size or greater can be obtained.

Extension tubes, bellows and macro lenses however all move the lens further away from the film plane, thereby reducing the amount of light reaching the film. When using a built-in TTL meter, this light loss will automatically be taken into account, but when using a hand-held meter, allowances must be made. As a rough guide, allow two extra stops (by either opening up the lens aperture or by using a slower shutter speed) when using an extension which equals the focal length of the lens; for example, 50mm extension with a 50mm lens, or 90mm extension with a 90mm lens. If the subject is not moving it will be better to retain an aperture of say, f8 and to use a slower shutter speed (say 1/30 second instead of 1/125 second) rather than to use a larger aperture (f4 instead of f8) and retain a shutter speed of 1/125 second, because the depth of field becomes reduced as the aperture is enlarged.

One of the most common faults of close-up pictures is a fuzzy image. This may be caused either by moving the camera while taking the picture, or by the subject moving. The best way of eliminating camera shake is by using a tripod and preferably a cable release to trigger the shutter. Some photographers advocate using a wind shield to cut down plant movement, but I have found they can still create eddies behind the plant, and unless the shield is made of clear Perspex, it may be obvious in the picture. Movement of a tall-stemmed plant such as a scabious can be reduced or even eliminated by using a plant clamp made simply from two metal double-ended knitting needles and a metal paperclip. One knitting needle is pushed vertically into the ground beside the stem. The other, fixed at an angle across it with plasticine, has a paperclip embedded in plasticine at one end. The paperclip is partially opened out so it can be carefully hooked around the plant stem.

When taking any close-up it is most important to focus the camera carefully, since an out-of-focus close-up conveys little information about

the plant. The whole picture need not be sharply focused, but the subject at least should be clearly defined; indeed, it can be quite effective to photograph a flower through an out-of-focus framework of leaves. For crisp close-ups, use a small lens aperture such as f11 or f16 so that the zone of sharp focus – the depth of field – is increased. With a non-automatic lens or with a depth of field button on the camera, the way in which the depth of field varies as the aperture is changed can be seen. Look carefully at the subject when stopping down the lens or depressing the depth of field button before taking a picture.

When taking a subject a metre or less away from the camera, the depth of field extends almost equally on either side of the plane on which the camera is focused. Therefore the plane of focus should be on a part of the flower slightly behind that nearest to the camera, so that when the lens is stopped down, the whole flower will appear sharply in focus. It is much easier to get several rose flowers in focus when they are growing in a vertical plane up a wall than if they are branching out in all directions in an open bed. Similarly, it is easy to get flowers which carpet the ground sharply in focus by holding the camera overhead, parallel to the ground.

Focus on flowers

Before photographing flowers, make sure the blooms you have chosen are as near perfect as you can find since frosted or shrivelling petals will be all too obvious in a close-up. One of the most frequently photographed garden flowers must be the hybrid tea rose. The solid sculptured flower is an excellent subject for close-ups because it makes an easy target on which to focus the camera. I prefer to photograph modern roses from the side when they are half open so that their upright flowers are set off by surrounding foliage. However, some of the older roses with flatter blooms of many petals are most beautiful when fully open and I can then look into the flower – a viewpoint also preferable for single roses, especially if the stamens contrast in colour with the petals.

It is just as important to appraise the direction and type of lighting for a close-up as for a garden scene. Side lighting will help to model the shape of large many-petalled flowers such as roses, peonies, dahlias, carnations and chrysanthemums, although very early or late in the day the shadows will be long and may need to be filled in with a reflector (page 27). Flowers with translucent petals such as poppies, can be lit from behind. The petals then radiate their colour in a similar way to a lampshade lit from within. The same effect can be achieved on a dull day by lighting the flower with flash, but you will either need someone else to hold the flash in position or else set the flash up on a little tripod behind the flower. Make sure when the flash is angled towards the flower it is not in the field of view.

A special kind of electronic flash, known as a **ring flash**, is useful for lighting extreme close-ups of deep-throated flowers and I often use one when photographing orchids. The circular flash is fitted around the lens, so it provides front, shadowless lighting.

Backgrounds, too, must be appraised when deciding on the best viewpoint; the impact of a close-up is immediately lost by distracting colours or shapes behind the flower. Flowers of climbers growing up stakes, or on a pergola or along a rope or chain, as well as tall flower spikes like lilies and gladioli can be isolated from their background by using a low

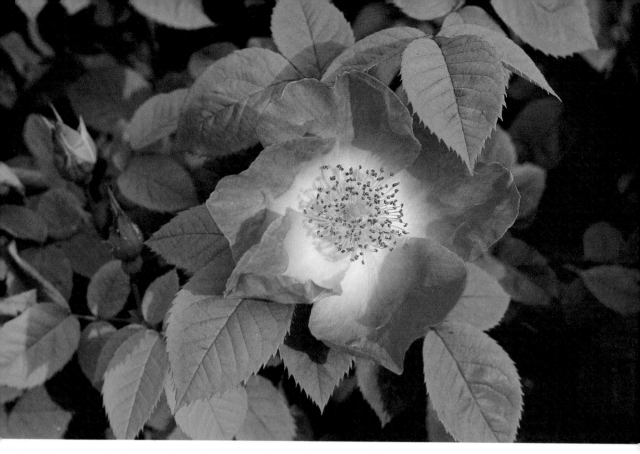

Late afternoon sun lit this *Rosa gallica* x 'Complicata' bloom in my Surrey garden. The orientation of the flower made it easy to get both the petals and the stamens sharply in focus.

viewpoint to set them off against a blue sky. Try to avoid photographing any flowers (or fruit) against a white sky because like a white wall (page 66) this will present too great a contrast for colour film. In a similar way, flowers of waterside plants can often be set off against water – providing a slightly higher viewpoint can be found to look down on them.

Even if it is not possible to isolate a flower against sky or water, the background can be deliberately thrown out of focus so that it appears uniform in tone and colour. The limited depth of field associated with close-ups means that unless the background is very close to the flower, it will automatically appear out of focus. **Differential focus** is a widely used technique for isolating a subject from its background and sometimes it may be necessary to open up the lens by one stop to ensure that a focused flower really does stand out from its background. A confusing background can, of course, be eliminated simply by inserting a plain board behind the flower, but then the uniformity of tone will appear unnatural.

A simple but very effective way of highlighting a flower is to increase the contrast between it and the background. This can be done by someone casting a shadow behind a sunlit flower. My husband is used to doing this for me, but when I am working on my own, I have to resort to using a rucksack's shadow behind short-stemmed flowers.

The majority of bulbs flower early in the year when there are fewer daylight hours available for photography than during the summer months. Small flowering bulbs such as snowdrops, winter aconites, *Muscari* and crocuses planted in groups can be taken as a clump. Tulips, too, look better grouped together; typical catalogue pictures of a few perfect, equidistantly positioned blooms photographed against a plain background are completely unnatural. Where different coloured tulips have been bedded

out together, dramatic colour mosaics can be produced by using a long focus lens to foreshorten the perspective. Since you are more likely to get freak weather in spring than in summer, never delay taking a perfect clump of bulbs. I can recall two years in six when all our tulips have been perforated and beheaded by a sudden hailstorm.

Grassy swards set off flowering bulbs well, as can be seen by the sweeps of miniature *Narcissus bulbocodium* in the alpine meadow at Wisley, or the snakeshead fritillaries and many other flowers in the meadow lawn at Great Dixter. Bulbs also bring woodland gardens alive in spring: the Dell at Bodnant is filled with daffodils and other spring bulbs, while carpets of bluebells flower beneath trees at Winkworth Arboretum and in Tatton Park's Bluebell Glade. Other gardens noted for their daffodils are Stagshaw where many different kinds can be seen, and Barton Manor in the Isle of Wight with a spectacular quarter of a million bulbs. Plants such as alliums or ivies with compound flower heads made up of masses of tiny flowers, create a confused image when one head merges in with another. They therefore need to be taken individually or else backlit to show the fine detailed structure.

Instead of taking flower close-ups completely at random, none of which relate to one another, it can be more rewarding to specialise in photographing one group of flowers or flowers associated with one kind of habitat. As well as roses, other popular flower groups are dahlias, carnations and chrysanthemums while in the winter months, orchids can be taken under glass (page 141). Alpine flowers (page 115) are probably the most widely photographed flowers adapted to life in a specialised habitat, but wetland and woodland flowers are just as interesting in their own way.

A long focus lens was used to take this colourful spring bedding display in the RHS Gardens at Wisley in Surrey. The foreshortening effect of this lens has concentrated the colour blocks of the tulip flowers.

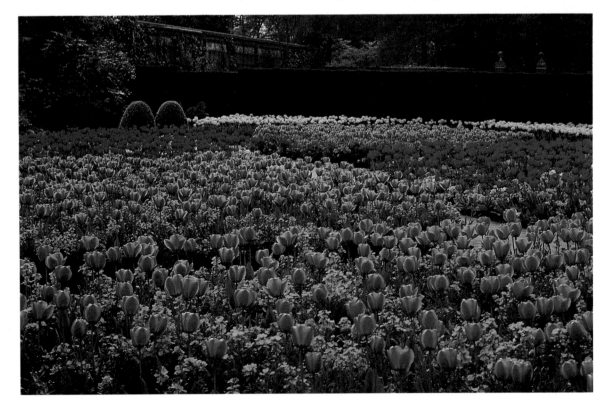

An overhead view of Cox's orange pippin apples in a box produces a graphic design. Rain drops on the fruit bring an additional sparkle to the freshly picked fruit.

Fruits and seeds

Colourful fruits which are worthy of a photograph include those of *Berberis, Cotoneaster, Pyracantha, Skimmia japonica*, the stinking iris *Iris foetidissima*, many *Sorbus*, crab apples, the strawberry tree *Arbutus* and the red fleshy arils of yew. The hips of species roses are also useful subjects for autumn photography: rounded, pendulous or clustered, they provide different forms, while colours vary from the tomato red of *Rosa rugosa* to the blackcurrant of *Rosa spinosissima*.

All shiny fruits reflect sunlight or flash as bright highlights. This can be very distracting when taking a close-up of a cluster of holly fruits by flash for a highlight will appear in each fruit and tend to dominate the picture. These highlights can be toned down either by bouncing the flash off a white card, or by diffusing the light by covering the flash window with layers of tissue paper. Ways of reducing skylight reflections on shiny fruit are the same as described for shiny leaves on page 103.

Most fruits are solid and are therefore quite unsuitable as backlit subjects; one notable exception is the flat capsule known as a silicula of honesty. The only way to show up the internal seeds is by photographing the capsules against the light. The persistent fluffy styles of clematis fruits are also most effective when backlit.

Large ornamental fruits such as gourds and the multi-coloured varieties of corn grown in New England always make attractive photographs.

Gourds can be taken while growing attached to the plant or after they have been harvested, but the colourful corn seeds are revealed only after the cobs have been cut and the protective leaves pulled away.

Fruits of trees trained on walls are usually more accessible for photography than those on large open grown trees, but even then it may be necessary to lift up or tuck back a leaf or two if the fruit is hidden by too many leaves. Look for a good cluster of apples, pears or plums and if it is not evenly lit, use a reflector to light up the shadows. An early morning rise may be rewarded by finding dew-covered fruit, which advertisers would have us believe adds extra freshness!

The abundance of fruit varies from one year to another, since it depends on a number of factors including the weather which prevailed at the time when the flowers were open. Insects are not active on rainy or windy days and so will be unable to pollinate flowers in these conditions, dry weather is also essential for wind-pollinated flowers to liberate their pollen. Therefore all flowers which depend on cross-pollination for the fertilisation and subsequent development of the seed and fruit to take place, produce a poor crop of fruit after a bad spring.

Fruits are dispersed away from the parent plant in a number of ways. The mechanism may be wind (pines, acers and composites), mechanical (brooms, *Impatiens* and *Erodium*), water (water lilies) or animal dispersal. Getting an action picture of Himalayan balsam fruits dispersing their seeds presents a real challenge because the ripe fruits explode instantaneously when touched. However, fruits with miniature parachutes like *Crepis* float leisurely upwards in the breeze and so can be photographed using either a fast shutter speed or flash.

Autumn is a time when pictures can be taken of birds feasting on, and thus dispersing, garden fruits; indeed some plants are now promoted specifically for their bird-attracting fruits. Wild birds fed regularly during the year will be less wary of a close approach, but even so a longer focal length lens than the standard 50mm lens will need to be used in order to get a reasonably sized picture of the birds feeding. A 200mm lens can be hand held quite easily but a shutter speed of at least 1/250 second must be used to freeze a moving bird and to stop all movement of a hand-held camera. In a harsh winter it pays not to delay photographing berries, since almost overnight a bush can be stripped by hungry birds – unless they are thwarted by covering the fruit with plastic bags, as one of our neighbours does each year with her holly tree. Long after all the berries have gone, birds will still be attracted to a garden by food on a bird table or simply by nuts or fat pushed into holes bored into logs. Squirrels can play havoc with a lawn as they dig holes to bury their nuts. This is another example of fruits being dispersed by animals and can be photographed through a nearby open window or by setting up a camera with a **motor drive** on a tripod in the garden and triggering it with a long air or electronic release.

Pollinators and pests

An obvious way of adding interest to a flower picture is to take it with a butterfly feeding on the flower. Unless there are abundant naturalised buddleias near your garden, you cannot fail to attract butterflies by planting this shrub – also known as the butterfly bush. Other good butterfly plants are aubretia, sweet rocket, valerian and, in late summer,

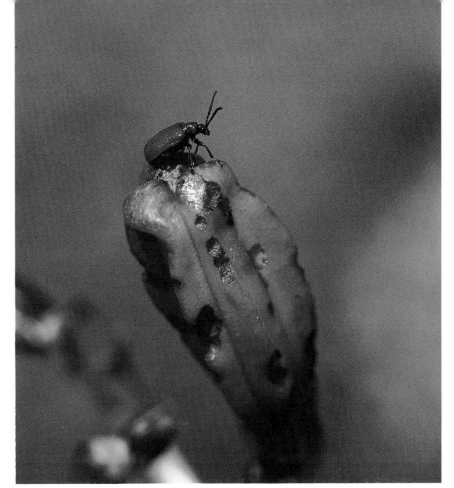

A macro lens was used to photograph a lily beetle *Lilioceris lilii* and the damage it has caused to a fruiting lily. The sharply defined beetle shows up well against the out-of-focus background.

sedums and Michaelmas daisies. Butterflies are attracted to simple cottage garden flowers in preference to showy, unscented cultivars. The motivation for taking photographs of any useful insects such as bees and butterflies on flowers will be for purely aesthetic reasons, but good photographs of pests or diseases of flowers and fruits may help in a correct identification so that advice can be sought in controlling the problem.

The techniques used for photographing insects are similar to those used for taking flowers in close-up, namely, careful focusing and framing and attention to background. However, an active insect will not remain static for long, so you will have to act quickly if you are to get any picture at all. A medium long focus lens, such as a 105mm, with extension tubes, gives a greater **working distance** than a standard 50mm lens used with extension tubes which means the insect is less likely to fly away when approached. There will be no time to set up a tripod; although a **monopod** will help to steady the camera for an available light picture, it will be unnecessary for a flash picture. Several macro flash units are now available for close-up photography incorporating twin flashes mounted onto a bracket which is screwed into the base of the camera.

Many books are devoted solely to flowers, so that the illustrations in this chapter cannot possibly do justice to the infinite variety to be found even in one simple garden. Fruits, too, are highly variable, but many are overshadowed by the splendour of their flowers. An interesting, photographic project would be to illustrate the yearly cycle of a plant from the time the buds burst open to when the seeds are dispersed.

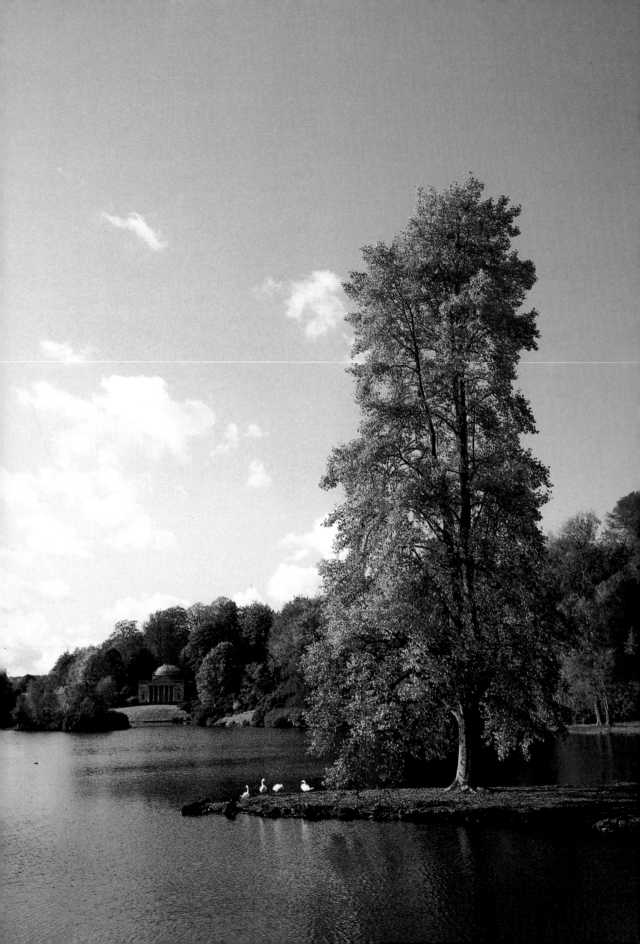

5 Trees and Shrubs

Deciduous trees and shrubs are worthy of photography in any season. By following the natural progression of leafing out, flowering, fruiting and leaf fall, an interesting sequence of photographs can be obtained. A deciduous tree in winter cannot compare with its short-lived autumnal glory, but the form and branching patterns can be appreciated only at this time of year. Evergreens may not change quite so dramatically but they too are enlivened by flowers and fruits. Before I began to photograph trees I hardly gave them a second glance; now I anticipate when the new spring growth is likely to appear, study leaf mosaics, search for small wind-pollinated flowers and feel bark texture. For the magnificence of specimen trees to be captured on film they need to be photographed in large open spaces, whereas shrubs can be photographed in the smallest of gardens, as can the foliage, flowers, fruit and bark of trees.

Extensive tree and shrub collections can be seen at Hillier's Arboretum and in Savill Gardens among other places, while the National Pinetum at Bedgebury, the Younger Botanic Garden in Scotland and Powerscourt in Ireland specialise in conifers. Notable mixed tree collections flourish at Westonbirt Arboretum, the Royal Botanic Gardens at Kew and Edinburgh, Wakehurst Place and the National Botanic Gardens at Glasnevin.

The introduction of trees and shrubs to Britain was a random process; some collectors covered certain regions of the globe, while others concentrated on particular genera. Centuries of exploration have culminated in the rich diversity of trees and shrubs gathered in British gardens from almost every corner of the earth. Local variations in climate clearly affect the species distribution. For example, only in certain gardens in the extreme west of Britain can trees sensitive to frosting survive and grow. A visit to these gardens is a revelation; here can be seen tender exotics such as the Australasian tree fern *Dicksonia antarctica*, (at Trelissick in Cornwall), the New Zealand rata tree *Metrosideros robusta* (at Tresco Abbey Gardens, Isles of Scilly), the Chilean lantern tree *Crinodendron hookerianum* as well as many other trees and shrubs (at Inverewe in Ross-shire). Likewise, the mild microclimate in the Chelsea Physic Garden, London allows three Mediterranean trees, a cork oak, a prickly Kermes oak and an olive tree – the biggest specimen in Britain – to thrive.

Specimen trees

Open-grown trees in parks or large gardens should be easy to photograph, for they can be taken from any position depending on the angle of the sunlight. So often, however, tree pictures are disappointing and it is advisable first to walk right round the tree and appraise lighting and background. Side lighting will show up the colour of the foliage, convey

Swans rest beneath a magnificent open-grown tulip tree *Liriodendron tulipifera* on an islet in the lake at Stourhead in Wiltshire. The contrast between the autumnal colour of the tree and the blue sky was enhanced by using a polarising filter.

the three-dimensional form of the tree as a whole and help to balance the picture with the shadow pattern of the tree on the ground. John Bartram of Philadelphia, an early plant collector in the new American colonies, said in 1755 that he could often identify different species of oaks – up to a mile away – by their growth form. Today, photographs of specimen trees, carefully taken, may be useful for confirming their identification.

Before Dutch elm disease struck English elms, I took a series of photographs of a mature isolated tree in Surrey's Farnham Park in different seasons to illustrate how the mood of the tree changes with both the direction of the light and the season. These pictures, like so many of English elms, are now of historic interest.

In autumn, deciduous trees with an open branching system will have the autumnal colours of their leaves, enriched by backlighting, but this is not suitable for evergreen conifers which will be reproduced as a solid silhouette. When documenting the seasonal changes of a deciduous tree, try to select a tree which is near your home, otherwise it may be too much effort to make the journey outside the conventional garden-visiting season. Do not despise misty mornings, for they can help to simplify the background by blotting out distant trees or buildings and the shape and form of the selected tree can be better appreciated. After a snow fall, a white slope will show up tree silhouettes to good advantage.

Photographs taken of open-grown trees filling most of the frame will show the characteristic shape of the tree, but they cannot illustrate how trees are used to add form and colour to the landscape. A good example of this is the National Trust property at Stourhead where there are many fine mature specimen trees. After Henry Hoare II inherited the property from his father in 1741, he worked for half a century laying out pleasure grounds for others to enjoy. His tree planting was not extensive but it was impressive and, as in a painting, he aimed to create a picture of contrasting greens. Lighter foliage of beech was placed alongside the evergreen yew. Around this time, cedar of Lebanon and the Norway spruce were introduced to Britain. Since then, many exotic trees and shrubs have been planted at Stourhead, notably tulip trees, tiger-tail spruce, noble fir and Macedonian pine. In recent years, the mature trees have been catalogued and numbered. They can be identified by using the National Trust publication entitled *Mature Trees in the Stourhead Landscape (1981)*.

Avenues

In the seventeenth century, avenues were an essential part of the great formal gardens, but they had little place in the designs of the Landscape Movement of the eighteenth century. However, many have since been created and provide another aspect for tree photography, although scope is much more limited than for specimen trees. From ground level, avenues have to be taken end-on along their length, although the roadway need not always be placed centrally in the picture.

One of the earliest avenues in Britain, believed to have been created by Bishop Croft to celebrate the Restoration, is of Spanish chestnuts at Croft Castle. The common lime is by far the most popular avenue tree and huge ones are lined up at Euston Hall – a legacy from John Evelyn. Limes also form one of the longest avenues in Britain, designed by Repton for Clumber Park and stretching for three miles, two-thirds of it as double

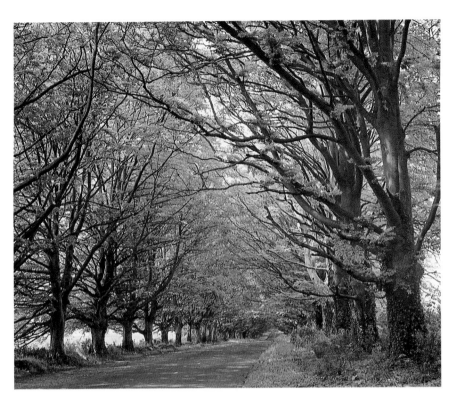

Near Wimborne in Dorset, is an avenue of 365 pairs of beech trees planted by the Kingston Lacy Estate. When the sun shines in May, it filters through the young leafy canopy.

rows. Beeches, originally planted in 1707 at Tyninghame in Scotland, lead unexpectedly to the sea; they also provided a double avenue (green inside and copper outside) at Cranborne Manor.

Small-scale avenues can be seen in many gardens where fruit or ornamental trees are trained into tunnels or arcades. Laburnum tunnels with their rich cascades of yellow flowers are at their peak for photography at the end of May or the beginning of June, and examples can be seen at Bodnant and at Ness Gardens. Bateman's, once Rudyard Kipling's home, has a pleached pear walk decorated with clematis. Cranborne Manor has an apple tunnel, but the famous one at Tyninghame extending for 110 metres, recently had to be replanted.

Some avenues are evergreen and can be photographed throughout the year. Among the more unusual ones in Britain are a 500-metre stretch of monkey puzzle trees in Bicton Park, a series of clipped arches to form a yew arcade at Alton Towers and 14 evergreen holm oaks, planted in 1840 and clipped to form giant 10-metre-high cylinders at Arley Hall Gardens. Lining a drive of a private garden in Australia, an avenue of lemon-scented gums, *Eucalyptus citriodora*, with their smooth white trunks, echo white pillars fronting the house.

In spring, look for ornamental trees like flowering cherry, horse chestnut and hawthorn, lining roadsides. At this time of year, avenues of beech and sycamore are a fresh green, so different from their autumnal hues. For a brilliant shrub avenue in autumn, the Enkianthus Walk at Crathes Castle is superb. Winter is a good time to photograph the knobbly tops of pollarded planes and limes, often found in urban streets. The bizarre ancient limes that line a path near the Privy Garden at Hampton Court, also look especially good in winter.

The Pagoda Vista at the Royal Botanic Gardens, Kew, extending over 700 metres from the edge of the Rose Garden to the Pagoda is lined with an avenue of over 40 different kinds of trees planted in opposite pairs, thus providing varied interest for the photographer. Some asymmetrical avenues occur because of soil changes, gale damage or attack by honey fungus but gaps can be disguised with careful camera positioning.

There is no single ideal lens for photographing avenues, which are so variable in their width, height and length. For a wide, sweeping avenue, I might select a standard lens, but if the avenue opens onto a narrow road facing a wall, where it is impossible to move backwards, I may have to use a wide angle lens so as to include the full height of the trees. A long lens can be used to deliberately flatten the perspective of an avenue – particularly of Lombardy poplars – so the columnar trees appear to be growing much more closely together than in reality.

Woodland gardens

Working in woodland gardens presents the same problems for photography as are found in natural woodlands and forests; namely poor light or, when the sun is shining, dappled lighting with shafts of bright sunlight piercing the shadows. This extreme contrast makes it impossible to expose colour film correctly for both sun and shadow. I therefore prefer to work in woodlands on a day when there is light cloud cover so that the natural light is soft and indirect and preferably when there is no wind. Because I use slow speed films (25 and 64 ASA) to ensure the colours of the slides are well-saturated, when taking general views in dark wooded areas I am forced to use long exposures (¼, ½ or even 1 second). With the camera on a tripod, I can use the lens stopped down to a small aperture, such as f11 or f16, so as to increase the depth of field.

A tripod is also worth using for taking carpets of spring flowers in their woodland setting. By using a wide angle lens and a low camera angle in a flat woodland site, the foreground can be filled with snowdrops, bluebells, trilliums or cyclamens with the trees visible behind. But the most photogenic of all woodland plants must be azaleas and rhododendrons and where they have been planted on a vast scale as at Exbury and in the valley woodland garden at Leonardslee the effect is quite breathtaking. Yellow, orange and red flowers stand out from the more sombre trees in any weather, but when illuminated by sunlight, their beauty is intensified. A similar effect can be seen in autumn at Westonbirt Arboretum where acer glades have been planted beneath trees. If trees are included in a photograph, they provide stature and a pleasantly harmonious backcloth for the richly coloured flowers or leaves.

Other pictures worth taking in woodland gardens include autumnal fungi, fallen leaves (page 96) and mossy carpets. Moss is commonly used as ground cover in Japanese gardens, and the most famous of all is the landscaped moss garden of Koke-dera (Moss Temple) in Kyoto where over 50 kinds of mosses grow beneath the trees. Mosses like shade and moisture, and if they are deprived of water they will turn an unattractive brown reverting back to green again when rain falls. Attractive moss carpets flourish beneath beech trees in the Savill Gardens where nothing else will grow. The greens are enriched after rain and when the leaves fall in autumn, they add new colour and texture to the woodland floor.

Try looking skywards to see if there is a picture worth taking through the overhead woodland canopy. Comparative pictures can be taken illustrating the amount of sky visible through the canopy of a deciduous woodland in summer and in winter, providing the identical camera angle is used. The position of the tripod legs should be marked, the focal length of the lens noted and as a final check reference should be made to the original picture before the shutter is released.

Close-up photographs in woodlands can often be improved by using a reflector or a flash to help fill-in shadows (page 27). It is surprising how much difference a gold reflector makes to a cluster of flowers, fruit or leaves – even on an overcast day.

Autumnal colours

After summer, when the days begin to shorten, garden landscapes change; at first, almost imperceptibly and then suddenly we are aware that deciduous trees and shrubs have turned from sombre greens to colours ranging from brilliant yellow (sycamore, *Ginkgo*, field maple and poplars)

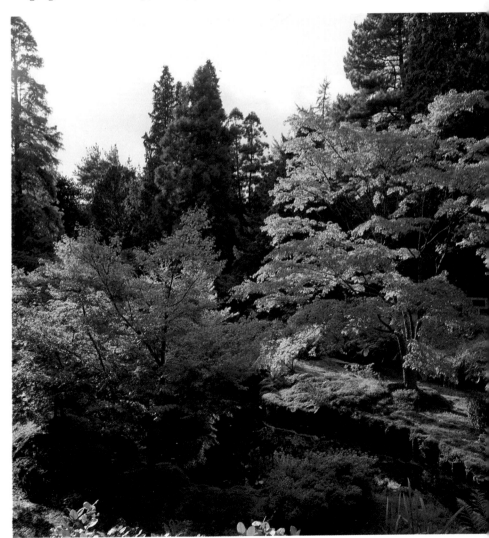

When the maples in the Japanese Garden at Tatton Park in Cheshire turn colour in autumn, they stand out against the evergreen conifers. A wide angle lens was needed so as to include both of the coloured maples in the frame.

through gold (larch) to orange (*Nyssa sylvatica*) and red (guelder rose, deciduous azaleas, *Cornus florida, Liquidamber, Fothergilla major* and some north American oaks).

The colour will depend not only on the actual species, but also on the moisture content of the soil and the air temperature, so that the intensities of the colours vary from one year to the next. The best autumnal tints develop (page 33) when sunny days alternate with cold nights. An extended dry summer such as occurred in Britain in 1983, results in the leaves on many shrubs and trees shrivelling and falling before they change to their autumn colours.

The approach to photographing single trees, or groups in a woodland during autumn, will be much the same as described at the beginning of the chapter, except that at this time of year the emphasis will be on colour instead of shape and form. A dramatic effect can occur when sun spotlights a single maple surrounded by evergreen trees, or when a yellow silver birch or tulip tree is seen against a dark stormy sky. You may like to try recording the moment when a sudden gust of wind triggers an obvious leaf fall. As when photographing moving water (page 93), a fast shutter speed will freeze the leaves in mid-air, whereas a slow shutter speed will blur the leaves thereby giving an impression of movement.

A cluster of leaves at the end of a branch can be isolated against the sky by using a long focus lens. The vibrant hues of autumnal leaves are magically enriched when lit from behind so they appear to glow against a blue or dark stormy sky. However, metering the light for this kind of picture can be tricky without a **spotmeter** directed precisely onto a leaf. One solution is to pull more leaves down so that they temporarily fill the frame. You can then meter the light passing through the leaves without the light from the sky boosting the reading and thereby giving an under-exposed picture. The contrast between the leaves and the sky can be further increased by using a polarising filter.

More photographs are taken of red acers in autumn than probably of any other tree, and during the last two weeks in October it is virtually impossible to photograph in the acer glade at Westonbirt Arboretum without people appearing in the field of view. But the more subtle autumn tints – the pinky-brown turning to foxy-red of swamp cypress, the clear buttercup of field maple, the warmer gold of larch needles – are equally well-worth photographing. The foliage of many species roses also contributes a wealthy bonus in autumn with the gold of rugosas, the bronze tints of Scots briars and the rich red of *Rosa nitida* and *R. virginiana.*

Architectural trees

The forms of some trees are so distinct that they are often planted as architectural trees. Columnar and cone-shaped conifers such as Irish yew, Leyland cypress and Western red cedar are popular, as are the slender Lombardy poplar, the palm-like cordyline and fastigiate forms of oak and beech. More irregular trees can also be made into striking features by repeated clipping into artificial shapes which may be simple geometric forms or animal interpretations. This art, known as topiary, was popular in Roman gardens, and may well have been introduced to Britain by the Romans. The most widely used topiary tree in Britain is yew, popular for its ability to survive severe cutting back, but holly and box are also used.

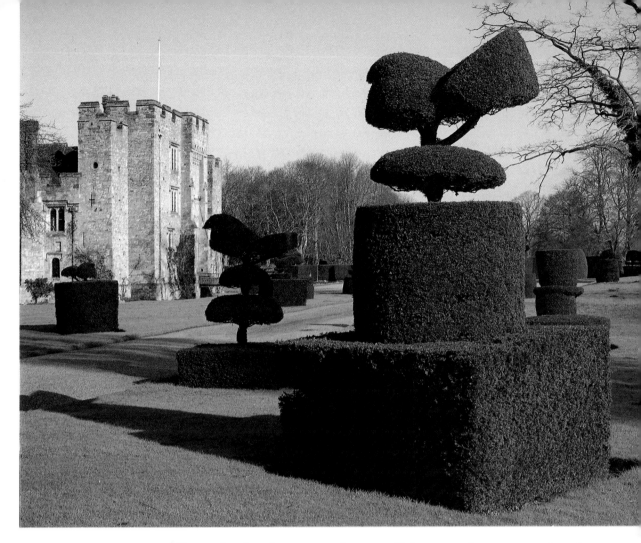

The crisp shapes of recently–clipped topiary figures at Hever Castle were photographed in February. The low-angled sun casts long shadows across the drive leading up to the castle.

The scale of topiary ranges from small figures such as a peacock or fox surmounting a hedge, to an array of trees in a topiary garden such as at Levens Hall where some date back to 1692. Green and golden yews, as well as box, have been clipped into assorted shapes at Levens Hall. The scope of a topiary tree can be seen by comparing the intricate chessboard figures at Hever Castle with the towering shapes at Packwood House. One way of conveying the size of the huge Packwood yews – some of which reach over 6 metres in height – is to include a person in the picture for scale.

Smaller topiary gardens can be photographed as a whole, but large ones must be taken portion by portion. There is no difference in the technique between the photography of natural and of man-made evergreen shapes; both are solid forms which do not allow light to pass through them, so that if they are backlit they will appear as solid areas of black, rim-lit by the sun. Where different coloured yew trees have been used, it is easier to separate one shape from the next. On a dull day, dark green conifers can look very sombre, unless they are etched with hoar frost, whereas on a brighter day, a photograph of conifers can be enhanced by waiting until the sun lights up some of the green facets.

Like all topiary forms, an evergreen hedge maze can be photographed during any month, but without an adjacent high viewpoint looking down onto it, the layout of a maze cannot be discerned. Additional interest and

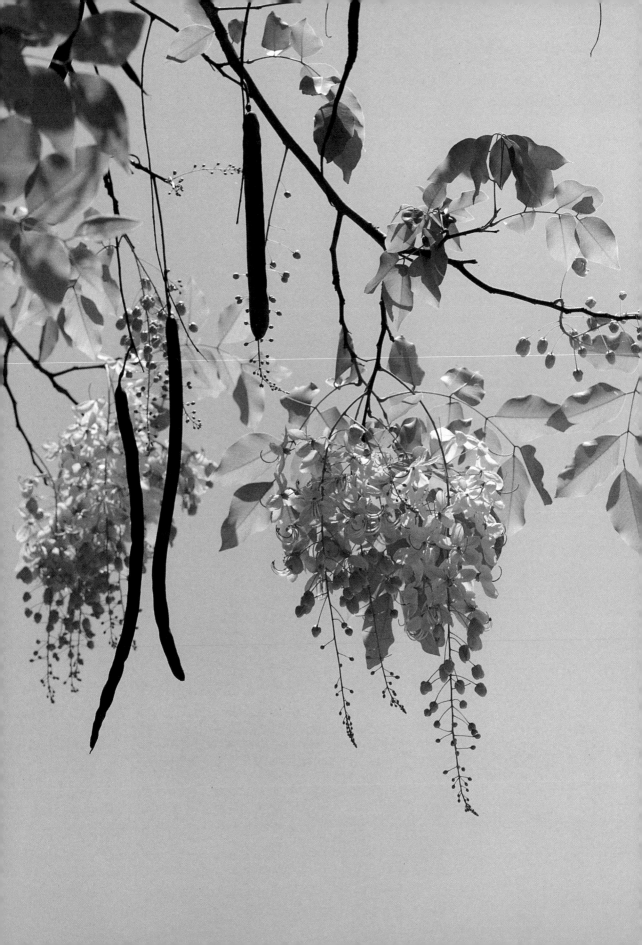

Indian laburnum or purging cassia *Cassia fistula* flowers and pods were photographed in Sri Lanka against the sky using a long focus lens.

height is given to the centre of the yew maze planted at Somerleyton Hall in 1846, by an attractive pagoda rising well above the hedge tops.

Bonsai 'trees' are also architectural garden features, albeit on a miniature scale. Grown in shallow containers these unnatural – but often highly artistic tree forms – can be positioned precisely where you want them for photography.

Flowers and fruits

Flower viewing – notably of groves of flowering cherry and plum trees – is a national pastime in Japan and now also popular with tourists. Ornamental shrubs and trees which are grown for the beauty and colour of their flowers and fruits offer wonderful potential for some unusual colourful close-ups. Throughout the year, there is a succession of shrubs in flower. In January, the delicate witch hazel *Hamamelis* flowers on bare twigs, followed by *Daphne mezereum*, *Mahonia*, *Camellia*, *Forsythia*, azaleas and rhododendrons, *Laburnum*, brooms, *Magnolia*, *Ceanothus*, roses, fuchsias, *Clerodendrum*, heaths, *Viburnum* and the winter jasmine *Jasminum nudiflorum*. More than once I have photographed witch hazel flowers after a snowfall, which makes a striking contrast to the more conventional sunlit summer garden scenes.

The fleshy red arils of a yew tree *Taxus baccata* were taken in a Surrey garden in mid-winter, using a gold reflector to bounce back some natural light onto the fruit.

All the techniques for taking close-ups described in chapter 4 are relevant here, although special mention should be made of tree flowers which are not always so accessible. Large or showy flowers like those of magnolias, cherries, eucalyptus, rhododendrons and proteas, which are insect pollinated, contrast well against foliage or sky and can be taken from ground level by using a long focus lens. In particular, white and pink magnolia flowers look most dramatic when photographed against a blue sky. It is the inconspicuous wind-pollinated flowers however which present a greater challenge, such as birch, alder, hazel, walnut and oak catkins often similar in colour to the unfurling leaves. Wherever possible, I try to photograph them against a simple out-of-focus background or to light them from behind. If the catkins are blowing in the wind, you will have to use either a fast shutter speed or flash to arrest their movement. A sudden tap on a branch may be enough to show a catkin dispersing its pollen. An exquisite tree flower, rarely appreciated because it is so small, is the larch 'rose' which opens just before the new green needles appear.

Fruits and cones can be photographed in a similar way to the flowers of trees and shrubs, often by using a long focus lens. When the first frosts arrive, go out early in search of magical close-ups of berries and fruits etched with hoar frost. If you are too late to take fruit on a tree, look down at the ground, where there may be a picture worth taking. I always think

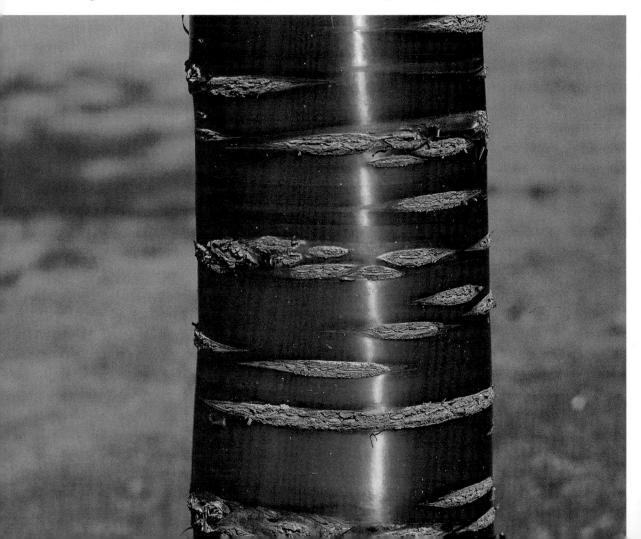

This fine *Prunus serrula* trunk can be seen in the Univesity of Liverpool Gardens at Ness in Cheshire. The direct frontal lighting from the sun created the vertical highlighted strip which emphasises the shiny surface.

that horse chestnut fruits are more interesting when the husks split open on impact with the ground to reveal the familiar conkers, than when growing intact on a tree.

Bark

Many trees are grown specifically for their attractive bark, notably the snake bark maples, several birches and cherries. Among shrubs, several willows and shrubby dogwoods provide a welcome splash of winter colour to a border. The variable colour and texture of bark offers limitless scope for intriguing close-ups. Bark, which is the outer protective layer of woody plants, is constantly being added to by the living tree. Fissures appear in thick bark such as cork oak and pines as the trees increase in girth, whereas the thin bark of birch and eucalyptus constantly peels away. The London plane, paperback maple and eucalyptus all have especially photogenic bark patterns which reveal contrasting colour patches where the old bark is sloughed off the tree.

Winter is an excellent season for taking bark pictures. Firstly, it is a time of year when you are not going to be tempted to take more colourful garden subjects; secondly, leafless deciduous trees allow more direct light to reach the trunks and, thirdly, bark on a mature tree can be photographed even when the wind is blowing.

The irregularities of rough, highly textured bark such as that of Douglas fir and redwoods, show up best when they are lit from the side so the raised portions are accentuated by the shadows they cast. Smooth-barked trees can be taken on a dull day; indeed this may be preferable for taking highly polished cherry barks which on a sunny day may show a distracting highlight down their length. On the other hand, such a highlight immediately conveys the true glossy nature of the surface. Some barks colour-up quite dramatically when wet, so that during a dry spell it is worth watering bark to see if the colours are enlivened. We have a large strawberry tree, *Arbutus unedo* in our garden, and the lower trunk turns a rich chestnut colour after rain.

When photographing a large tree, there will be no need to consider the background, if the bark fills the entire frame. However, when photographing slender-stemmed shrubs such as the Japanese wineberry *Rubus phoenicolasius* (red stems) and the related ghost bramble *R. cockburnianus* with white stems, or the shrubby dogwoods, there will inevitably be gaps between the stems, so it is then important to appraise the background.

All solid stems should be lit by front, side or diffuse lighting, otherwise they will appear as silhouettes; however the young stems of *Rosa omeiensis pteracantha* bear huge translucent red thorns which look very striking when they are back-lit.

The topics covered in this chapter, together with the chapters covering foliage, and flowers and fruit, prove that the photography of trees and shrubs is much wider reaching than simple portraits. These woody plants are particularly valuable because unlike annuals, biennials and perennials, their lifespan is not nearly so ephemeral and a single specimen can be enjoyed and photographed very often throughout a lifetime. Seeing today the huge clipped yews overhanging the upper terrace at Powis Castle, it is hard to imagine them as the tiny pyramids depicted in a drawing of 1740.

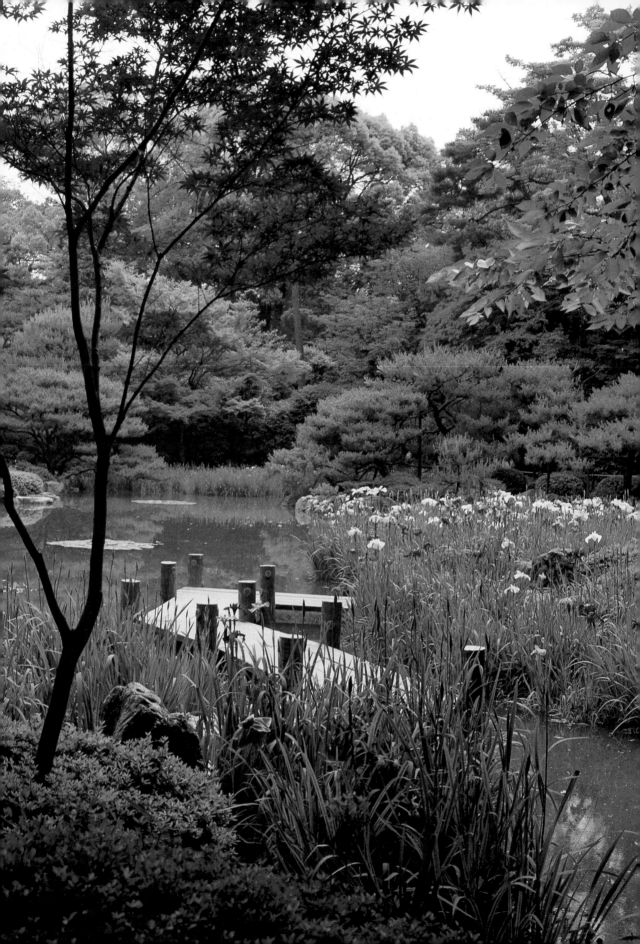

6 Walkways and Walls

Anyone who enjoys plants would probably regard taking photographs of walkways and walls to be rather a fruitless occupation. Surely one path or wall is very much like another? Consider for a moment the basic building blocks of a garden wall; gone are the days when gardeners could afford to build extensive brick boundaries. We now see them constructed from a great variety of both natural and man-made materials, ranging from stone, solid concrete or open scree blocks, to wooden fences, bamboo canes, reed or plastic panelling, wrought iron and living hedges. All these ensure variation in colour and texture, the shape and size of each wall being selected to suit a particular garden. Therefore both the wall and the plants associated with it contribute to the infinite range of subjects available for this aspect of garden photography.

Walkways, too, are much more variable, no longer being made simply from brick, gravel or crazed paving. Today, concrete is a cheap, but very boring substitute. More imaginatively, paths are created from wooden railway sleepers, cross sections of tree trunks, or simply by mowing a grassy strip through unchecked swards on either side. More extensive areas such as courtyards and patios may be constructed from cobbles or tiles, or from a combination of two or more contrasting, but complementary materials.

Adjacent to a house, especially within confined town gardens, walkways and walls invariably merge, making it virtually impossible to isolate one from the other, but I have separated them here, because each presents different problems for the photographer.

Working with walls

The vertical structure of walls makes them easier to photograph than horizontal walkways which recede from the camera. Every garden which is adjacent to a house has a wall – even if it is only the side of the house itself. In a confined space, the garden area can be extended from the ground up vertical walls, which serve not only to define boundaries but also function as wind-breaks.

Free-standing walls, plain or adorned with plants, may themselves be garden features. This is well-exemplified in the grounds of St. Catherine's College, Oxford, where they form an integral part of the campus. When the sun shines, white or grey courtyard walls form a backcloth for dark shadows of foreground trees, plants or architectural features.

Although gardeners will naturally take wall aspect into consideration when positioning their sun- or shade-loving plants, the photographer should also bear in mind the latitude of the garden location. If you have planned a day with your camera in a large garden with many aspects, it

Although forming only a small part of the picture, the pale tone of a wooden bridge stands out against the darker water and vegetation in the West Garden of the Heian Shrine in Kyoto, Japan.

would be wise to do an initial reconnaissance noting the direction the walls face and the time of day they will be lit by the sun. Alternatively, if you are able to obtain in advance a list of plants with their wall aspect, you can plan the timing of your visit. This is possible with the National Trust property of Polesden Lacey, where the Garden Guide conveniently lists this relevant information.

If you want direct sunlight on a wall in the northern hemisphere, a south-facing wall will be lit for most of the day. An east wall will be lit by an early morning sun, a west wall by the last rays of the sun and a north wall will have no direct sun in winter. In the southern hemisphere, the situation is reversed with a north-facing wall receiving most light.

Sequential photographs of walls and the shadows cast by them taken at timed intervals throughout the day provide a permanent record of sun and shadow patterns in a garden. These can be referred to at a later date as an *aide memoire* for determining the planting of sun- and shade-loving plants.

Most often the wall faces are straight, one notable exception being the serpentine 'crinkle-crankle' walls which feature in several gardens in East Anglia, notably at Melford Hall in Suffolk. Wall plants help to break up stark vertical lines by adding their own upthrusts or cascades of colour – depending on whether the plants grow up from the ground or hang down from the wall.

Sooner or later when photographing any vertical structures, you will notice how parallel lines appear to converge with one another when you tilt the camera skywards. This perspective distortion is most apparent when using a wide angle lens to photograph a building or straight-boled conifers growing in plantations. On many SLR cameras, the **focusing screen** is interchangeable and one with a grid pattern is invaluable for precise viewing of converging verticals. These can be corrected by standing further back from the subject, and eliminated altogether by finding a higher viewpoint so that the camera no longer needs to be tilted. This is where I find the platform on my car roof invaluable for photographing creepers on walls, houses or garages beside the road. There is a special kind of wide angle lens known as a **perspective correcting (PC) lens** – which corrects the distortion seen from ground level by moving the lens axis a few millimetres up or down.

Windows in walls provide scope for framing views of other parts of the garden (page 123) or of the surrounding countryside. A simple moongate is a popular feature in Far Eastern gardens for encircling a garden vista. This concept can also be used in gardens where neat windows are maintained in pleached hedges, as at Horsted Place.

Walls of houses are never uniform; their lines are interrupted by windows and doors. Nothing detracts from a simple wall picture more than part of a door or a portion of a window – especially if it is painted with a strong colour which automatically leads your eye away from the wall and the plants. This problem does not arise where a white door merges in with a white-washed cottage, although then the white background reflects so much direct sunlight it becomes impossibile for colour film to cope with the range in exposure from the white wall and, say, red roses; the only solution is to wait for an overcast day when the tonal extremes are much reduced.

Hidcote Manor garden is in fact a series of small gardens each contained

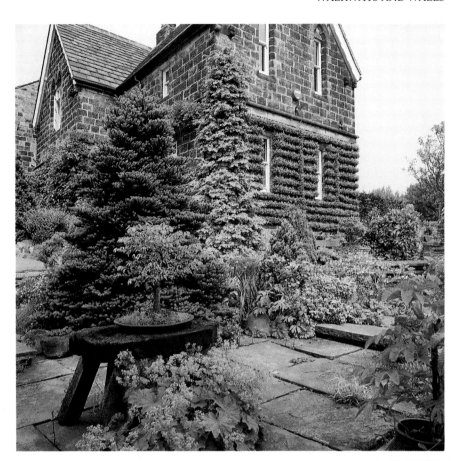

An array of textures adds interest to the pavement garden at York Gate in Yorkshire. Neatly clipped climbers on the wall of the house complete the picture, which is marred only by the brightly coloured burglar alarm!

within their own living wall, for hedges reign supreme here. Originally planted as wind-breaks, the colour and texture of each hedge, whether it be yew, box, holly, beech or hornbeam, has been carefully selected as being the most appropriate for each garden and plays a predominant part in it. In this situation walls aid the photographer by sheltering plants within their boundaries.

Recently built walls quickly become clothed with plants – especially if crevices are left in drystone walls or holes left in the mortar – but old walls appeal much more to me. Decades of weathering create attractive colour gradations making a far more attractive background than pristine bricks. The formal garden at Edzell Castle surrounded by ancient freestone walls with recesses arranged in a chequer-board pattern, filled with boxes of flowering plants, must be one of the most striking of walled gardens.

Sandstone and limestone weather more rapidly than hard granite or flint, and so seeds or spores become lodged in cracks and crevices allowing plants to gain a foothold on these soft-stoned walls. Attractive wild plants, such as rosebay willow herb, may appear quite spontaneously on a garden wall. This is no great surprise, since each seed bears a tiny parachute which buoys it up in the slightest breeze. Yellow corydalis and wallflowers often grow on garden walls, yet their seeds are far too heavy to be wind-borne and they are not attractive to birds. It is a much smaller six-legged animal – the ant – which is responsible for their dispersal upwards as it scurries across the wall.

For many years I have studied and photographed plants which naturally invade walls, noting with considerable interest the random mosaics created by mosses and lichens. The best examples of these can be seen on old walls, not only in gardens, but also in churchyards and along field boundaries in areas free from atmospheric pollution. The colours of both mosses and lichens are enriched by rain, and because they grow flush with the wall, they do not blow around in the wind – two factors which make them ideal winter wall subjects for the camera.

Recording the succession of plants which naturally invade a wall can be an interesting continuing photographic project. Damp, shady walls will support quite different plant associations from dry walls in open situations. The latter will be much easier to photograph using available light, while shady walls, with lush green ferns and mosses look unnatural if they are lit solely by direct flash because the picture will erroneously infer that the site is sunlit.

When I walk into an unknown garden for the first time, walls may attract my attention in one of two ways. Firstly, a climber with striking foliage, flowers or fruits will catch my eye more easily than the wall itself; but if the

Taken in autumn, a mosaic of ivy and Virginia creeper completely covers a wall. By using a long focus lens, the insect visitors, attracted to the ivy flowers, can be seen.

Artemisia 'Powis Castle' perfectly complements the sandstone wall on the upper terrace of Powis Castle in Wales. Since the colour and design of the wall itself are so attractive, the picture has been composed so that the wall is the dominant feature.

colour of the bricks or stones has been enhanced by a recent rainfall, then this can entice me to take a closer look at the wall. I then have to decide whether to fill most of the frame with the wall itself, with maybe only a hint of a tendril or a leaf, or to concentrate on the plants with no trace of the wall. As can be seen by the pair of pictures on this spread, both approaches can make a striking picture; the emphasis can be decided simply by the framing.

When including part of the wall with a detail of a climber, it is important to note whether the colour of the bricks or stone complement the leaves or flowers. Virginia creepers may blend harmoniously with any coloured wall for most of the growing season, but once the leaves turn to a brilliant red, they are only worth photographing against grey or beige stone walls. Red brick and red Virginia creeper leaves are simply not compatible. Yellow-leaved or variegated climbers, on the other hand, like the ivies *Hedera helix* 'Buttercup' and *Hedera colchica* 'Paddy's Pride', flowering *Ipomoea* or clematis look equally good against red brick or grey stone. Gertrude Jekyll appreciated the worth of yew as an effective background for almost any colour as she wrote in her book *Gardens for small country houses*, '. . . it comes first among growing things as a means of expression in that domain of design that lies between architecture and gardening.' Pale statues can also be well displayed in niches of dark green topiary walls.

Close-ups of flowers or fruits on walls behind wide herbaceous borders or backing an expanse of water cannot be taken with a standard lens, but they can be taken in a similar way to small unapproachable birds – namely with a long-focus lens which enlarges the size of the subject and eliminates much of the unwanted surroundings.

Do make sure when taking any close-ups of flowers, fruits or foliage on walls to look critically at unnatural plant supports. A vigorous self-supporting climber such as Virginia creeper presents no problems, since it will completely carpet the wall and provide a uniform frame-filling pattern of vibrant autumn colour. But the exquisite shape of a passion flower or the colour of a clematis bloom can so easily be marred by an unsightly rusty nail, a coloured plastic tie, criss-crossing wires or even a plant label! Another eyesore frequently seen in close-up pictures of climbing roses is an obvious flaw in foliage, caused by black spot or insect damage, spoiling the appearance of a perfect bloom on a wall. In your own garden you can decide whether or not to remove such eye-sores, but elsewhere the only solution may be to select another flower or fruit.

Paths in perspective

A walkway is nearly always functional, but with careful thought it can be sited so that it also serves to invite the eye onwards to explore the garden still further. When photographing paths end-on from ground level, it is difficult to get the whole path sharply in focus unless the lens is stopped down to a small aperture. A path with parallel edges will appear much wider nearest to the camera. This exaggerated perspective is increased still further with a wide angle lens, and is a technique which can be used for dramatic emphasis.

The way to overcome unwanted distorted perspective is to look for a higher viewpoint, such as a flat-topped roof or the first floor of a house. This viewpoint – often sketched in gardening books – also helps towards a better appreciation of the layout and inter-relationships of the garden.

It is much more restful to the eye however, if the path moves across the picture at an angle or if it snakes away into the background. In the same way that the curved edges of a border or of a meandering stream lead the eye onwards, so a curved path provides soft, flowing lines in contrast to the harsh, regimented lines of paths laid out in a formal garden. In the latter case, symmetry of walkways must be upheld in a photograph, otherwise the basic concept of the garden design will be destroyed.

If the detail of a path is to be the main subject, a head-on view can be quite effective. Such an approach cannot provide a restful composition however, and a useful exercise for putting paths in perspective is to hold a camera up to your eye as you walk round the garden. Only then will you be able to appreciate how the position of the path and its size in the viewfinder changes in relation to other features. By changing the viewpoint, the impact of dominant lines may become reduced.

Possible ways in which a path can be positioned in a photograph are sketched on this page. By comparing these sketches with the suggested approaches for photographing beds and borders on page 77, you will see that while paths have become the main feature, they do not always completely dominate the composition.

The line of a path can be reinforced by an adjacent lawn hugging it.

Photographing paths

A Exaggerated perspective
B Curve softens picture
C Path encircling pool
D Winding path
E Portion of curved path
F Path joins paving

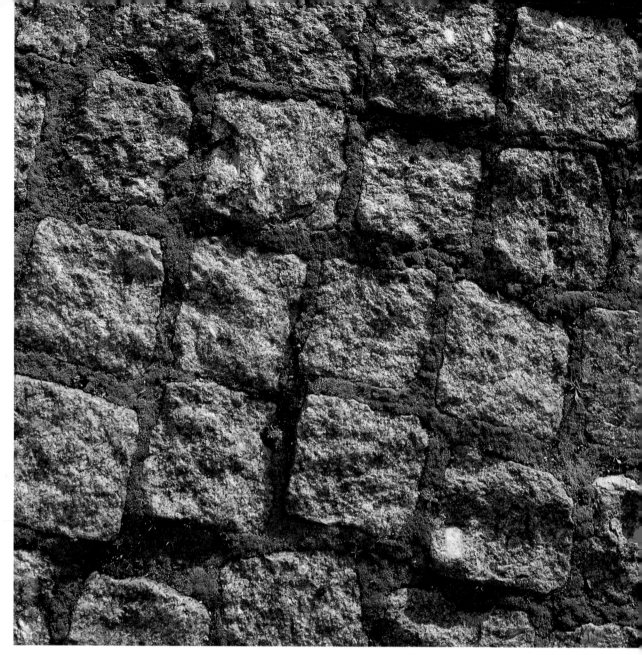

Mosses outlining square-cut stones in the Queen's Garden at the Royal Botanic Gardens, Kew were taken in mid-winter when the mosses were in good condition. Grazed lighting reveals the uneven surface of the path.

Conversely, the firm edges of a path become softened by plants growing over them, or in the case of gravel paths, by plants growing up through them. Unless I feel a path helps to invite the eye towards the rest of the garden, or has such strong colour or design which should dominate the picture, I prefer either to include only a small portion or to stand to one side, so that foreground plants partially mask it. Fallen rose petals or autumnal leaves will help to break up and soften a uniform path.

Textured walkways always add interest to a garden and if well-lit, make a photograph more interesting. Japanese garden designers delight in using contrasting textures; cobbles, moss and sand often being used beside one another to carpet the ground in both free-flowering and symmetrical designs. When visiting the Andromeda Gardens in Barbados, I noted with interest impressions of tropical leaves with pronounced veins in concrete stepping stones. At Cranborne Manor large stones set into cobbles, create

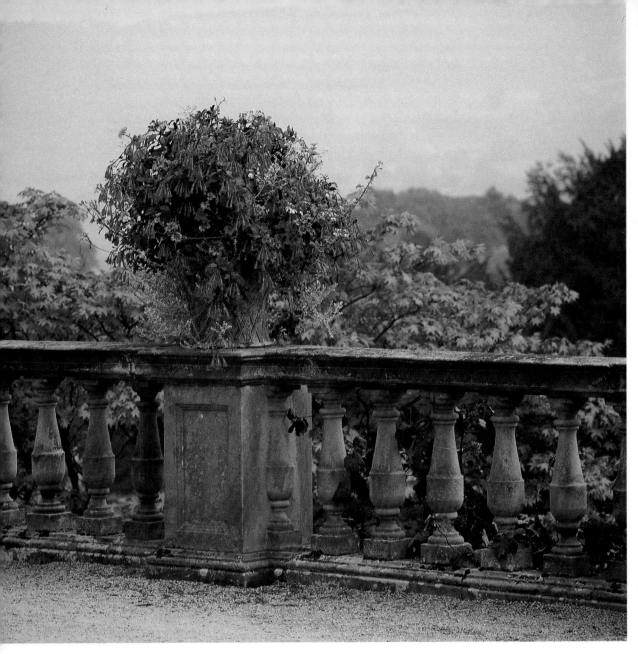

an impression of stepping stones in a stream. Herringbone brickwork, often used for paths in formal gardens, adds both texture and colour; the warm terracotta tones provide an ideal complement for both white cascading flowers or green fringing foliage. Texture of another kind can be seen at Denmans where a dry gravel 'stream' planted with a host of foliage plants snakes across a meadow. As the plants have grown, so the area of visible gravel has been much reduced, but the effect is none the less very striking.

The decorated surface of paths and patios can be emphasised by moving in closer to record detail. Where plants have been encouraged to invade terrace flagstones they can develop into a rich mosaic of interwoven colours as on the Geoffrey Jellicoe terrace in Pusey House garden. Even green mossy growths – deliberately encouraged by scattering spores, or accidentally spread by wind and wildlife – complement cobble-stone, red

Basket-like pots provide a colourful focal point to the balustrade on the main terrace at Powis Castle. The fallen flowers of *Fuchsia* 'Gartenmeister Bonstedt' were deliberately left on the ground to repeat the colour.

brick and paved paths.

Walkways may be inanimate, but they can none the less lend a variety of moods to photographs taken in different weather and lighting conditions. This can be appreciated by watching how the 'atmosphere' changes in your own garden. Come rain or shine, the uneven texture of a path laid with cobbles is highlighted when back-lit by a low angled sun and wet flagstones positively glisten after rain (or wetting with a hose) when viewed against the light. Extensive paved areas, unadorned with plants, can be rather monotonous in a picture unless they are enlivened on a sunny day by interesting shadows cast from architectural plants, the crown of a tree or even an overhead pergola.

Steps and stairways

The most interesting steps for photography are those which have been constructed as an integral part of the garden design, instead of being a solely functional link from one level to another. Changes in level lead the eye on down the garden, while an artificial bank with steps or a water garden with a series of cascades, adds height and impact to a completely flat garden.

Time and time again, the skilful combination of more formal solid architecture with the art of sympathetic planting can be seen in the gardens jointly created by Lutyens (1869–1944) and Jekyll. Lutyens often used wide curving steps with short risers to descend from one terrace to another, as can be seen at Hestercombe and at Great Dixter.

Whatever their design, steps always create three-dimensional interest, especially on a sunny day when sunlit treads alternate with shadowed risers. In addition to the shadow patterns cast by steps in sunlight, the materials used for their construction can make a worthwhile picture even on a dull day. In Hatfield House garden a flight of cobbled steps are edged in stone risers, while Lutyens used bricks or tiles for the risers, and stone for the treads of many of his steps. Interest and colour are added to more informal steps by planting low growing plants at the base of the risers or larger clumps of flowering plants and ferns along the sides. The invasive Mexican wall daisy *Erigeron mucronatus* grows out from cracks in the steps in our garden, enlivening the brickwork as well as helping the eye to focus on changes in levels.

The three main terraces beneath the historical Welsh castle of Powis have been built on such a steep slope that the steps inevitably have high risers, which are not so attractive to photograph as a flight of gently rising steps extending from a terrace. However, the magnificent stone balustrades, which are such a feature of the Powis terraces, can be photographed from the steps or from one terrace looking down to another. The balustrade on the main terrace decorated with attractive basket-like pots overflowing with fuchsias provides elevated colour set against the distant Welsh hills.

As well as the architectural nature of these garden features, they can also provide clues as to which animals visit gardens. On my own garden paths and steps I have found a thrush's anvil littered with broken snail shells, remains of hazel nuts left by squirrels, and small mammal tracks criss-crossing snow in winter. When you next walk down a path, pause to look at what is probably the most under-rated part of a garden; you may discover unexpected potential for a different picture.

7 Beds and Borders

In the height of summer, beds and borders which look so attractive and potentially photogenic, all too often make disappointing pictures. Many a time, I have visited the Royal Horticultural Society's garden at Wisley and seen people exclaim over the long herbaceous borders, pause and take a horizontal picture from the front looking straight across to the back. All this can show is a portion of a border; it cannot convey the wealth of plants along its length. A slight rotation of the body, a turn of the camera through 90° is all that is required to take the border at an angle, so that foreground interest is combined with an impression of the whole border stretching towards the top of the picture (see diagram A on page 77).

The plants which are grown in mixed borders range from hardy annuals, biennials, bulbs, tender bedding plants, to roses and shrubs; but it is the perennials which form the basis of the herbaceous border.

Herbaceous borders

The true herbaceous border, planted solely with hardy herbaceous perennials, originated in England, and it is still very much a feature of traditional English gardens. Each winter, the plants are pruned to ground level ready for next year's growth. Within a few short months, bare ground with maybe a few leafy rosettes is transformed into a galaxy of shapes and colours, fading all too soon. The quality of a photograph of a herbaceous border depends to a very great extent on the way in which the border was originally planted and subsequently tended.

Although herbaceous borders can still be found in a number of English gardens, many of the huge ones have disappeared simply because their upkeep is too labour intensive. Ness Gardens once had a series of seven borders. Four of these were planted so that each one flowered during a different summer month starting with May and ending with August; the other three comprised separate aster, delphinium, and dahlia borders. In 1958, the area was redesigned to make one main herbaceous border, thereby reducing the working area by one fifth. A private garden in Surrey featured in Peter Coats's book *Great Gardens of Britain* in 1967, is described as having 'perhaps the best herbaceous borders in England'; but in 1983, all trace of these borders had gone and the beds had been grassed over.

Borders are traditionally long and straight, making their photography more difficult than curved beds harmoniously flowing through a picture. Double borders can be viewed end-on with the central path of lawn narrowing into the distance (diagram B). This approach works best when the path is not too wide and the borders slope upwards away from the camera. Alternatively, if a high viewpoint can be found, the picture can be composed so that the line of the borders extends the whole length of the

The full extent of the twin herbaceous borders at Bramdean House in Hampshire can be appreciated from this elevated viewpoint looking down from the house. A soft evening light enhances the multitude of colours by casting an even light across the whole scene.

picture, as can be seen on page 74. The magnificent 320-metre-long double herbaceous borders at Newby Hall in Yorkshire need to be photographed end-on to include the unique backdrop of the River Ure. Other possible viewpoints for photographing borders are sketched on the following page. In each, the area of lawn or path is subordinate to the border – contrary to the approach adopted when photographing paths (see page 70).

Even though many borders are now designed to give colour over several months, there is a very limited time when a herbaceous border is at its peak with impeccable individual blooms, overall colour harmony and ideal lighting. Within minutes, a freak summer hailstorm or a gale can ruin the perfect scene, which never completely recovers. This means that you may have to wait another year for the optimum harmony of the blooms and the lighting for capturing the shades of summer on film.

The herbaceous border which I find best for photography is the one which is set off against a tall dark evergreen yew hedge. This gives a perfect backcloth for flowers of any colour, and in certain lights, it provides a stark unlit black background in complete contrast to spotlit flowers. Double herbaceous borders are easier to photograph if they have a path separating them from the background hedge or wall, because it is then possible to walk behind one border and gain a view of them both. By standing on a step ladder, I can often include a small portion of the nearest

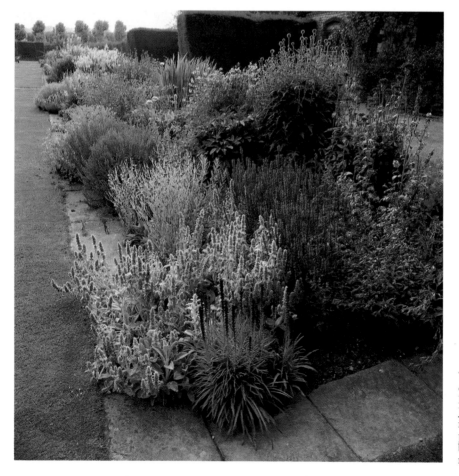

Taken from ground level, a corner of one of the long herbaceous borders at Jenkyn Place in Hampshire illustrates how judiciously placed plant supports can be completely concealed in mid-summer.

Taking beds and borders

A Slanting border view
B Double borders end-on
C Double borders angled
D Island bed
E Pattern of beds
F Flowing curving edges

border in the foreground, a central path or lawn running across the frame at an angle, whilst still concentrating attention on the opposite border (diagram C).

When I consider a herbaceous border for the first time, I look for the way in which the taller plants are supported. If I spot bright green plastic-coated wire hoops, oversized stakes or conspicuous labels, I will by-pass the border for another part of the garden – reflecting that the gardener is obviously no photographer! Weathered wooden supports blend in better than new bamboo canes; but best of all are the more subtle, hidden ones. What a joy it was for me to photograph the splendid herbaceous borders at Jenkyn Place where the plants were ingeniously supported by short pea sticks so carefully positioned to be out-of-sight.

Mixed borders

In many gardens, herbaceous borders have been replaced by mixed ones and careful choice of early and late flowering shrubs and of plants with foliage changing colour in autumn or winter, greatly extends the photographic value of the border. Conifers provide excellent backing, shrubs add solid form and permanent ground cover sets off the plants above it. The long border at Great Dixter is a mix of annuals, perennials, shrubs and even small trees, while at Hidcote the long borders in the Kitchen Garden have been planted with old French roses, lupins, lilacs, peonies, sweet peas, Japanese anemones, spring flowering bulbs, pinks and penstemons against a background of upright Irish yews. Hidcote is also noted for its red borders where plants are grouped according to their colour (see the chapter on Colour Appreciation).

Delightful double borders of mixed early spring plants can be seen at Cranborne Manor where flowers and fruit intermingle so that spring flowers bloom at the same time as a backcloth of apple blossom.

The aim when photographing any border should be to make sure that the individual flowers are large enough to be identifiable, yet also to ensure that the angle of view is wide enough to do justice to the overall design and colour schemes. This means that any imperfections will also be visible in the photograph, so check to see if there are any conspicuous mildewy leaves or dead heads.

Border portraits

Blooms at the front of a border can be taken with a standard lens and either a close-up lens or extension tubes attached to a standard lens (page 45), although sometimes a bit of extra work is needed before a flower portrait can be taken. I always carry a metre-long piece of black tape with a safety pin and a coil of green plastic-coated garden wire in my camera rucksack. The tape is used to tie back (out of view of the camera) unwanted stems of plants which cut across or maybe partially hide the chosen subject; the wire is used to gently pull down a woody branch of a shrub or rose into the field of view, or to bring together several branches so the flowers or fruits are better grouped in the picture.

Some photographers even resort to cutting flowering or fruiting branches to 'improve' the composition. Personally, I do not favour doing this – even in my own garden – since it takes a great deal of time and effort to ensure that the orientation of leaves of the transplanted branch look

completely authentic; also, on a hot day, the foliage on a cut branch soon begins to wilt.

Taking a close-up of a plant at the back of a solid border is quite impossible with a standard lens and I find that the only way I can isolate one flower or a group of flowers, from the rest of the foreground border, is by using a long focus lens. I have taken delphiniums, *Kniphofia, Crocosmia* and *Macleaya,* in this way, using a hedge as a simple background. Another instance where a long lens is invaluable for bringing flowers in closer is where a border runs along behind a stretch of water.

Before taking a clump of flowers in the middle of a border, look critically to see if blooms behind them compete for attention. Moving a few paces to the left or right may be all that is needed to gain a more harmonious background, and even a slight change in the camera angle can dramatically alter the background colour or texture.

Formal bedding

Vegetables, as well as flowers, can be laid out in a formal way, and a delightful potager can be seen at Barnsley House where vegetables and flowers are integrated in beds edged with low box hedges. The garden has been adapted from a seventeenth-century design, with brick and block paths dividing it into narrow beds which make for easier weeding. Apple trees have been trained as espaliers and as unusual goblets.

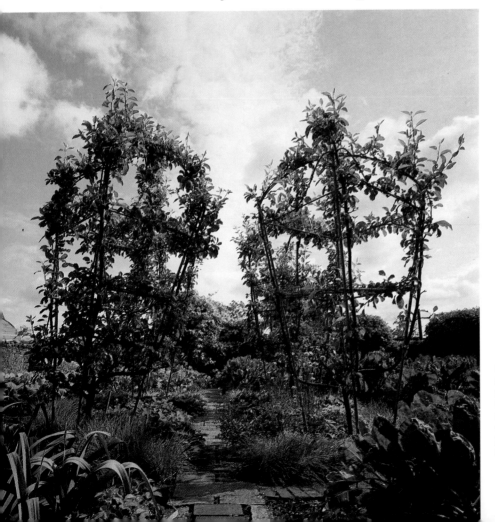

Within the formal potager adapted from a 17th century design at Barnsley House in Gloucestershire, apple trees are trained as goblets. A low viewpoint and a wide angle lens helped to isolate the trees against the sky.

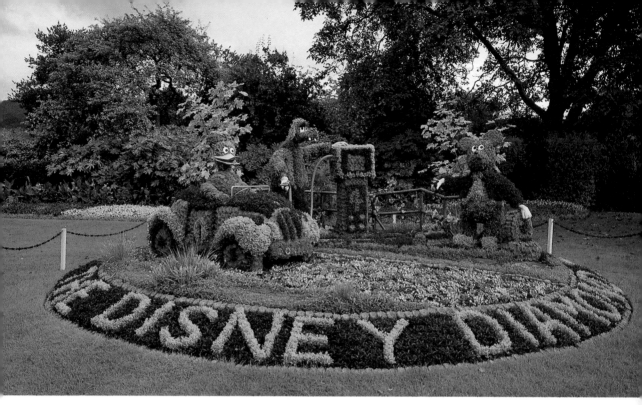

The theme for the 1983 3-dimensional carpet bedding display in the Parade Gardens, Bath was the Disney Diamond Jubilee. The only way I could illustrate the entire bed without the surrounding chain was to move in close and use a wide angle lens.

While some herbs have for a long time been used for outlining decorative knot gardens (page 81), all other herbs used to be banished to the kitchen garden. More recently, herbs have been incorporated into mixed plantings especially in small gardens where their foliage makes a good foil for other flowers. Formal herb gardens can be seen at Wisley, at Cranborne Manor, at the Ledsham Herb Garden in Ness Gardens and in the award-winning garden designed by Netherfield Herbs in Suffolk. The photography of formal herb gardens should follow a similar approach to that adopted for knot gardens. Where it is not possible to gain a high viewpoint to see the overall design, attention can be focused on plants with interesting texture or attractive flowers by photographing them from ground level.

Formal carpet bedding reached its height of popularity in the Victorian era, when it was not unknown for a country mansion to change the bedding schemes from one week to the next! Today, examples can still be seen in many municipal parks during the summer months. Dwarf plants with coloured foliage like *Alternanthera, Herniaria, Mesembryanthemum* and *Pyrethrum* are planted out in geometric designs. Originally, these two-dimensional carpet displays were elaborate designs reminiscent of Turkish carpets; nowadays they tend to depict a floral clock or else commemorate an anniversary. The bed is usually raised up at an angle for viewing from the front, which means it can only be photographed from the front. Care must be taken to align the camera so that the symmetry is not distorted. Any blemishes in a symmetrical design will be very obvious in a photograph, so that it is preferable to take these formal displays fairly soon after they have been planted up, before stray dogs or inquisitive squirrels have a chance to uproot any plants, and before litter gets caught up in the display. After I had taken a few pictures of a floral clock in Bradford's Lister Park I noticed the number four was askew. One thing you cannot do is walk on a floral clock. Fortunately, a friendly policemen appeared and handed over his truncheon for me to nudge the number back into position.

Each year, during the peak tourist season from July to September, a fine example of three-dimensional carpet bedding can be seen in Bath's Parade Gardens. Skeleton figures are made from a framework of steel rods, covered with chickenwire. Loam-based compost is then inserted into the framework with *Sphagnum* moss, before typical bedding plants such as *Echeveria* and *Alternanthera* surround the outside. Like raised two-dimensional bedding schemes, these displays are best photographed from the front.

Floral lettering and carpet bedding are not permitted however, in the Borough of Brighton's annual Gardens of Greetings Competition launched in 1955. Each summer, a series of 13 flower beds – adjacent to the main London Road – in Preston Park, are laid out according to plans submitted by local authorities and horticultural societies. Judging takes place in August when marks are awarded for general effect, design, use of colour and selection of material. Sometimes a better picture of a formally planted bed with strong colour design, will be obtained by standing back and using a long focus lens to foreshorten the perspective.

Beautiful Britain in Bloom is another annual competition, launched in 1964 by the British Tourist Authority, but now run by the Keep Britain Tidy Group. The aim is to encourage cities, towns and villages to brighten their streets and gardens with flowers. I happened to drive through the Welsh village of St. Florence in Dyfed, when I found the local inhabitants busy preparing for the final judging. An attractive planting of yellow nasturtiums and *Lonicera japonica* 'Aureoreticulata' caught my eye in one garden, a detailed close-up of which can be seen on page 42.

Like carpet bedding, ribbon planting was also popular in Victorian times. An 1871 edition of a popular dictionary of gardening, describes how the plants – annuals, perennials, bulbs and even variegated foliage – should be planted in parallel rows of contrasting colour up to 18 inches (0.5 metre) wide increasing in height towards the back. An example of ribbon planting is still maintained with geometric precision in Australia along a walk of Melbourne's Fitzroy Gardens.

The formality of nineteenth-century gardens was challenged by William Robinson (1838–1935) and Gertrude Jekyll at the turn of the century. Both favoured a more natural concept with harmonious drifts of colour (see page 34). Although isolated formal beds are still used in public gardens in resort towns in Britain and France – with additional height and interest provided by an urn or statue – the flowing formation of the modern island bed (completely surrounded by grass) tends better to complement the average private garden.

Island beds

The concept of island beds was conceived by Alan Bloom as recently as 1955 and many examples can be seen in his Norfolk garden at Bressingham, as well as in the lovely grounds of Blickling Hall. Island beds can be planted with perennials, foliage plants or heaths and conifers, so that they increase in height towards the centre, and can be viewed from any angle. This obviously makes their photography very much easier, for if the lighting is not ideal, it is a simple matter to move on round the bed. Also, the free flowing edges make for much easier composition. The graded heights of the plants give interest over a wider area of the picture

At Horsted Place Gardens in Sussex roses are planted in circular beds framed by iron baskets. Painted white, the island baskets stand out clearly against the green lawn, hedges and trees.

than the narrow band of colour from a bed of low-growing plants. If an island bed is domed, and there are no tall trees nearby, it can be photographed against the sky by crouching down. However, to show they really are islands in a sea of grass a high viewpoint will have to be found. Even shrub roses are now included in mixed island beds and give the photographer opportunities to consider the blooms, the form of the bush, its seasonal foliage and fruit as well as the associated planting.

Knot gardens and parterres

Knot gardens, or simply knots, are formal ornamental beds which were popular in Elizabethan times. Low-growing miniature evergreen hedges of scented herbs such as lavender, thyme, rue or rosemary were planted as twisted knot designs to create compartments for infilling either with flowering plants or with coloured sand, brick dust, coal and even broken china. Thrift and cotton lavender were also used for edging, but nowadays box is often substituted.

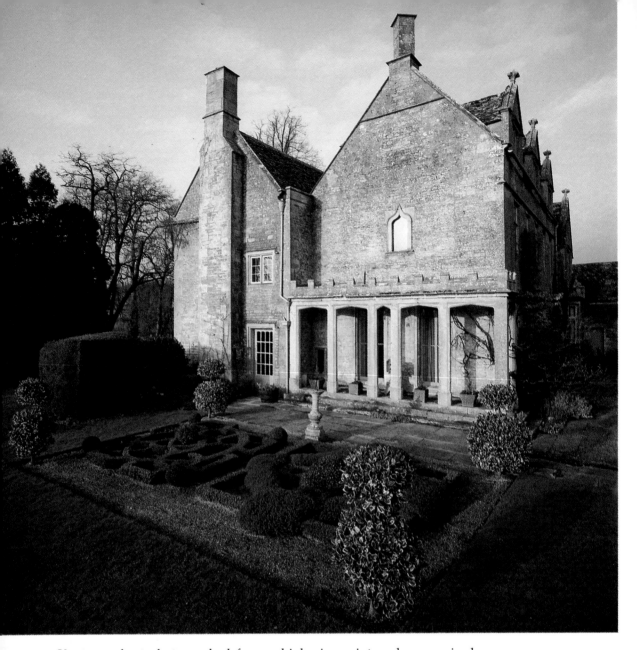

Knots are best photographed from a high viewpoint such as a raised terrace or from an upper window of the house overlooking the bed. The knot garden at Cranborne Manor is filled entirely with plants typically grown in sixteenth- and seventeenth-century gardens. The Hampton Court knot is a reproduction of the original one on this site using box, dwarf lavender, cotton lavender and thyme to make the knot shape while the central bedding plants are changed so that different displays are shown in spring and summer.

Parterres, which were also designed to be viewed from above, developed after the knot garden, but were planned on a much larger scale. Four large parterres laid out in decorative patterns can be seen in the Great Garden of Pitmedden, restored by the National Trust for Scotland. 30,000 annuals, planted out in May, provide the main colours to the parterres with additional colour from pebbles and stones. One parterre alone, which depicts the Sefton coat of arms, requires a 3-kilometre line of box planting.

The knot garden at Barnsley House in Gloucestershire was originally laid out in 1975 using 17th century designs. To the left, the lover's knot – created entirely in box – is from a design in *The Compleat Gardener's Practice* by Stephen Blake (1664). The design on the right comes from *Maison Rustique* or *The Country Farme* (1616) translated by Gervase Markham and is made from box, *Teucrium chamaedrys* and *Phillyrea*. Taken early in 1984 from a stepladder using a wide angle lens, this picture shows the knot garden and the 1830 gothic-style veranda added to the 1697 house.

The walled garden or pleasance adjacent to Edzell Castle contains a much smaller, but no less dramatic example of a parterre. This immaculately restored garden was originally laid out some 350 years ago. The box parterre at Mosely Old Hall is a reconstruction of a 1640 design discovered in Yorkshire in the 1960s. Two grey-coloured gravels were used to infill the parterre. Knot gardens and parterres constructed solely from evergreens and inanimate coloured infilling can be photographed during any month of the year, although they look their best shortly after the hedges have been clipped.

In the 1825 edition of *Hortus Ericaeus Woburnensis* there is a plan of a parterre for hardy heaths. The tallest growing heaths were planted in the centre of the Woburn parterre which was edged with the native heather *Calluna vulgaris* and cross-leaved heath *Erica tetralix*, for at this time only 35 species and varieties of hardy heaths were grown in Britain. Considering the current popularity of heaths and heathers, it is surprising that no-one has revived this idea for a more formal approach to planting the huge range of heaths now available, so as to make an attractive display worthy of photography in any season.

Raised beds and sunken gardens

Beds which are raised up from the ground, or sunken gardens where the ground is excavated to a lower level than the surrounding beds, reveal plants from an aspect quite different from conventional ground level planting. Plants in elevated beds present themselves for closer scrutiny – this is well-illustrated by the display of miniature roses in the Royal National Rose Society's Hertfordshire Gardens of the Rose.

If there is no high wall, hedge or tree behind the raised bed, plants can easily be isolated against the sky by crouching down. As with elevated pools (page 90) the wall of an elevated bed brings a vertical dimension to a horizontal border.

As well as adding height to a flat garden, raised beds also serve a very practical purpose for disabled gardeners, allowing them to sow, weed, prune or water from a wheelchair. The Garden for the Disabled at Wisley is designed specifically to show how they may garden efficiently, and they can also use their cameras to advantage, especially for close-up pictures.

The sunken garden at Packwood House has a flat grassy floor with a central narrow lily pond. Brick walls, rising up from the grassy margins, bear a rich assortment of flowering plants with the colour schemes changing as the season progresses. From below you can feast your eyes upwards over the tiered flowering beds to the sombre giant clipped yews behind. The sunken portion of the Queen's Garden in Kew Gardens, on the other hand, has a series of beds and paths on the floor, bordered by terraced beds. This Nosegay Garden can be photographed either looking down on it from the top tier; or from ground level looking along its length or up the ridged terraces.

Whether formal or informal, beds and borders delight the eye and provide endless opportunities for recording colourful facets of the garden, particularly in the summer months. However, the current popularity of foliage borders, and beds with many seasonal flowering shrubs, designed to provide winter colour, now extend the possibilities for this aspect of garden photography practically throughout the year.

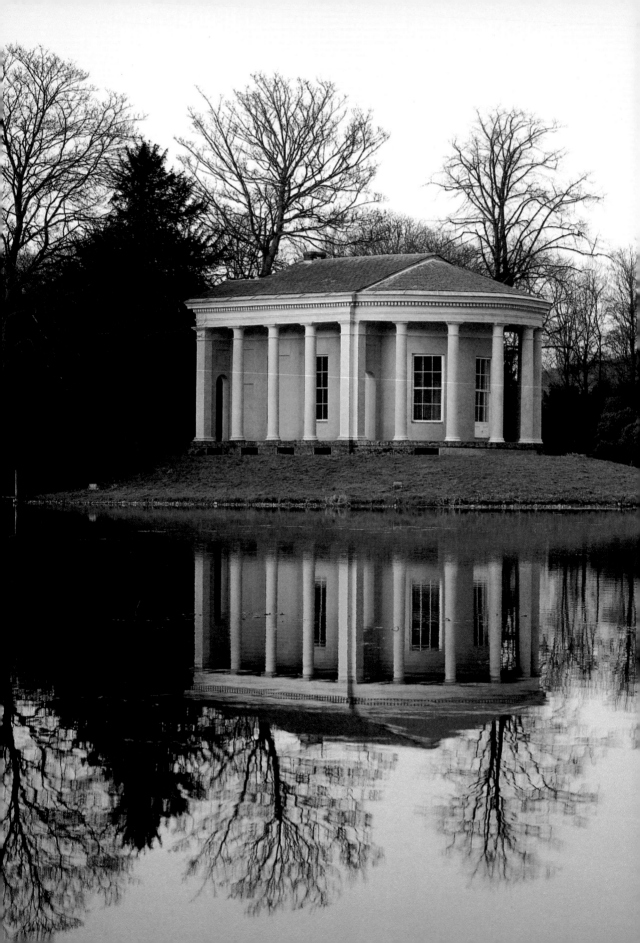

8 Reflections and Ripples

Water is a medium which attracts artists and photographers alike. Essentially a colourless liquid, its ability to reflect light enables even the still water of a tiny pond – chameleon-like – to adopt the colours of its surroundings. On a sunny day it may appear as a patch of blue on the ground, or it may mirror the tints of overhanging trees and various hues of waterside flowers. Movement of water brings a variety of magical sounds to the garden, whether it be the gentle bubbling of a natural brook, the gushing of a fountain, the tumbling of a cascading waterfall or the roar of a weir. The two distinct moods of water – tranquil and turbulent – provide endless opportunites for photographing a water garden.

The designs of modern water gardens encompass both simple and grandiose styles, the simplest approach being the Japanese and Chinese water gardens designed originally by priests, poets and painters. They worked along purely aesthetic lines achieving natural effects by followng written rules, using water-worn stones only in a water tableau. Plans were drawn up, but adjustments were made during the construction to achieve the effect which was most harmonious to the eye, because the garden was meant to be a place in which to meditate. These water gardens are by far the easiest to photograph, for at every turn in the path, the scene is set so perfectly all you have to do is choose the best viewpoints.

On the other hand, the more austere and highly elaborate architectural displays produced by Italian architects, engineers and sculptors collaborating during the Renaissance period need a much more precise approach. The camera angle and the lighting must both be critically appraised so that the photograph shows off sculptures and water to the best advantage. There can be nothing casual about photographing the full spectacle – now rarely seen – of the Versailles fountains or the magnificent combination of sculpture, fountains and cascading water falling away from the façade of Petrodvorets (Peter the Great's Summer Palace) near Leningrad. In Britain, on a lesser scale, Blenheim's classical water parterre – shallow formal areas of water divided by small stone walls – presents a challenge to the photographer's appreciation of line and form. Like all parterres (page 82), the whole plan is best appreciated from an elevated level.

Modern water displays created by landscape designers and hydraulic engineers may be less extensive, but they are every bit as impressive in our design-conscious world. As well as the architecture of the fountain itself, the shape of the water jet has evolved beyond the simple single jet. An exciting modern sculptured fountain can be seen in London in the centre of the landscape deck at St. Thomas' Hospital. Designed by the Russian-born sculptor Naum Gabo, the three-metre-high steel fountain revolves once every 2½ minutes with 1,200 jets providing a beautiful display of

The Music Temple reflected in the lake at West Wycombe Park, Buckinghamshire was taken late on a winter's afternoon. Compare this picture with the spotlit Temple on page 30.

85

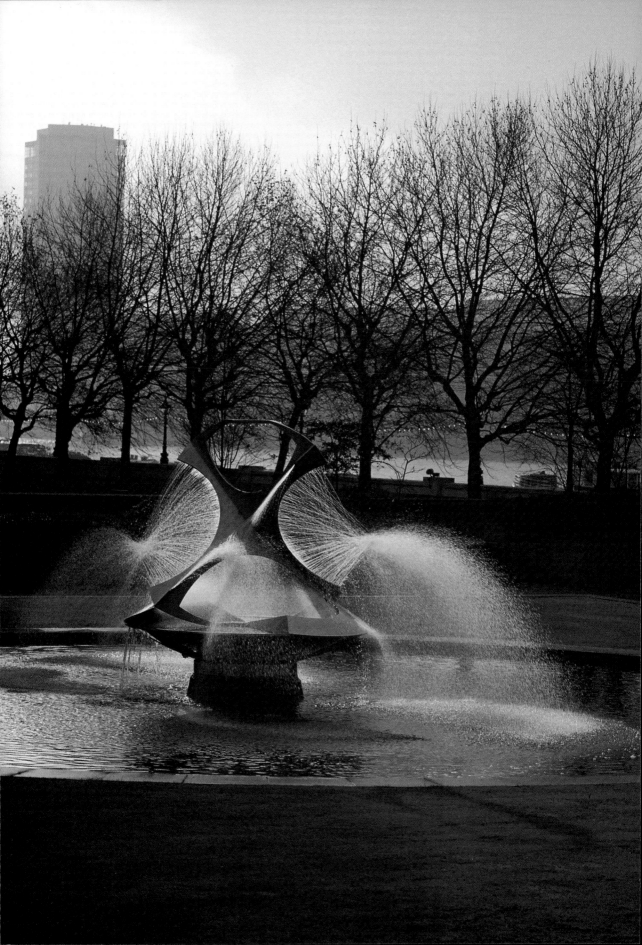

water tracery. Unlike water displays of static fountains (page 93) revolving ones must be taken with a fast shutter speed, to prevent a blurred image of the sculpture.

Having spent more time exploring seashores, rivers and ponds with a camera than any other habitats, I have a great affinity for water and the life it supports, and find it a most rewarding garden feature. As a schoolgirl I tried to construct a small garden pond without much success, but now, in our Surrey garden we are enjoying a newly-built series of pools stocked with a variety of water plants and fish. However, my dream water garden for photography would be a small replica of Georgia's Okefenokee Swamp – a large watery expanse carpeted with lily pads, emergent trunks of swamp cypresses bearing branches festooned with curtains of epiphytic Spanish moss and swampy islands rich with carnivorous plants. The only way to explore and photograph the swamp would be to drift through it in a canoe. The Cypress Gardens at Charleston in South Carolina approach this, although the introduction of azaleas and other exotics inevitably removes the evocative atmosphere.

Still water

When taking a photograph of still water in a garden, the whole setting should be considered. Extensive areas of water tend to dwarf the shape and design of individual aquatic plants; conversely, plants can disrupt the classical lines of formal water gardens. Pools which were designed to be completely weed-free, are often sited so they reflect surrounding features. For example, in one Surrey garden, Lutyens used a 'tank court' – a pool of dark water adjacent to the house – in order to reflect brick pillars which supported the curtain roof of the house. Similarly, at Bodnant one end of the canal is kept free of water lilies so that the gabled pin mill is perfectly mirrored in the still water.

Grandiose garden designs may look pleasing to the eye, but where there appears no obvious focal point in a huge area of water, the effect is pictorially monotonous. Ornamental water fowl, if present, can add interest to a sheet of water. Duck or geese flying in to land on the water will provide action, or even the simple movement of a swan dipping its bill into the water creating radiating ripple patterns will add some pictorial interest. A calm, silvery surface, as water appears when looked at facing towards the sun, makes a very effective setting for emergent plants such as iris or arrowhead leaves; the shape of their simple leaves being repeated as a black shadow in the silver water.

Colourful and showy stalked flowers of aquatic irises and lotus lilies also stand out well against a background of green leaves. A telephoto lens, used with some extension tubes, is a convenient way of getting close-ups of inaccessible blooms growing out in the middle of a pond.

Floating plants – especially those with radially symmetrical flowers – look best when viewed from above. Water lilies, which open out fully only when the sun is shining, are most easily photographed where they are growing in a sunken pool or where a raised walkway has been built over water, although a long focus lens may be needed to get a frame-filling close-up of a single bloom.

A wide angle lens can also be useful for photographing water gardens where extensive lily plantings are adjacent to the water's edge. Then

The kinetic fountain designed by Naum Gabo outside St. Thomas' Hospital in London has 1200 fine jets. The low-angled winter sun effectively spotlights the fine water tracery against the unlit background.

emphasis can be placed on the foreground flowers, which can be seen within the context of the water garden as a whole. I used this approach to photograph water lilies in the Barbican Lakes in the City of London.

Where large fish share a pond with water lilies, they repeatedly upheave leaves and push aside flowers as they nose their way up to the surface, so that even on a calm day the lilies can suddenly move whilst they are being photographed. In Japanese gardens, it was turtles, not fish, which kept bobbing up to the surface, thereby causing a blurred image of the water lilies which I was taking with a slow shutter speed on an overcast day.

In a large lake, the best water lily blooms are invariably out in the middle, in which case the only way to reach them is by boat, but here, movement is a problem. Any fellow passengers need to sit absolutely motionless, for a rocking boat not only shakes the camera, but also sets up ripples which cause the lilies to bob up and down. Wind will ruffle the surface and cause the boat to drift away from, or worse still, over the subject, so it is worth trying to anchor the boat either by driving a pole into

Irises growing in the Koishikawa Garden in Tokyo, Japan were photographed in June. The back lighting helps to highlight the water surface between the emergent clumps.

88

a soft bottom, or tethering it to rooted weeds. Even then, it is advisable to use a slightly faster shutter speed than would be normal with a hand-held camera on dry land, although this may be impossible on a dull day unless a fast film is used. A boat is one of the few places where I will dispense with my tripod – especially if there are engine vibrations which will be transmitted to the camera via the tripod.

People who share my fascination with the close-up world will enjoy seeking out miniature water worlds in the garden. A moss-filled gutter, the crotch of a tree, even the bases of teasel leaves contain water long enough to support some life. You will almost certainly need a tripod to photograph these tiny pools, which will reflect or absorb light falling on the water.

Floating plants, some of which rarely or never flower, can be photographed in any kind of light. The natural mosaics of their varied leaf shapes make attractive patterns. In temperate still waters the pattern may be created by the water fern *Azolla* growing intermingled with duckweeds and neat kidney-shaped leaves of frogbit *Hydrocharis morsus-ranae*; whereas in tropical waters the vigorous fern *Salvinia* may intertwine with the water hyacinth *Eichhornia* or with the water lettuce *Pistia stratiotes*. I prefer to use a small container such as an old sink, or a wooden tub for a floating plant garden, as the tiny plants seem to get lost in anything much larger. These kinds of containers also make it much easier for taking close-ups, because the tripod legs can be placed astride them on firm ground.

Pools with plants attract animals, and it is surprising how quickly after a garden pond is created that dragonflies and amphibians appear and start to lay their eggs. Dragonflies fly too fast for them to be photographed in mid-flight without a high-speed flash, but they can be taken when they alight on a plant or on a lily pad to oviposit. Frogs or toads can disappear from the field of view by submerging, but sooner or later they have to surface to breathe and you may be lucky enough to photograph a frog resting on a lily pad.

Pairing giant toads *Bufo marinus* surface beside a water lily in the Andromeda Gardens, Barbados. The silver skylight reflection on the water surface simplifies the background by obscuring the submergent vegetation.

High-walled tank pools or canals are not only safer where there are young children about, but they also present a view which is comparable with plants in raised beds (page 83). Raised pools, although not quite at eye-level, give a pond skater's eye view across the surface, instead of a heron's eye view down onto it. This may present a problem when taking small clumps of emergent plants; instead of being set off against water, they may have a background of brightly coloured herbaceous plants which may strike a discord. A discerning gardener, however, will avoid such unnatural clashes.

Even in winter, long after aquatic plants have died down, pools may still be worth photographing. Look for freshly fallen leaves trapped in ice. Their rich golden colours contrast well against the dark hidden depths of the pool – especially if a polarising filter is used to remove any sunlight reflections on the surface of the ice.

Under the surface

Pictures of fish and submerged aquatic plants can be taken *in situ* through the surface, providing the water is not too turbid, and is calm and

Freshly fallen autumnal leaves float on water and so become trapped in ice when a pond freezes over. These beech and sweet chestnut leaves with contrasting *Myriophyllum* shoots, provided an unexpected winter picture in my own pond.

ripple-free with an absence of skylight reflections. As soon as the surface ripples, the shape of fish or weeds will be distorted, which can give some curious abstract images. To photograph their undistorted shapes wait for a calm day or use a wooden framework floated on the surface to exclude the ripples from the field of view.

A TTL light reading of fish swimming below the surface will give you a correct exposure providing any bright skylight reflection is excluded from the picture. This reflection can be reduced by walking round the pond or lake to where it is less obtrusive. Alternatively, unwanted surface reflections can be eliminated by using a polarising filter, which darkens the water. It also increases the colour intensity of floating leaves because it eliminates reflections from the leaves themselves – particularly if they have a shiny cuticle like the pondweeds or potamogetons. This filter gives the best results when the camera is held at an angle of approximately 35° and not directly above the water. There is no need to worry about accurately measuring such an angle as it can be found simply by trial and error.

Crystal-clear pools add another dimension to a garden when a feature is made of the pool bottom. A layer of water-worn stones can be used to provide contrasting colour, or, more elaborately, a mosaic mural can add colour and design to a pool in a public precinct. The bottom of such a pool may be photographed using the same guidelines as for fish photography, making sure to focus on the pool base and not on the water surface. If necessary, a slow shutter speed can be used for this static subject.

Reflections

Calm water mirrors its surroundings and few can resist the urge to photograph the huge sweeps of colour repeated in a lakeside reflection of strategically planted cherry trees, rhododendrons or azaleas flowering in spring, or of deciduous trees turning in autumn. The best reflections are obtained with simple shapes and the maximum water level. Then, providing the water surface is absolutely calm, the reflection can be so perfect no-one will notice if the picture is turned upside down. In addition to trees, landscaped gardens which boast a lake invariably have an architectural feature on the lakeside to augment the scene (see page 84).

If there is no foreground interest to a large lake, it is worth searching for a reflection to help break up the watery expanse; or it may be possible completely to mask out the view and take only its reflection. Not all the light is reflected back from the surface, some will be absorbed by the water and so the correct exposure of the reflection will be slightly less (½ to 1 stop) than the exposure of the object in air. If skylight reflections are present on the surface, the intensity of colours in the mirrored scene can be increased by using a polarising filter.

The pictorial impact of marginal aquatic plants can be enhanced by including their reflections in a photograph. Gigantic leaves of *Gunnera manicata* and spectacular flowers of skunk cabbage *Lysichitum americanum*, as well as dramatic plantings growing above the water line, will all add emphasis to a picture. I first saw a huge Kiftsgate rose growing beside an Oxfordshire mill pond at eight o'clock on a June evening. In this light, with the sun setting behind poplar trees, the almost monochromatic scene was quite spell-binding and infinitely more subtle than when seen in a harsh mid-day light on the following day.

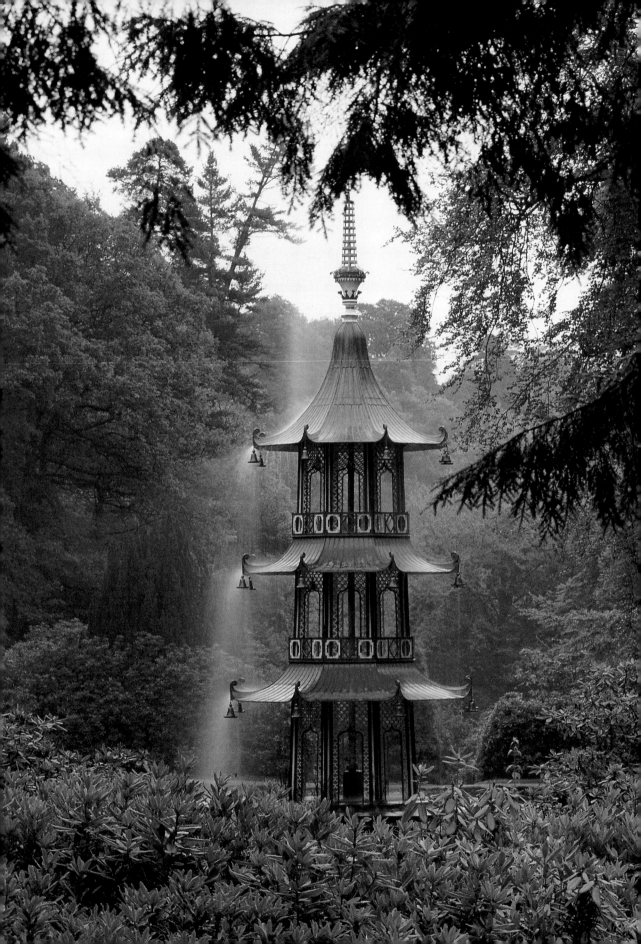

Moving water

Variations of light on calm water can generate great changes in mood, but catching the fleeting patterns of light on moving water is infinitely more challenging and exciting. The instinctive way to photograph action is to use a fast shutter speed to freeze movement. A shutter speed of 1/500 of a second will stop the upward spray of a fountain or the cascading of a waterfall so that they appear sharp and unnaturally frozen. How different the same scene looks when a slow shutter speed of 1 second is used. The water blurs into continuous lines of movement which convey a sense of motion better than the split second image. The choice of effect is yours.

None of the pictures I had seen of the Chinese pagoda fountain at Alton Towers prepared me for the magical sight on a slightly misty October morning. Built in 1827 by Robert Abraham for the 15th Earl of Shrewsbury, the gravity-fed fountain sends up a 21-metre-high jet of water. During a dry summer when water must be conserved, the fountain rarely plays, so I was indeed fortunate to have it switched on specially for me to photograph. As I rounded a corner and glimpsed the pagoda for the first time, I caught my breath. The rich colours were quite unexpected: tiered green roofs were supported by a red and white framework rising up from a small lake surrounded by both evergreens and glorious autumn-tinted maples. I managed to find two clear views of the pagoda through the trees, one of which is reproduced here.

Turbulent white water reflects far more light than calm dark water, so it may not be possible to obtain the correct exposure with a slow shutter speed, unless a slow film such as 25 ASA is used. Even then, in harsh sunlight the brightness may need to be reduced by using a **neutral density filter**. For this reason, I much prefer photographing cascades and waterfalls on an overcast day. It is wise to resist the temptation to crop in tightly on cascading water, because rocks – bare or mossy – add contrast as well as colour and they also provide a strong natural framework to the water. A waterfall clearly presents different moods at different times of year; the seasonal variation of plants, the direction of the light and the rate of water flow will inevitably alter the 'feel' of a picture. A good flow of water must be maintained if the full effect of a cascade or a waterfall is to be captured on film. Fortunately, I timed my visit to photograph the informal cascade at Bowood after the end of a summer drought by which time the water had begun to flow again.

There is no reason to photograph informal cascades head-on, whereas the symmetry of formal cascades will be maintained only by using this camera angle. When the Great Cascade at Chatsworth is flowing, a view looking up from the bottom of the stone staircase, shows the falling water – originating from moorland run-off – perfectly framed by grass slopes on either side.

At the base of an informal cascade, water splashing onto rocks can make an interesting study, as can changing patterns of light in rippling water flowing over a pebbly bottom or over slates set edge-on into a narrow water channel. For a few brief weeks in autumn, fallen leaves add colour and a new dimension to the water surface, whether it be still or moving. The small octagonal pool and the narrow serpentine rill leading from it designed by Kent at Rousham both collect leaves in autumn. Here you can

A view between the trees at Alton Towers in Staffordshire, reveals this magnificent pagoda. The gravity fed fountain rarely plays, but when it does, the green roofs glisten from the continual spray.

93

see still patterns from light and shadows reflected in the pool or moving patterns as the water flows along the rill among the leaves.

Together, ripples and reflections can contribute yet another aspect of water interest. A small circular lily pool set into a domed wall, as can be seen at Hestercombe, is often a feature of Lutyens gardens. When the sun is shining these pools throw up sunlight patterns from the water surface

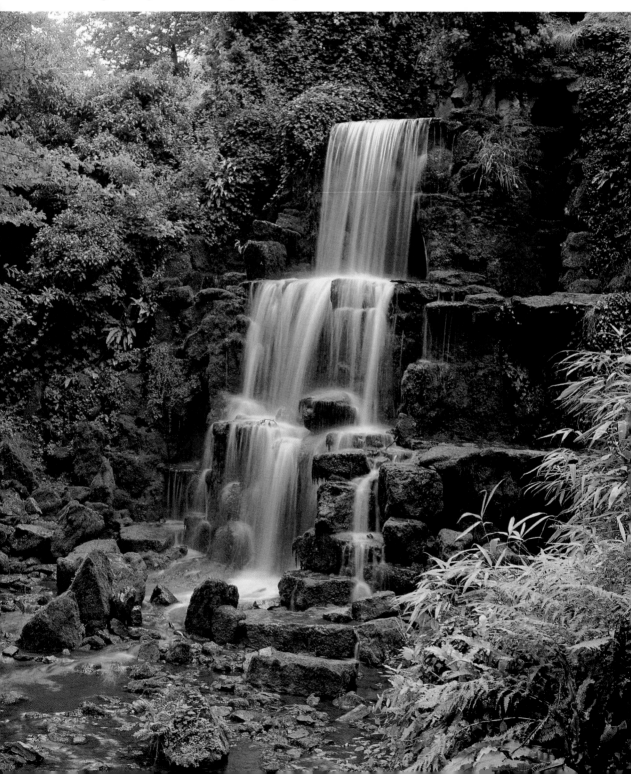

onto the wall. As the wind ripples the water surface, these patterns appear to dance on the wall, adding vitality to the miniature cave.

Even in the smallest of gardens, fountains are a focal point, but care needs to be taken if they are to be photographed successfully. Dull days should be avoided when taking fine spray jets which can only be viewed against the sky, because they will not stand out well from such a colourless background. In a similar way to a garden hose, multiple fine jets produce a spray which in certain lights may create an attractive rainbow. Aerated jets produce a bubbly effect which will reflect a lot of light thereby boosting the meter reading. Formed nozzles produce a thin sheet of water which, most simply, looks like a bell or a mushroom; and when many formed nozzles are arranged into a sphere, they resemble an outsized dandelion head such as the 4.8-metre-diameter Berger fountain in Loring Park, Minneapolis.

The camera viewpoint is particularly important when photographing fountains. If the jets are vertical, they look much the same from any position, and it is the lighting or the background which will determine the best camera angle. The full throw of horizontal jets however, can only be appreciated from the side. The optimum effect of a fountain is seen by photographing it when the sun is backlighting the water and there is a dark background – maybe a wall, building or a tree. If the background is a confused mixture of light and shadow, it may be better to photograph a vertical fountain from a low viewpoint against a blue sky; the intensity of the sky can be increased by using a polarising filter provided the camera is directed at right angles to the sun.

In climates where the temperature drops below freezing in winter months, waterfalls are generally turned off because the sheer weight of ice can damage the water nozzles. This is a pity, because magical ice mounds can build up around the fountain as the water freezes layer upon layer. Ice mounds can be seen in Kansas City where a few fountains play year-round. Ice, like glass, presents problems for photography, but when lit from behind with direct sunlight both the ice and water jet will appear to glow and the effect will be a magical spectacle.

Fountains which are illuminated at night can be photographed quite easily, providing the air is still, but a tungsten light film and a tripod will be needed. The necessary long exposure will reproduce the water jets as soft continuous coloured lines against a night sky.

We all have a mental picture of how water appears when it cascades, drips, falls, floods, gushes, meanders, races, ripples, runs, rushes, spouts, surges, swirls, trickles or tumbles. An interesting exercise might be to attempt to capture these diverse moods of water, showing how the camera can convey them in a simple uncaptioned still photograph.

The fickle nature of water means that the mood of the smallest pond can alter dramatically during a single day. Aquatic plants also change but in a more leisurely way. In temperate climates, they grow up as the temperature and daylight hours increase, then come into flower and set seed before dying back in autumn. It is well-worth taking a closer look at some of the more insignificant flowers of aquatic plants such as the pond-weeds, the bur-reeds and the exquisite water violet *Hottonia palustris*. To my mind, they are worthy of just as much film as the showy water lily. However, it is the dynamic aspects of moving water and the interplay of light on water which presents the greatest challenge to the photographer.

The cascade at Bowood in Wiltshire was designed by Charles Hamilton in a rococo style in 1785. A 1-second exposure has reproduced the tumbling water as continuous soft lines.

9 Focus on Foliage

We tend to ignore unspectacular leaves which are present the year round and instead turn our attention to the more ephemeral colourful flowers or fruits; yet to a plant, leaves are essential for photosynthesis and growth. It has taken a long time for gardeners to appreciate the potential of foliage plants. In Victorian times, exotic foliage plants became fashionable in the conservatory, but it was not until the middle of this century that hardy foliage plants selected for the form, texture or colour of their leaves, began to make an impact in the garden. Attractive foliage will always catch the photographer's eye, but there are many other aspects of leaves to be considered.

The variable shapes and textures of leaves present endless opportunities for exciting close-up subjects, although gigantic leaves of plants such as *Gunnera manicata* are beyond the close-up range. Brilliant autumnal hues are most alluring especially on a sunny day, but I also enjoy searching for the more subtle colours of unfurling young leaves which contrast well with the mature foliage. Even freshly fallen leaves are worth a closer look.

Tree foliage

The shape of the leaf is a basic recognition feature for identifying a tree. However, the sheer scale of large mature trees such as beech or oak – especially if they are grown in parkland where deer maintain a high level browsing line – makes it difficult to appreciate their individual leaves. Instead, it is the colour of the foliage *en masse*, or the growth form of the tree which is appraised.

The leaves of deciduous trees and shrubs are shed before the onset of winter as a precaution against water loss, for, unlike leaves of evergreens, they are not specially adapted with either a thick waxy cuticle or an inrolled margin to limit water loss through the leaf surface. Therefore, they would continue to lose water in winter – especially on a windy day – yet be unable to replace it when the ground was frozen. Popular evergreens grown in gardens are the conifers (larch, dawn redwood and swamp cypress being deciduous exceptions), rhododendrons, box, laurel and eucalyptus – all of which often look much healthier and therefore better for photography during winter than in a scorching summer.

In the autumn of 1983, I noticed how striking a holly tree laden with fruit looked against a golden backcloth of a huge beech tree. This colour combination created by an evergreen foreground and a deciduous background lasted for a few brief days before the beech leaves fell, and blackbirds and thrushes gorged themselves on the holly berries.

As always, when taking photographs of natural objects of very different sizes, some idea of comparative scale is useful, so that by including an

At Winkworth Arboretum in Surrey colourful *Disanthus cercidifolius* leaves caught my eye. The hint of green grass and the rain drops both enliven this autumnal picture taken from directly overhead.

unnatural object, such as a coin, or a lens cap, the picture automatically becomes a scientific record. It is for this reason that wherever possible, when taking fallen leaves on the ground, I try to include a well-known natural object – such as an acorn, beech mast or a Scots pine needle adjacent to the leaves. Whether or not I incorporate a natural object for scale, I always record the magnification of the subject on the picture mount, so its actual size can be calculated when the picture is enlarged on a printed page.

Fallen leaves can also be photographed on the surface of a pond even when it is frozen (page 90). Water-soaked leaves tend to have richer colours than dry leaves. Try to take leaves as soon after they have fallen as possible, before they begin to get eaten by leaf litter fauna or broken down by bacteria or fungi. Only leaves with prominent veins, such as magnolia, are worth photographing as skeleton leaves; in this state they are also much sought after by florists. I have lit a portion of a magnolia leaf from behind so that the veins made an intriguing abstract photograph.

Foliage plants

We can appreciate the leaves of shrubs, herbs and perennials at or near ground level much better than leaves on the tops of trees. Indeed, some gardens have a whole border devoted to growing foliage plants which are much sought after by flower arrangers. When foliage plants are sited so their colour, texture and scale of leaves complement each other or help to set off brightly coloured flowers or fruits, photographing them is an easy job, because the whole scene, or part of it, is pleasantly harmonious.

Deep purple-coloured foliage plants such as purple varieties of beech, hazel and the smokebush *Cotinus coggygria* are often planted to set off light foliage in the foreground; but equally well plants with pale foliage such as *Gleditsia triacanthos* 'Sunburst' or the neat yellow leaves of the honeysuckle *Lonicera nitida* 'Baggesen's Gold' can be used as a foil for darker foreground interest. On a sunny day, the contrast between one and the other may be too great for colour film to correctly expose both. If the foreground is pale, I would then expose correctly for that, even though the darker background (which will probably be out of focus) then becomes slightly under-exposed.

To appreciate foliage in general, it is well worth visiting gardens which have either set aside a special area for foliage plants or which grow them scattered all over the garden. Plants in the foliage garden at Harlow Car and in the leaf garden at Jenkyn Place have been selected for the beauty and interest of their foliage, which is attractive in any month of the year. This also applies to Beth Chatto's Gardens in Essex, where a wealth of unusual foliage plants are grown.

Foliage plants also feature strongly among non-hardy bedding plants and pot plants – *Begonia* and *Coleus* leaves offer good scope for taking frame-filling foliage mosaics. In the autumn of 1983, a display of dozens of *Coleus* varieties under glass at Wisley aroused a great deal of interest.

Shapes and sizes

Leaves come in all shapes and sizes, ranging from the tiny bud scales protecting the winter buds of deciduous trees, to the huge circular leaves of the tropical water lily *Victoria amazonica* reaching two metres in diameter. This spectacular water lily flowered for the first time in Britain in 1849 and

Leaves arranged in a radial or spiral design need to be photographed from above. This ornamental kale 'Osaka red' was one of several plants grown at the front of one of the herbaceous borders at the RHS Gardens, Wisley in 1983.

is still a popular tropical glass-house plant in temperate countries. Photographing plants with such large leaves from the side at ground level cannot give a good impression of their size, but in landscaped glass-houses with raised walkways, it is possible to look down on them from above. An overhead or oblique view is also best for illustrating ground cover foliage.

I much prefer to photograph groups of smaller leaves because this makes a more interesting picture than a single huge leaf. Tiny leaves also present problems since to see any detail in them, they need to be taken several times larger than life size, which is not as they are normally seen. Careful focusing is also very important for all plants with fine filigree foliage – such as fennels, *Anemone pulsatilla* and many ferns – because all detail becomes lost in an out-of-focus picture.

Vertical leaves and horizontal leaves can be compared with walls and walkways in the way they orientate themselves relative to the normal camera position. Thus, the striking lanceolate leaves of *Iris pallida* 'Variegata' growing up in a vertical plane are much easier to get completely in focus than the large horizontal leaves of *Rodgersia tabularis*. However, a viewpoint looking down on *Rodgersia* leaves will show their shape and allow the whole clump to appear sharply defined.

The orientation of leaves on a stem or a branch is a characteristic feature of the species. When a branch of a shrub or a tree is viewed from beneath against the sky, the leaves are clearly arranged in a precise way known as a leaf mosaic. The resulting pattern is easiest to photograph when the individual leaves are fairly large so the shape of each one can be clearly defined. When mosaics of evergreen leaves are taken against the light they will appear as silhouettes; but young unfurling leaves or autumnal leaves which have lost their chlorophyll are thin enough for sunlight to pass through them so they positively glow. Backlighting also highlights leaf venation patterns, as well as hairy or spiny leaf margins. Rose foliage is often neglected by the photographer, yet it provides a diversity of shape, texture and colour. Pictures of roses showing their leaf shapes can help to place them in the right group for identification. It may come as a surprise to discover that rose leaves can be flat, drooping, folded or cupped.

Juvenile leaves may have a shape quite distinct from mature leaves of the same species. Plants which push their cotyledons above the ground can be difficult to identify in the seedling stage because the simple shape of the seed leaves bears no resemblance to the true leaves. Unfurling fern fronds initially appear shaped as croziers, which is an attractive stage for photography. Later in the growing season the hard fern *Blechnum spicant* produces brown fertile fronds quite distinct from the original sterile green ones so that it is possible to illustrate both types of fronds in a single photograph. Trees also exhibit leaf variation. Unlike the stalked, lanceolate leaves of the older tree, juvenile eucalyptus leaves are sessile and oval. They can be retained on a tree by repeated pollarding – the lopping of all the branches from the trunk some two metres from ground level.

On some plants, notably several aquatics, different shaped leaves can also be found throughout their life span. Arrow-head *Sagittaria sagittifolia*, which is equally at home in ponds or sluggish waters, has three leaf designs. Above the water are arrow-shaped aerial leaves, while floating on the surface are oval leaves, and underwater the leaves are strap-shaped. An oblique camera angle is preferable for showing all three leaf shapes in a single picture.

Leaves of carnivorous plants are greatly modified for trapping their prey. The sundews (*Drosera* spp) use a fly paper technique, each leaf being covered with sticky glandular hairs; while the pitcher plants have pitcher-shaped leaves as traps. Perhaps most ingeniously of all, the Venus fly trap *Dionaea muscipula*, sports a hinged leaf which snaps tightly shut – reminiscent of a gin trap – when two or more sensitive hairs are touched by an insect crawling around. Venus fly trap and sundew leaves both provide scope for a before and after sequence of pictures. You may need to use a flash though, to stop the frantic movements of a trapped insect attempting to pull itself free from a sundew leaf.

Textured leaves

When photographing flowers and fruits, colour is so often the focal point and the leaves take second place, whereas plants which are grown for the colour or texture of their foliage may have insignificant flowers, or, in the case of ferns, no flowers at all. The direction of the light falling on leaves is of paramount importance in conveying their surface texture as well as the form of the whole plant.

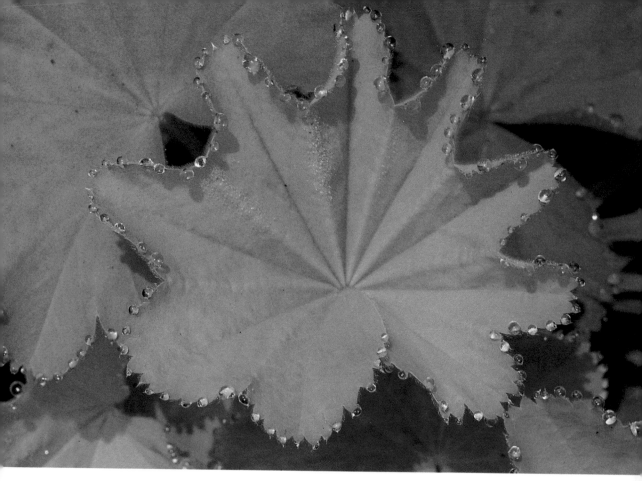

A lady's mantle *Alchemilla vulgaris* leaf shows water exuded around the leaf margins. This phenomenon, known as guttation, occurs on warm humid nights and needs to be photographed early in the morning before the water evaporates.

The way in which we describe the texture of a surface is related to what it feels like when we run our fingers over it. Hence, textureless leaves are smooth and maybe silky, while textured leaves are rough or uneven to the touch. Reference has already been made to bark (page 63) which exhibits a more obvious texture than leaves. There is no better way of appreciating texture in the garden than by feeling it. I can never resist stroking swamp cypress *Taxodium distichum* leaves whenever I pass a young tree on the way to my studio at the bottom of the garden and my six-year old son strokes the oversized woolly leaves of *Salvia argentea* as he would a passing cat.

Textured leaves, such as *Salvia officinalis* 'Tricolor', *Artemisia arborescens* and pelargoniums, have an unreflective matt surface and so can be photographed equally well on a sunny or a dull day. Among textured leaves, I regard lady's mantle *Alchemilla mollis* as being in a class of its own. Every time I go into our garden after rain, I never cease to marvel at the way silvery rain drops are retained on the velvety leaves long after it has stopped raining. After a warm and humid night, *Alchemilla* leaves also demonstrate well the phenomenon of guttation, whereby water is actively exuded from the margins or tips of leaves. I have pointed out this strange happening to several gardeners who had mistaken it for dew, despite the regular spacing of water drops around the leaf margin. Guttation must be photographed early in the day before the water evaporates and a tripod will be needed to ensure the droplets are pin sharp. However, great care must be taken not to destroy the magical effect – which can be highlighted by a touch of sun or flash – by accidentally knocking the leaves with a tripod leg.

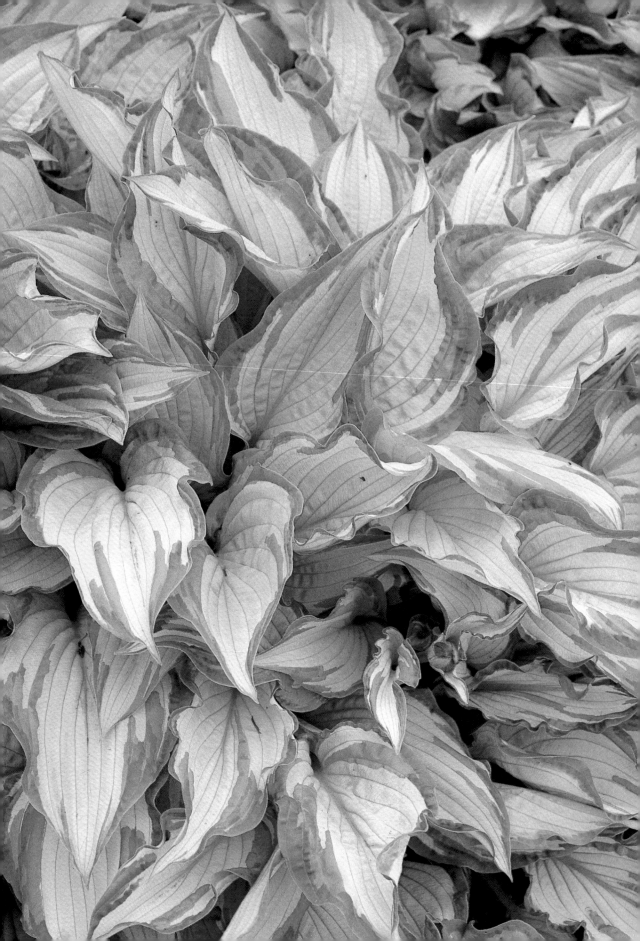

I would also rate the hostas high among foliage plants, both for the pleasure I get when seeing the range of colours, shapes and texture of the leaves and for the enjoyment of photographing them. Providing slugs and snails do not find them first, I never fail to get useful pictures of the sculptured leaves. The black hellebore *Veratrum nigrum* is a plant with highly textured leaves, which are best photographed with the light shining across the corrugations so that the ribs and grooves are accentuated. This also applies to deeply veined rugosa leaves, the most textured among species roses.

Foliage texture on an even smaller scale can be seen throughout the year in the heather garden and on the smaller needled conifers. The wonderful range of foliage colours which now exist among heathers and dwarf conifers, gives plenty of scope for multi-coloured scenes of complete beds or for a detailed close-up of a single-coloured shoot.

Sun or flash directed onto shiny leaves produces the same effect as on high gloss paint – namely a highly reflective sheen. Some plants are grown specifically for their light-reflective foliage; plants such as laurel, mahonias and camellias as well as those rhododendrons with a silvery sheen on young leaves. Other plants with lively leaves are the strap-shaped fronds of hart's tongue fern, hollies and the red-leaved *Perilla atropurpurea* 'Laciniata'; all of which add sparkle to a picture of a border with non-reflective foliage.

Reflections on any shiny leaves are always visible on a sunny day and we accept them because our eyes are not focused on one plant for long. In a still colour photograph on the other hand, reflections can irritate and jar because wherever they appear, the colour intensity of the leaf is reduced. If you have an SLR camera, it is worth moving your position relative to the sun to see if this eases the problem. Another way to reduce conspicuous skylight reflections is to stand at right angles to the sun using a polarising filter on the camera. You can preview this effect by simply rotating the filter in front of your eye. As the skylight reflection disappears, so the colour of the leaf dramatically intensifies. However, since no-one normally walks around the garden viewing it through a polarising filter, it can be argued that photographing leaves through such a filter is falsifying their appearance and, indeed, can completely change the intended effect.

As with any photograph, it is a decision which only you, the photographer, can make. Often it is a matter of degree – the size of the reflection in relation to the size of the leaf. As soon as a friend of mine sees a holly leaf, on goes his polarising filter! If a sheen is too pronounced – as it will be with direct flash or sun – it can indeed detract from the leaf shape or colour. A cheap and easy way of reducing sheen is to hold a diffuser, such as a sheet of muslin, between the sun (or flash) and the leaves.

Colour changes

Not all colour changes in leaves take place in the autumn; nearly all new leaves unfurl to reveal a colour distinct from older leaves. Often this difference may be quite subtle, but sometimes it can be very spectacular, as in the case of *Pieris formosa forrestii*. It is always exhilarating to see the brilliant red leaves open above older green ones and among drooping panicles of white flowers. The whole shrub then presents a dazzling tri-coloured effect, which sadly can so easily be ruined overnight by a

Hosta fortunei 'Albopicta' is just one of many hostas which can be seen at Harlow Car Gardens in Yorkshire. The best conditions for taking such a view looking down into upright leaves is on an overcast day when soft lighting casts no obvious shadows.

spring frost. Brilliant red young foliage is also a feature of many tropical plants and, if photographed with the light shining through it will appear to glow like autumnal leaves (page 12). The attractive bronze hues of young walnut, deciduous azalea and *Catalpa bignonioides* leaves last for a few brief weeks before the chlorophyll pigments develop and the leaves turn the more familiar sombre greens. Young leaves of any deciduous trees are worthy of a picture, if only to remind you of spring in autumn or winter. When I visited New Zealand in the southern hemisphere springtime, bright red leaves were bursting forth from the evergreen beeches and I have a magical picture of red beeches *Nothofagus fusca* with their spring growth set off against snow-capped Southern Alps. As well as exhibiting attractive colours, young newly-opened leaves are also less likely to be damaged by wind or leaf-eating insects than are older leaves.

The explanation of why and how green leaves change colour in autumn can be found on page 33, where several examples of trees and shrubs with spectacular autumn tints are given together with hints on how to photograph them. In addition to these, there are plants like some of the bergenias, which enliven a border in winter when their leathery green leaves turn into eye-catching shades of bronze or purple after frosting. These provide welcome winter subjects for photographing in this off-peak season. Look also at this time of year for etching by hoar frost on the outer margins of evergreen leaves such as ivy or holly, as well as on recently

When the new leaves of *Pieris formosa* var. *forrestii* unfurl, they bring welcome splashes of colour to the older evergreen leaves. This detail, taken at the RHS Gardens, Wisley also shows the pendulous white flower spikes which open at the same time.

The swamp cypress *Taxodium distichum* is a deciduous conifer which turns an attractive foxy-brown colour in autumn. In some years, if heavy frosts come before leaf fall, an unusual picture can be taken of the leaves decorated with hoar frost.

fallen leaves. On a frosty morning in November, I had to work fast to get all the pictures I wanted in our garden before the sun melted the frost fantasies. Most important of all, I knew this would be my one and only chance of getting the attractive combination of brown and green foliage – covered with frost – before the leaves fell from a swamp cypress tree.

The best way of illustrating variation in colour between the upper and lower surfaces of a leaf, is to wait until the wind ruffles the leaves quite naturally. You will need to use a fast shutter speed of at least 1/250 second to freeze the movement so you can see both the white undersides and green upper surfaces of whitebeam, or of silver lime leaves. The gold and silver poplar *Populus alba* 'Richardii' also has leaves with whitish undersides and when they first open, they have an attractive golden topside which turns greener with age.

Among all the photographs which I appraise over a year, I sense that leaves are much neglected camera subjects. This is a strange anomaly when one considers that each kind of flower and fruit is present for a limited time, whereas evergreen leaves exist throughout the year and even deciduous leaves are present for almost half the year. Now that gardeners are becoming more foliage conscious, perhaps leaves will be better appreciated by photographers.

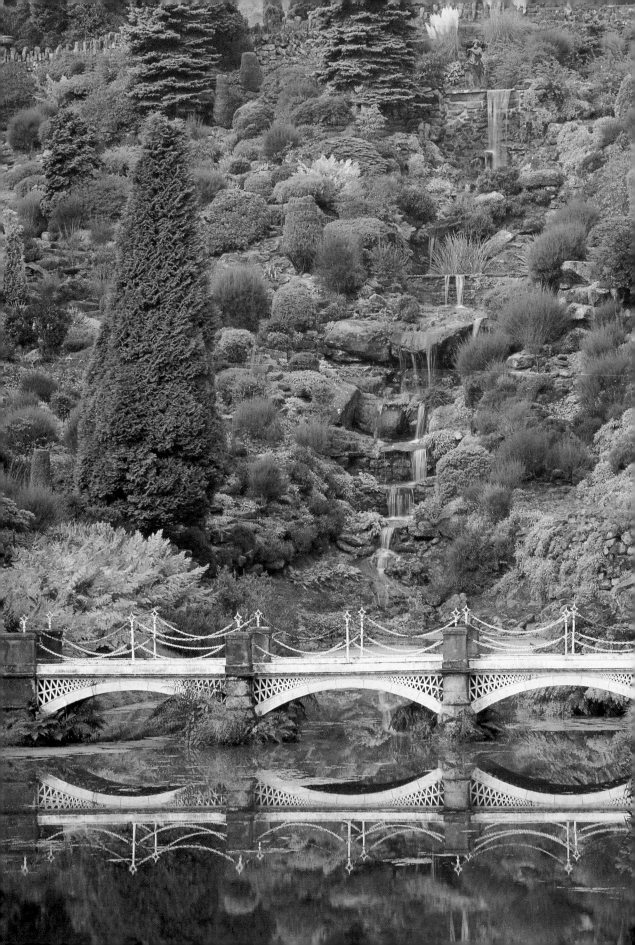

10 Rock and Scree Gardens

Rocks in gardens can be used in many ways – to build walls, to construct rock gardens, to create fanciful garden features, or simply to blend in as an integral part of the garden landscape. In Far Eastern gardens, rock and water have for long been considered essential elements in the creation of scenes which symbolise nature. In China, the more contorted the rock, the better it is prized. The best rocks originated near Suzhou from the bed of Lake Tai, where they were sculptured by natural erosion into curious shapes riddled with holes and furrows. Once selected, each was precisely positioned in the garden and so great was the devotion lavished on these bizarre-shaped rocks that special pavilions were built for the purpose of viewing and contemplating them.

Such reverence is not bestowed upon individual rocks in western gardens. Instead they are most often used as the building blocks of rock gardens for the display of alpines and rock-loving plants in general. Other garden features constructed from rocks are grottos (page 119), hermit's caves and informal cascades (page 94) all of which became popular in Britain during the eighteenth century.

Rock gardens

The scope of our rock gardens today must, in part, be credited to Reginald Farrer (1880–1920) who collected vast numbers of alpine plants, including *Rosa farreri*, *Geranium farreri* and *Gentiana farreri* found in China. He was highly critical of the unnatural rock gardens built around the turn of the century, likening them to an Almond pudding, a Plum-bun and a Dog's grave. Even today, we have all seen rockeries in private gardens where rocks are evenly positioned on a mound of soil bearing no relationship to a natural scene. No amount of care with the photography can ever make a pile of stones with overgrown clumps of aubretia, candytuft and yellow alyssum into anything resembling a replica of a natural rock garden. The best pictures will be taken of naturalistic rock gardens displaying rock-loving plants in an authentic setting, as advocated by Farrer.

One of the first rock gardens in Britain was created by William Forsyth, gardener at the Chelsea Physic Garden, in 1772 he assembled 40 tons of old stone from the Tower of London, flints and chalk, as well as lumps of dark volcanic lava collected by Joseph Banks on an expedition to Iceland. Small wonder then that although the Apothecaries recognised the artificial rockwork would be 'a very ornamental addition to the Society's Garden', the ensemble is not one of the most endearing rock gardens in Britain. However, this garden helped to spark off the idea for gathering stones for 'stoneries', as they were known.

Old photographs taken towards the end of the last century of the

A cascade falls down the near vertical rock garden at Alton Towers in Staffordshire. To take the cascade with the iron bridge and its reflection, I stood on the roof-rack of my car and used a medium long focus lens.

original rock garden at the Royal Botanic Garden, Edinburgh, reveal the unnatural and incongruous scene of regimented rock-walled compartments – known as pockets – above which monkey puzzle trees were planted on raised ground. Today, the extensive rock garden in Edinburgh – completely rebuilt between 1908 and 1914 – is a delight to the eye and a photographer's paradise. A profusion of alpine, Arctic and Mediterranean plants grow between or tumble over the conglomerate slabs collected from the slopes of Ben Ledi in Perthshire, while plants which prefer moister conditions are planted among sandstone rocks. The large-scale rock garden with low-level widely-spaced paths at the Royal Botanic Gardens, Kew, unfortunately makes it quite impossible to see – let alone photograph – plants on the uppermost levels. Originally laid out in 1882, the rock garden simulates an alpine valley with streams running down towards the main path and the low-level plantings beside the streams are the most attractive parts.

The best rock gardens for photography are the ones designed with paths meandering up through them as at Wisley and at Edinburgh. It is then possible to take pictures from the bottom looking up, from the top looking down or from any level in between. Steps lead past pools and falls in the rock garden designed by Ellen Willmot at the turn of the last century at Newby Hall in Yorkshire. Much more recent constructions in Yorkshire can be seen at Harlow Car, where separate limestone and sandstone rock gardens provide good views of all the plants. Also at Harlow Car are several small demonstration rock gardens, each displaying a different rock type and a planting appropriate to it. The rocks chosen for this unique display are Forest of Dean limestone, millstone grit, Westmorland water-worn limestone, tufa, north Norfolk carstone, Westmorland slate and artificial stone. Commissioned by the Consumer's Association and completed in 1983, they show how similar attractive small features can be built in today's modern garden from readily obtainable stones.

Photographing the vertical rock garden with cascade at Alton Towers is comparable with photographing a wall on a grand scale. From the bottom, the rising vista presents a patchwork of vibrant colour, particularly in the autumn when the maples are a glorious red. Thirty miles off Land's End lie the Isles of Scilly where Tresco Abbey Gardens enjoy the warmest winter

A low camera angle was chosen so as to hide labels behind the clump of *Helianthemum* 'Fire dragon' at Harlow Car Gardens in Yorkshire.

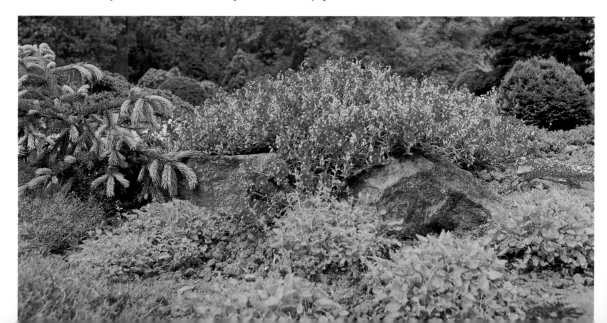

climate in Britain. Plants from both the Mediterranean and the southern hemisphere abound, their luxurious growth and architectural form providing wonderful opportunities for unusual and exciting garden photography. In both the East and West Rockeries, New Zealand rata trees produce scarlet staminate flowers in summer. Also present are South African succulents, aeoniums from the Canaries and the beautiful Queensland lily *Doryanthes palmeri*.

Pictures of rock gardens in some situations may not be very easy to take. The aspect of both vertical and huge step-like rock gardens will have some bearing on the best time of day for photography. If the stonework is large and pale, avoid photographing the garden when the shadows are long. A major problem with general scenes of newly planted rock gardens is the multitude of labels which resemble a miniature forest. There is nothing you can do except wait for a few years until the plants begin to fill out. In my own garden I either move labels discreetly behind a plant or to one side out of the field of view. A useful method of eliminating any distracting background objects from the picture, is to crouch down so that the plant is set off against a background of sky or trees.

Gardens with natural rock outcrops have the basis of a ready-formed rock garden. Whinstone outcrops smoothed by glacial action surface at Rowallane in Northern Ireland, where they are enlivened by plants. Vertical rock faces which have had ferns planted in shady places, or flowering plants on sunny outcrops also provide wonderful opportunities for photographing plants in a naturalistic setting. Even artificial rockwork can look remarkably natural if it is skilfully shaped as at Leonardslee. The rock garden sponsored by the Royal Horticultural Society at the 1984 International Garden Festival on Merseyside is an imaginative variation of the traditional tiers of rock set into a sloping bank, using an alpine meadow to soften the rocky outcrops.

Scree, sand and pebbles

Farrer popularised the moraine or scree garden as it is known, and he described in his book *In a Yorkshire Garden* how he made his first moraine: 'Four big blocks of beautifully worn limestone were arranged in a hollow square, with a well at their centre. Some sharp, large rubbish was put in for drainage, and then the whole filled in with chips of blue limestone . . . and with this a faint adulteration, only, of soil.' Where there may not be enough room to build a large-scale rock garden, scree gardens – especially if they are incorporated into raised beds for easy maintenance – are ideal places for growing and photographing alpines.

Chippings used to finish off scree gardens and rockeries help drainage and also act as a weed-deterrent but, depending on their colour, they can present problems when photographing plants. An ambitious replica of a portion of the European Alps at Hoole House in Cheshire in the 1830's created micro-climates by the selective use of pebbles. Dark fragments of stone increased ground heat, while white pebbles reflected light, thereby keeping a patch of ground slightly cooler. For the photographer, a white background is an anathema, because it throws back too much light and so over-exposes the film. A black background is less problematical and it can offset coloured blooms well – although for anyone who has not seen plants growing on black volcanic rock, it can look unnatural. Coloured gravels are

totally false and divert the eye away from the plants.

Walls or raised beds made of tufa, on the other hand, provide a naturalistic background for photographing smaller lime-loving rock plants. The tufa cliff adjacent to the rear wall of the alpine house at Wisley displays alpines particularly well. Tufa looks like rock, but when held in the hand, it is surprisingly light, due to its composition of porous limestone built up from layers of calcium and magnesium carbonate deposited by the evaporation of lime-rich spring water. Fibrous-rooted alpines can be grown directly in a miniature tufa garden, but they tend to dry out quickly during hot weather.

Rock gardens in Japan bear little resemblance to the colourful plant mosaics created in western gardens; often the stones and sand dominate in an almost monochromatic scene of grey and white with maybe some green provided by moss and evergreen shrubs. The unique dry rock garden of Ryoan-ji in the old capital of Kyoto is simple to the extreme – fifteen stones in five groups are set in fine white gravel as they were laid out some five centuries ago. The gravel at Ryoan-ji is raked lengthwise, but in many other Japanese gardens the fine gravel – referred to as sand – is raked into intricate patterns which will usually last for about two weeks. As with any

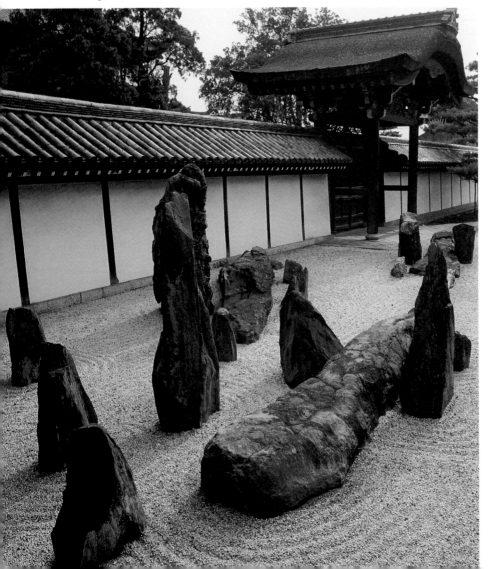

The southern garden in the Tofukuji Temple, Kyoto, Japan consists of four groups of rocks positioned in a sand garden floor. The low-angled evening sun has accentuated the pattern of the raked sand.

The small pinetum at York Gate in Yorkshire is covered with water-worn pebbles which complement well the grass and trees. The bands of the recently-mown lawn reinforce the edge of the bed and contribute to the textures.

textured surface, a low-angled light will reveal the pattern better than an overhead sun. It is quite impossible to photograph white sand in bright sun, since it produces a blinding glare. These sand gardens are best seen and photographed after the rocks and sand have been wetted from recent rain, because water darkens the sand and thereby reduces the contrast.

Japanese gardens also use carefully graded water-worn stones and pebbles arranged in flowing stream-like paths so they suggest waterways in dry gardens. An extensive area of grey cobbles has been used to stabilise a pond bank at Sento Palace in Kyoto. These cobbles glisten when wetted and make an abstract picture well-worth taking without any suggestion of living plants.

In many countries, washed gravel, scree and pebbles are used in public places as ground cover for beds and borders after planting. Outside several hotels on the main tourist islands in the Hawaiian archipelago, I noticed volcanic scoria was a popular covering, while in New Zealand, I saw pumice stones used in the same way. Highly textured or coloured inanimate coverings can dominate a photograph, unless the plants

growing up through them have architectural status, such as the large yuccas and agaves.

The grey pebbles covering a small pinetum at York Gate and the scree spread over prostrate conifer beds at Hillier's Aboretum complement well the evergreens throughout the year, both adding a pleasant neutral contrast to a green scene. A practical and effective idea of a disabled rose grower was to extend his drive gravel over a bed of rugosa roses to inhibit weeds, at the same time providing a neutral background to offset the rose flowers, foliage and fruit for photography.

Sink gardens

Where space is limited, miniature rock gardens in the form of sink gardens or troughs provide all-round access for close-up photography. If part of the trough has to be in the picture, old stone types much sought after by alpine gardeners are best for photography as they are not intrusive. Any trace of unnatural containers, such as white glazed sinks, are far too conspicuous in a photograph, but they can be camouflaged by coating them with Hypertufa (a mixture of cement, sand and peat).

Troughs which are raised up from the ground will be easier for photography than low-level sinks. There is a fine display of troughs of varying heights set out on a paved area adjacent to the Alpine House at the Royal Botanic Garden, Edinburgh. The troughs are attractively grouped and their hard rectangular outlines softened by plants growing from between the paving slabs around their base.

Careful focusing, preferably combined with a small aperture, is needed for taking sharply defined close-ups. This overhead view of *Jovibarba hirta* was taken with a 55mm macro lens at the Royal Botanic Garden, Edinburgh.

The compact growth of mats and cushion-forming plants, such as the Australasian scabweeds *Raoulia*, androsaces and moss campion *Silene acaulis* can be photographed from directly overhead in the same way that floating plants can be photographed in a wooden tub (page 89). *Sempervivum* and *Jovibarba* rosettes are usually shown to their best advantage when seen from above. However, when erect flower stems are produced they are better photographed from the side.

Alpines in close-up

Most plants which are grown in rockeries are often loosely grouped as alpines, to the botanist however, alpines are plants which grow on mountains in the alpine zone between the upper tree line and the permanent snow line. Some of these plants also grow in the Arctic and are known as Arctic-alpines, for example, the alpine azalea *Loiseleuria procumbens*, the reticulated willow *Salix reticulata* and the mountain avens *Dryas octopetala* which, incidentally, grows at sea level in the Burren on the west coast of Ireland.

When photographing creeping plants, make sure the flowers themselves are sharply in focus, even if all of the cushion or mat cannot appear sharply defined. For any detail to be shown, low-growing plants need to be taken with the camera close to the ground. Either a **waist-level viewfinder**, or a **right-angle viewfinder** attached to a fixed pentaprism will allow you to use the camera very close to the ground without having to lie prone.

For a rigid camera support close to the ground some conventional tripods can be used simply by reversing the centre column, or the head of the column. The most versatile tripod I know is the British-made Benbo which can be adjusted so the head is locked into any position – including ground level – on any sort of terrain, including rocky outcrops, scree or rock gardens. Permission to use a tripod should always be requested in other people's gardens – especially in a confined space. Alternative light-weight low-level camera supports such as **table top tripods** or **ground spikes** can also be used.

Careful close-up photography ensures that you give any subject more than a cursory glance and hence a greater appreciation of the shape and form as well as the colour will be gained.

Mention has already been made (page 39) of the problems of reproducing the true blue of some flowers, such as gentians, although the New Zealand gentians have white flowers which present a different problem (page 27). Many other New Zealand alpines have white flowers, notably *Myosotis*, *Ourisia* and *Celmisia* and, compared with the European alpine flora, New Zealand alpines exhibit a limited range of colours among their flowers. This trend is partly due to the scarcity of long-tongued pollinating insects (butterflies and some bees). Instead, it is short-tongued insects such as flies, beetles, short-tongued bees and moths which are attracted to the white (often short-tubed) and yellow (often composite) flowers, thereby pollinating them.

The lack of brightly-coloured flowers among New Zealand alpines is more than made up for by the highly-coloured fruits of coprosmas, gaultherias, pernettyas and podocarps. Over 90% of New Zealand's alpines are endemic to the New Zealand Biological Region and one of the most bizarre plants must be vegetable sheep *Haastia pulvinaris*. When I first

Aquilegia fragrans was found growing at an altitude of 4000 metres beside a glacial lake while on a pony trek in Kashmir. The grey/blue water perfectly sets off the white flowers in their alpine setting.

saw it growing on an alpine fellfield at an altitude of 1,700 metres in the Nelson Lakes National Park, the off-white cushions did look remarkably sheep-like.

Natural rock gardens

No chapter on rock gardens would be complete without a brief mention of how to photograph rock-loving plants and alpines in their natural surroundings. The techniques for taking close-ups are no different from those used in a rock garden, but the joy of working in the field comes from looking for the perfect location spot where it is possible to photograph a choice clump of flowers set in a natural habitat. For this sort of photograph, the flowers need to contrast well against the surrounding turf, rock or scree and to be erect rather than prostrate. Then, by using a wide angle lens, it is possible to get both the flowers sharply in focus in the foreground and a clear impression of the rock face, mountain or glacier behind.

For anyone who is unable to climb high, the Rock of Gibraltar is a delightful natural rock garden, readily accessible on foot. The limestone bedrock dominates the Rock, with patches of overlying shales, sands and grits where a rich assortment of plants flourish. Indeed, there is no month of the year when flowers cannot be found, but the peak flowering month is April, which is a pleasant time for photography.

The true alpine botanist, however, who is prepared to spend much time and energy in search of choice specimens at high altitudes will know that the main advantage of working on a mountain-side is that spring arrives later with increasing altitude. This means that if a species has finished blooming at one level, there is a good chance it will still be in flower higher up the mountain.

The most pleasurable and exciting trip I have made in search of alpine flowers was a pony trek to Kashmir, where one of the most breathtaking scenes was finding *Aquilegia fragans* flowering beside a glacial lake, the exquisite white flowers repeating the white mass of the glacier. After several choice clumps of flowers had been eaten by my pony and therefore ruined for photography, I learned the hard way not to pull up alongside my potential picture.

The intricate shapes of so many alpine flowers make them ideal subjects for taking close-up portraits of life size, or even greater, on film. By specialising in photographing one type of plant such as miniature bulbs, or a single family such as Gentianaceae, the common floral structures which link the genera and the subtle differences which separate the species can be appreciated. Since the days when the early alpine botanists collected unknown riches, more and more people have been compelled to follow in their footsteps. Fortunately, the camera is now replacing the trowel and most people are content to collect alpines on film instead of in a vasculum.

11 Art and Architecture

Architectural features are relatively permanent and they can be appreciated and photographed all year round. In fact, winter is a good season to spend appraising walls, paths, statues, follies and temples when plants compete much less for attention. Even if the winter setting is too stark for photography, the best viewpoints can be assessed and noted for a later date.

The classical architecture of Italian Renaissance gardens with statuary, fountains and pillars first appeared in England at the beginning of the seventeenth century and gradually our gardens became over-ornamented; a situation much criticised by eighteenth-century landscape designers. Subsequently, the design and location of each architectural piece was carefully considered in the whole landscape picture.

Famous landscape gardens are referred to throughout this book, but one – not yet open to the public – deserves special mention. Painshill Park in Surrey was created by the Hon. Charles Hamilton in the eighteenth century, but is now in urgent need of restoration. The large lake was fed by a huge cast-iron water-wheel pumping up water from the River Mole, and bridges, temples and follies were set in parkland to provide a series of focal points to be viewed on a circular walk. A Trust has now been set up to restore Painshill to its former glory.

Today, few owners of private gardens can afford to commission statues and other ornamentations, but modern examples can be seen in parks and public plazas. A basic camera will be quite adequate for photographing complete garden architectural features, but close-up accessories will be essential for photographing intricate surface details.

Temples and pavilions

Early photographers tended to concentrate on taking architectural and landscape subjects because they were static – an important criterion for the obligatory long exposures. Even when using modern fast films, there is no need to hurry over these aspects of garden photography. The approach to taking buildings – whether they be garden pavilions, temples, obelisks or follies – is the same as for any architectural features. Most importantly, vertical pillars and walls need to be accurately orientated in the viewfinder, so the camera must be held level and not tilted skywards, when verticals will appear to converge. The use of a tripod is invaluable for checking this alignment, particularly if used with a spirit level, either built into the camera or tripod, or bought as an accessory which slides into the flash shoe on top of the camera. Architectural photographers often use perspective correcting lenses when photographing buildings. Sometimes the scale of garden architecture may be difficult to interpret in a large open vista unless

Supported by bronze cherubs, this sundial in the Surrey garden of Polesden Lacey was photographed in winter. The back lighting silhouettes the gnomon in contrast to the shiny dial.

people are included to provide natural scale. Thought must also be given to the way in which the form of a building relates to a garden: extensive landscaped gardens such as Chatsworth, Stourhead or Stowe, provide perfect settings for photography of architectural features. Look for a viewpoint where trees frame a building or water reflects it. A view looking out from a temple or pavilion across the garden can be effective, especially if framed with stone columns.

There will be little choice about the best time to photograph a building surrounded by trees because it will be effectively lit for only a short time. Whereas there will be more scope for selecting the time of day which provides the best lighting angle for a building set in spacious surroundings. Extreme side lighting, either from a low-angled sun or **grazed lighting** with flash, will reveal the surface detail of decorated façades by lighting only the raised parts and casting shadows in the hollows.

Regardless of season, the Stourhead landscape provides an attractive setting for photographing temples: the Pantheon can be viewed across the water with the stone bridge in the foreground, and in other parts of the grounds, the Temple of Apollo, the Temple of the Sun and the Temple of Flora are all beautifully situated. Further notable examples are to be found in the Yorkshire gardens of Castle Howard, Rievaulx Terrace and Studley Royal. However, Stowe has the largest collection of temples in Britain, one of which – the Gothic Temple – constructed in ironstone is an unusual ginger colour. The Temple of British Worthies, designed by Kent, is a classical semicircular building with portrait busts in 16 niches and from one striking viewpoint this temple is reflected in water. An even more intriguing siting is of the Music Temple on an island in West Wycombe Park, seen from the south bank of the River Wye it appears to float above the cascading waters.

Castle Howard's Temple of the Four Winds, the last work designed by Vanbrugh, was built after his death in 1726. It has an Ionic portico on each of the four walls and so offers four different aspects for photography, but it stands out best when taken from below the terrace against the sky.

Pavilions are not quite so romantic as temples, but the same principles apply to their photography. A pair of stone pavilions are a major feature of the large formal garden of Luton Hoo. An unusual pavilion built in 1956 is the Peacock Pavilion within the Child Beale Wildlife Trust Reserve outside which is an array of statues including a fountain of giant frogs and an orchestra of monkeys.

Follies, grottos and ruins

Some follies resemble temples, but usually the latter are classical ornaments whereas follies tend to be more eccentric, taking on any shape from a column, a pyramid, a tower, a pagoda – even a sham castle. The eighteenth century saw the heyday of follies, but as they were usually built well away from the house many have been vandalised. The bizarre frivolity of follies means that precise camera positioning is not as important as for temples. In fact, eccentric camera angles and dramatic lighting can portray the zany character of many follies.

Dozens of Chinese pagodas sprang up in Britain in the eighteenth century. The most famous – and indeed the first in Europe – built in Kew Gardens was designed by Sir William Chambers, reaches almost 50 metres

in height. In the water garden at Cliveden, is the chinoiserie pagoda made originally for the Paris 1867 Exhibition. The Chinese pagoda – complete with fountain – at Alton Towers is illustrated on page 92 and described on page 93.

In complete contrast to the formal symmetry of pagodas, man-made grottos most simply imitate natural rocky caves. Lightweight tufa was often used for their construction, so that a view from within such a grotto looking out into the garden was framed by jagged tufa rock. One of the most complete surviving grottos is at Stourhead where a long tunnel, intermittently pierced along roof and walls for the sun to spotlight the interior, leads to a subterranean hall lined with tufa. There the Nymph of the Grot stands guarding the source of the River Stour and further on is a magnificent statue of the River God. The eighteenth-century grotto at Powerscourt in Ireland is unusual in being constructed of petrified *Sphagnum* (bog moss) found on the banks of the River Dargle. Other more elaborate grottos extend below ground into labyrinths profusely decorated with shells or minerals. In the garden of Goldney House at Clifton in Bristol is one such grotto, which now has to be kept locked to prevent vandalism. Here a Neptune reclines at the head of a resounding cascade falling into a lavish interior encrusted with exotic shells, ammonites and corals. I noticed stag's horn coral was displayed high on the wall skilfully emulating deer antlers.

Lit by artificial lights at the far end of a cascade, water gushes form Neptune's urn inside Goldney Grotto, Bristol. A long focus lens and artificial light colour film were used to take this figure framed by the unlit rock.

If a grotto or folly is lit with artificial light it should be taken on artificial light colour film, or on daylight colour film using an 80A filter on the lens to correct the colour balance (page 31), or by flash. Any openings which let in daylight will come out an eerie blue on artificial light film. A useful technique for lighting dark areas with a single flash is to repeatedly fire the flash while the shutter remains open. The camera is mounted on a tripod and the shutter kept open by using the B setting and a locking cable release. Known as **open flash** this method literally paints light onto a stationary subject. Each time the flash is repositioned a black card is held in front of the lens and removed before the flash is manually fired.

Equally spectacular are grotto rooms. A well-preserved early seventeenth century example is at Woburn Abbey where the walls are covered with shells laid out in intricate patterns and mosaics.

Ruined buildings, both genuine and contrived, can produce an atmosphere of classical decay if complemented with subtle plantings or a rambling invasion of natural vegetation. Old Scotney Castle (page 8) must be the most picturesque of all ruins, whether viewed from the bastion lookout, or from the bridge across the moat. Built in the late fourteenth century, the castle was partially demolished during the period 1835–45 to create a romantic focal point for the garden. On a cloudless July day, black swans were weaving their way among the white water lilies in the moat, and the castle walls were bedecked with old roses. I photographed the castle from the moat bridge using a wide angle, a standard and two telephoto lenses. I prefer the pictures taken with the wide angle and standard lenses, because they combine the foreground interest of the water lilies with the castle behind.

Compared with the carefully preserved part of Scotney Castle, Fountains Abbey in Yorkshire, built in the twelfth century, appears delapidated, but it is the stunning focal point of a 'surprise' view from Tent Hill on a woodland walk in the garden of Studley Royal. This landscaped garden – now in need of urgent repair – was conceived by John Aislabie in the early eighteenth century, 40 years before Stourhead was created. In 1768 his son, William, bought the ruins, to complete this ambitious garden design. Another splendid architectural vista in Yorkshire is the view down from the elevated Rievaulx Terrace to the medieaval ruins of the Abbey.

Once gothic buildings had become popular in British gardens, their ruins – both real and sham – came into vogue. Weathered ruins also provide scope for taking close-ups of ferns and flowers which have found a foothold among the bricks.

Bridges

A bridge did not have to be functional in a landscaped garden built on a grand scale, and was often purely of aesthetic value. Both the stone bridge at Stourhead – arguably the most photographed garden view in Britain – and the Palladian bridge at Prior Park (1755) give a false impression of spanning a river. These bridges, and Vanbrugh's vast bridge at Blenheim, now partially submerged by the lake created later by Capability Brown, need to be photographed as part of the landscape and not in isolation. Therefore the picture should be composed so that the bridge neither dominates nor occupies the centre of the scene.

More modest bridges – both functional and decorative – are particularly

A long focus lens was used to show this magnificent Palladian bridge (c. 1755) in the landscape at Prior Park in Bath. Nestling in the valley bottom, the bridge is lit directly by the sun for only a short time each day and it took three visits before the bridge was found to be perfectly lit.

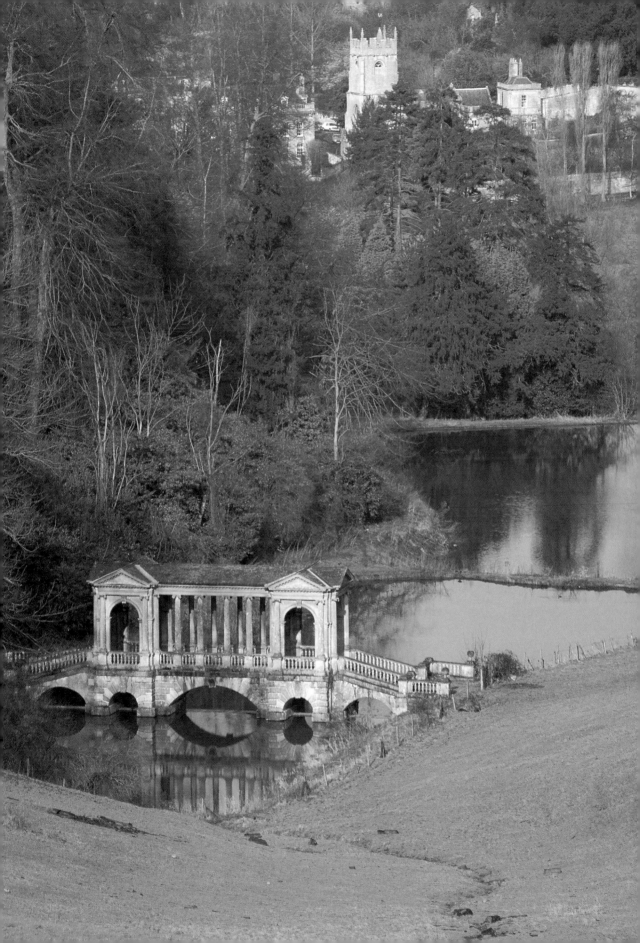

worth photographing, when the water surface is calm and the bridge is mirrored in still water (page 121). Curving wooden bridges are a regular feature of Japanese water gardens; most are small, but the arched bridge which links the Shinto Temple with the Japanese garden at Tatton Park is large enough to frame a view through it. The attractive white Chinese bridge spans the water of the lake at Pusey House so closely that it almost coalesces with the water lilies beneath; its pointed finials add depth to its mirrored reflection.

Statues and sundials

The most photogenic garden statues are those which either form an integral part of the total landscape, or are part of a more intimate garden design. In the heyday of formal gardens, a building or statue was invariably sited as an eye-catcher at the end of an *allée* or an avenue, as can still be seen today at Rousham and St. Paul's Walden Bury.

Both classical and modern figures are often incorporated as fountains in water gardens. Many of the jets which play in the formal water gardens at Petrodvorets (Peter the Great's Summer Palace) arise from classical gilded figures, while in smaller gardens an animal or human head is a typical spout for a wall fountain. For these the lighting of the water (page 93) as well as the figures must be considered. Wall-mounted fountains or statues in niches will only be lit by the sun for a limited time each day. The background to statues set into niches is important, for example, figures set into the curving hedge of golden yew at Easton Neston stand out well, whereas stone figures mounted in front of stone walls tend to merge in with the background.

William Kent, the first landscape architect in England, was originally trained as an artist and he appreciated that the land beyond garden boundaries could be an integral part of the pictorial scene. Rousham, designed in the late 1730s is the best surviving example of a Kent landscape. The walk is a series of surprise views each with a focal point of interest. Here there are plenty of opportunities for photographing classical statues reflected in water, framed in trees or set against an Oxfordshire rural landscape.

Other gardens where statues are featured can be seen at Waddesdon Manor, Polesden Lacey, Newby Hall, Hampton Court, Anglesey Abbey and Hever Castle. Statues are also featured at Athelhampton, renowned for its architecture and formal gardens. The lawn between the house and the river is dominated by a dovecote large enough to accommodate 1,500 nests. Collections of modern statues are also sited at Sutton Manor Arts Centre and at Dartington Hall.

Before photographing a free-standing statue, walk right round, note the way light and shadows fall on it and, at the same time, appraise the background. If there is only one viewpoint incorporating a good background, choose the time of day to photograph when the lighting best models the statue.

On stone ornaments and statues, yellow lichens and green mosses often provide the only splashes of colour. Garden gnomes, although not in the same class as statues, must appeal to a wide public, since some 25,000 visitors converge annually on the Gnome Reserve in Devon to view the 1,500 gnome inhabitants in their woodland setting.

Sundials, like bridges, may be purely decorative or functional, or both. A pedestal sundial with an ornate brass or copper plate engraved with the hours needs to be photographed from above, but even then, only part of the plate or dial will be sharply in focus unless the lens is stopped down to a small aperture. The upright pointer or gnomon, on the other hand, will show up more clearly if it is photographed either low down from the side to isolate it against the sky, or from above using surrounding grass, gravel or stone as the background. A house behind a sundial will make a confusing background, unless it is thrown completely out of focus.

The pointer of a vertical sundial mounted on a column or wall will be difficult to see unless it is photographed when the sun is casting an obvious shadow. At Packwood House, several wall-mounted sundials can be seen, including one dated 1667. Stone and wrought iron were used to build the unusual combined weathervane and sundial which stands in the forecourt of Newby Hall. An intriguing, although certainly not beautiful, sundial in the form of an obelisk can be seen in Drummond Castle gardens. It has 63 faces, 53 with gnomons. The date of this unique sundial which tells the time in most European capital cities, is usually quoted as 1630.

A circular peep-hole perfectly frames a statue of a discus thrower at Polesden Lacey in Surrey. The winter light enhances the colour contrast between the bare brickwork and sky.

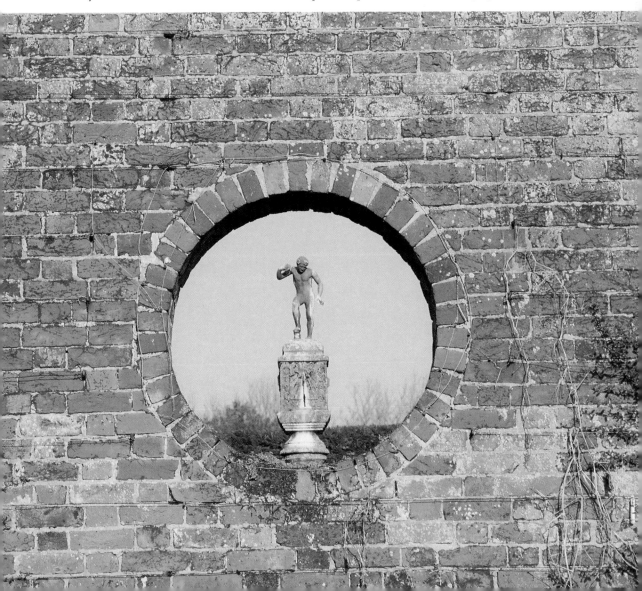

At Hever Castle a gilded astrolabe – a device used to study stars – has been converted into a sundial by the addition of a numbered band. An intriguing modern dial is the Silver Jubilee Sundial outside the National Maritime Museum, Greenwich, designed by Christopher Daniel. A pair of bronze dolphins sculptured by Edwin Russell is positioned so the tips of their tails almost touch to form the gnomon. The time is read by the point of sunlight between the tails projected onto a curved dial plate, and is accurate to within 30 seconds.

Gates and frameworks

Solid wooden gates prevent outsiders from viewing a garden whereas wrought or cast ironwork allows a tantalising glimpse of the garden beyond. Inside gardens, ornamental iron gates can be an attractive feature, and if they are left slightly ajar they lead the eye on through the garden. A good way of emphasising ironwork is to photograph it against the light so it is completely silhouetted. If this is not possible, try to throw the background out of focus, otherwise it can confuse the design of the gate.

Wrought iron gates and railings are a feature at Melbourne Hall where a magnificent birdcage arbour designed by Robert Bakewell is sited at the end of the main axis extending from the house. The arbour, painted in black and gold, provides a splendid subject for photography, viewed from either outside or inside looking up through the domed top. Ornamental gates also feature in Powerscourt Gardens, outside Dublin, together with a fine collection of European statuary.

Pergolas

The pergola was originally used in Italy to support vines and lemons to provide a shaded walkway in the hot Mediterranean climate. In cooler

A gilded astrolabe at Hever Castle has been modified for use as a sundial. Morning winter sunlight spotlights the circular bands against the castle wall in shadow.

climes the pergola is more ornamental, consisting of a series of arches made of wood, stone or brick uprights with wooden cross beams used to display climbing plants.

A huge 70-metre-long pergola can be seen in the Lutyens/Jekyll garden at Hestercombe, now owned and painstakingly restored by the Somerset County Council who received a European Architectural Heritage Year Award in 1975. It forms the southern boundary to the main formal garden, beyond which lie the fields and woods of Taunton Vale. The design of this pergola – like all those built by Lutyens – is robust. The upright supports are alternating round and square pillars of slivered stone, topped with oak cross beams. The original vines and forsythia remain, but other climbers such as roses and clematis were planted in 1976. The extent of this pergola in relation to the design of the main garden, known as the Great Plat, can be photographed from the terrace below the house, but a more dramatic view is looking inside along its length because the pattern of the wooden beams is repeated by their shadows cast on the flagstones below.

An open pergola lets in light along its length and so leads the eye towards a focal point of a seat or statue at the far end. A closed pergola covered with climbers will cast a more or less continuous shadow along its length, so that the only scope for photography is from outside and then, a single column clad with colourful blooms can be set off against the sky.

House and garden

As well as garden architecture and ornamentation the house itself can add interest to garden photographs. It can be framed by a cedar tree or a wrought iron gate, reflected in a pool or used to provide a contrasting background for a dramatic flowering shrub. Both colour and texture of the house can enhance a good garden picture – evergreens against a pink-washed wall or red-leaved maples backed by grey stone. In Chinese gardens with the emphasis being architectural rather than horticultural, the house and garden merge into one.

Even in the garden of a small modern house there will be scope for combining a picture of both house and garden. Looking up towards the house from the front gate will be an obvious viewpoint; more interest may be gained from a different angle by emphasising a small tree or clump of flowers. If the house and garden are equally lit, there will be no problem about deciding the correct exposure, but if the house is lit by low-angled sun and the garden is in shadow, expose correctly for the house so that it stands out clearly from the surrounding under-exposed garden.

Architectural features once positioned in a garden are reasonably permanent; they therefore make a more positive statement about the taste of the garden designer than the choice and positioning of the plants which constantly change as they continue to grow. The form of any particular type of tree even if it is modified by the elements, is consistent, whereas the form of a specially commissioned – as opposed to a mass-produced – architectural feature is unique and therefore needs careful thought for its photography. The enjoyment of gardens and the time spent photographing them can be greatly extended by encompassing garden art and architecture.

12 Town Gardens

Atiny town garden will require as much, if not more, care in its planning as a large country one and often very high standards are reached. Under constant survey, there can be no obvious eyesores and no wasted space, so here I have concentrated on small urban sites, since the techniques for the photography of larger town gardens will be similar to those in any reasonably sized one.

Anyone who has tried to photograph in small gardens will know how difficult it is to do them justice. So often there is simply not enough space to increase the field of view by moving backwards without coming up against a wall, a shed or even the house. There are two solutions to this problem: either use a wide angle lens or look for ways of getting up above ground level. A step-ladder has the advantage of being portable, although it may not be high enough, whereas a flat-topped roof of a shed or a garage can be ideal for viewing a small town garden (page 15). An easy alternative is to look down onto the garden from a room above ground level (page 74).

The majority of town gardens are tucked away out of sight to all passers-by and it is often only window boxes which provide a welcome splash of colour. However, many prize-winning gardens are on show during the London Gardens Week – an annual event organised by the London Gardens' Society and held in June.

The odds of finding an attractive town garden purely by chance – as a cottage garden down a country lane – will be slim, although it can happen. For instance, someone just beat me to a convenient parking place near Oxford Botanic Gardens forcing me to park much further away, and there just a few metres from my car I found a tiny gem of a pavement garden which is reproduced here. Often the only opportunity for discovering and gaining access to an enclosed town garden is by knowing the owner.

Patios and courtyards

The patio originates from Spain where it is strictly an inner courtyard open to the sky, enclosed by four walls of the house – a secluded, intimate place. Nowadays though, the word is used very loosely by estate agents to describe any paved area in a garden – whether it be a terrace or merely a few paving stones.

It is not difficult to find attractive courtyard gardens in the south of France, and in Spain and Portugal, where earthenware pots are often used to provide additional colour. In more formal courtyards there may be a pool, with perhaps a fountain. The Moorish gardens of the Generalife Palace at Granada in Spain abound with hidden water courts where water is channelled along canals and fountains play. In the 45-metre-long *Patio de la Riadh* (Courtyard of the Pool) curving water jets fall into a central canal

A pavement garden in Oxford with a Mediterranean micro-climate has been planted with harmoniously coloured flowers and foliage.

bordered by flower beds. This famous courtyard can be photographed from an elevated position in a surrounding building, or from ground level. The high viewpoint shows the overall plan of the courtyard, while the low viewpoint dramatises the exquisite water archway. Ways of photographing moving water are described on page 93.

White-washed walls, much favoured in Spanish and Mexican court-yards, certainly help to set off the rich coloured bracts of bougainvillea or a flowering jacaranda, but they always create problems for colour photography on a sunny day (page 66). Patios with white stone or marble floors resemble Japanese white sand gardens and snow-covered ground in the way they reflect light up onto the plants, and when viewed by a full moon the main garden features are clearly distinguishable.

More than once I have walked into a small patio garden and not immediately been able to see an obvious viewpoint for a picture, then as I began to walk round noting focal points of interest such as a shrub or tree, a statue or fountain, a picture was revealed. The problems associated with the photography of walkways and walls are equally applicable to patio photography where the difficulties are often compounded by the small working area.

Narrow patios and dark alleyways which are enclosed by high walls tend to look very dull when most, or all, of the area is covered by shadow. However, on an overcast day the whole area will be more evenly lit and plants will provide good colour contrast to concrete, stone, brick or woodwork.

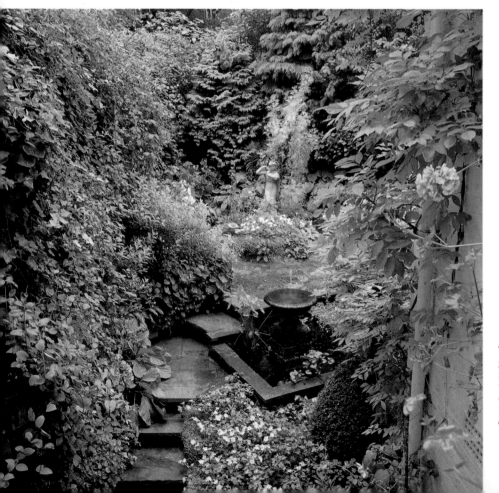

This view of a small London garden was taken from a first floor balcony with a wide angle lens so that most of the features, including the fountain and statue, could be seen.

A collection of plants in pots, grouped together on the patio of Beth Chatto's expansive Essex garden, illustrate the importance of choosing the right combination of colour, shape and texture.

Often the only way to include most of the patio area is to stand inside a room leading onto it, looking out through an open door or window. A bare patio filled solely with garden furniture is hardly worthy of a photograph, but a few strategically placed pot plants and maybe some water-worn stones can make a focal point in a dull corner. Containers (page 131) are also useful for blotting out fixed eyesores such as rusty drainpipes or broken tiles, but remember that if a long-established container is moved, it may reveal a tell-tale mark on the patio which can be even more distracting. By including the curved lines of a pool, lawn or flower bed beyond the patio, the scene is varied from the inevitable straight lines of surrounding walls or fences enclosing a narrow garden.

Patios also provide scope for taking detailed close-ups of textured pavings (page 71). A monotonous surface may be relieved either by replacing a slab with a prostrate plant or by sinking a small bed so that colour rises up to ground level. Thus a variety of texture and colour interest is added to the area – particularly useful if the patio belongs to a bungalow, where low horizontal lines are maintained.

Sometimes, advantage can be taken of an overhanging tree from a neighbouring garden. The owners of a delightful small London garden managed to persuade a neighbour to plant a *Robinia pseudoacacia* 'Frisia' precisely so it complements and completes the picture from *their* aspect!

Photographs of patios and courtyards can be taken in winter – or at any time of year by a handicapped person – from within a room overlooking the garden. If the window is closed, make sure the glass is clean and hold the camera as close to it as possible so as to avoid getting your own reflection in the glass. Modern plate glass is preferable for photographing through, since old leaded glass often has imperfections in it. Never use a flash on the camera to photograph through glass because the flash will be

reflected off the glass back into the camera. If a flash is required it can be set up on a stand in the garden to photograph birds feeding at a bird table, or drinking and washing in a bird bath and the camera still operated from indoors. A reflector or a second flash will help to fill in the shadows cast by the single flash.

Roof and sunken gardens

Whenever I climb skywards to work in a roof garden, I appreciate that the effort required to carry tripod, cameras and reflectors up onto a roof is nothing compared to the energies required to get bricks or stones, containers and soil – not to mention the plants – up to a garden in the sky. The rewards for these toils however, are great, for in the heart of a city a roof garden is like an oasis in a desert. One of the most spectacular and famous of all London's roof gardens is landscaped six floors up on top of the old Derry and Toms department store. When it opened in 1938, this 0.6 hectare site was the largest and highest roof garden in the world. Three quite separate gardens have been created here: a Spanish courtyard with fountains; a Tudor garden; and a woodland garden complete with stream and waterfowl – including flamingoes. The historical importance of the garden has been recognised and it is now protected by a preservation order which requires the owner to keep it maintained. A roof-top garden of this size provides plenty of opportunity for taking varied photographs in good lighting, with or without a city skyscape as the background.

Euphorbia myrsinites thrives in a terracotta urn on a London roof top garden. The split bamboo fence protects plants from the gusting winds and provides a neutral background.

Small roof gardens, on the other hand, constructed on top of a detached town house, are difficult to take well, because it is impossible to look down on them and often there will be no choice of viewpoint. Many photographs I have seen of roof gardens are highly distorted circular images taken with a **fish-eye lens**. Without such an ultra wide angle lens, it may be impossible to include the whole garden in a single picture, although I have managed to back away by climbing onto a fire escape or a neighbouring roof. Where present, chimney pots can provide a useful vertical element to a picture.

Roof gardens on high-rise blocks are likely to be much breezier than gardens at ground level, and adjacent buildings will create updraughts and downdraughts. Fences and screens help to reduce wind damage to plants and movement when taking photographs. Latticework or split bamboo screens are better than solid walls which tend to create swirling eddies.

Part of the original cascading roof gardens extending down over six floors of the old Wiggins Teape building in Basingstoke can be seen and photographed from the road, whereas the cascading gardens completed in December 1982, were not visible from the road a year later. The foliage in the latter garden has been selected to complement the cladding of the building. The very limited soil depth of these gardens provides localised soil pockets each with a varying pH allowing a wide range of plants to be grown in this carefully controlled ecological environment.

Small sunken front gardens set below street level present similar problems for photography as small roof-top gardens since both offer a restricted working space for a camera. This means that a wide angle lens will be essential for showing the entire area when standing looking down from street level. In addition, the four enclosing walls cut out light from any direction so that sunken gardens are invariably in shadow or are poorly lit. A long exposure will therefore be essential when using a small aperture to ensure the entire depth of the garden, from the floor of the basement up to the top of the wall, appears sharply in focus.

Tubs, troughs and urns

Plants in containers are always popular where space is limited in town gardens, and flower beds are a rare luxury. They help to break up a formal paved expanse and can be used to decorate any hard surface.

For centuries, market gardeners in China have grown flowers and small trees in pots, supplying customers with a succession for decorating house and garden all year round. Chrysanthemums and cymbidiums are amongst the most favoured flowers and their plain, grey clay pots are often slipped into most beautiful ceramic containers. These, placed strategically in courtyards and corridors, on low tables or walls, are readily accessible subjects for a camera.

In Britain, perhaps on a patio of a tall town house, plants of architectural value, notably *Yucca filamentosa* or the maidenhair tree *Ginkgo biloba* – which thrives in a city environment – can be individually featured. Foliage shrubs and trees, particularly evergreens, can be grown in large containers and used as a backcloth for offsetting seasonal bulbs or annuals. Roses grow well in pots, provided they have good drainage, and are fed and watered regularly. Miniatures are becoming increasingly popular and grouped in pots they provide lasting colour interest, while larger bushes and even

climbers can be grown in urns and tubs of appropriate size. Fruit trees, especially if trained as standards or pyramids, make attractive container subjects. Another useful contribution to a patio is a collection of herbs grown in an earthenware strawberry pot with some 12–16 planting holes – each plant providing a separate close-up facet for the photographer. This also applies to sink gardens, popular containers for growing alpines, discussed on page 112.

The main advantage of containers, so far as photography is concerned, is that if the background is not harmonious another may be selected simply by moving the pots around. When made of light-weight plastic or reconstituted stone they are easy to manoeuvre, but if castors are fixed to the base of heavier tubs or troughs, they can also be readily moved not only by the photographer, but also by the gardener for repositioning in sun or shade. Troughs are like free-standing window boxes which look equally well when placed on the ground or on the top of walls.

Decorative pots and urns, especially if they are old, are worth featuring and this is easily done if they are situated above ground or on the edge of a raised bed where, incidentally, they are well-placed for disabled gardeners to tend or photograph them. A low camera angle, however, will be needed to show to best advantage containers resting directly on the ground. On a bright day, plain shiny pots will be highlighted by the sun and this will detract from the plants themselves. They are then best taken either from a high viewpoint looking down onto the plants or, after rearrangement, with their sides camouflaged by other pots. Low saucer-shaped containers can be hidden by taking a picture from above, when the plants will completely fill the frame, without any trace of the container being visible.

The colour of pots – especially terracotta ones – becomes intensified when wet. This can always be achieved by using a watering can or a hose, but it will not look authentic unless all the patio area appearing in the photograph, is also wet. It is much easier and less time consuming to wait until after rain has fallen over the whole garden before taking a picture.

Large-scale containers used for enlivening public walkways and plazas provide lots of scope for photography. Although the containers cannot be moved it is usually possible to walk all round them to assess the background. Sometimes it is possible to include a well-known landmark in the background so the location is immediately recognisable. I did this with a large diameter container some distance from London's Tower Bridge, by moving a wooden bench so I could look through the camera mounted on a fully extended tripod. Using a long focus lens I was able to get the bridge directly behind the container to produce an integrated picture. On the other hand, if the background is unattractive, try to exclude it from the picture. This can be done by isolating tall canna lilies, standard fuchsias or geraniums against the sky, by crouching to photograph them from below.

Window boxes and hanging baskets

Window boxes are often the only hint of a garden in a high-rise flat, and it is noticeable when driving around London how the plantings vary from tatty ivy to a splendid array of foliage and flowering plants. There are firms employing armies of people to tend window boxes on commercial buildings, replacing the spring hyacinths with the ever-faithful geraniums and, come the end of the summer, substituting these with chrysanthemums or

orange-fruiting solanums. Huge water tankers are used to water the boxes early in the morning before the traffic builds up.

Nowadays, garages and public houses are also often enlivened by bright flowers in containers. Driving north from Oxford my eye was caught by a mass of petunias planted in a manger outside a public house, but when I looked through the camera the background was confusing, and it was only when the kind publican provided a beer crate for me to stand on, that I could set the flowers off against a strip of grass.

Window boxes are of course displayed at varying heights so care must be taken about the camera angle used to photograph them. It is important always to try to avoid tilting the camera, since vertical lines of doors and windows will then converge. Flowers in low boxes are easily seen from the ground, but when they decorate upper floor window-sills only a fringe of foliage may be visible and they need to be taken either by looking across at them from an opposite building or from inside the room or balcony they

A famous landmark, such as Tower Bridge, immediately identifies the location of a town or city picture. To get the canna lilies providing foreground colour to the bridge, I had to stand on a seat and use a long focus lens.

decorate. High rise window boxes on the London Shell Building can be photographed on their level from the elevated footbridge to Waterloo Station. This viewpoint also shows the excellent siting of many planted tubs as well as an ambitious town planting in an enclosed ground level courtyard.

Nearby, there is a good view from Westminster Bridge of the landscape deck beside St. Thomas' Hospital on the South Bank of the Thames where I took the picture of the kinetic fountain reproduced on page 86. A more extensive London water garden can be seen in the Wallside development adjacent to the Barbican Centre. Here it is possible to photograph a lake planted with water lilies by walking around the margins or by looking down on it from a raised terrace.

A front door, wall or fence enlivened with hanging baskets planted with trailing ivies, lobelias and nasturtiums as well as pendulous fuchsias, ivy-leaved pelargoniums and begonias, can be photographed, if necessary, from below as there will be plenty of interest from this viewpoint. Like a tub, a hanging basket can be positioned for viewing against any background or at any angle to the light, so that it does not have to be photographed during a limited period of the day. In a prolonged dry summer hanging baskets soon dry out, and many a time I have stopped the car when I was attracted by baskets seen from a distance, only to find on close inspection some of the plants shrivelled up and dying.

Allotments

The concept of allotments date back to 1629, when a plot of land was allotted either to a person or for a specific purpose. Under the 1908 and 1950 Allotments Acts, the borough, district and parish councils are obliged to provide allotments if six ratepayers or registered parliamentary electors apply for them, providing suitable land can be found. Today, allotments are usually rectangular plots measuring some 27 by 9 metres. The steadily rising price of vegetables has led to a renewed increase in the popularity of allotments. It is unlikely that many people will have an urge to photograph them, but competitive gardeners often want a permanent record of prize specimens. If the picture is to be used as evidence for obtaining an entry into the *Guinness Book of Records*, some obvious scale such as a hand, a person or a measuring rule needs to be included for comparative size.

General views of any allotment will, inevitably, include other plots, which may not be quite so orderly, so unless a record is desired of the planting pattern it will be better to concentrate on close-ups. However, rows of high-growing plants such as runner beans may be used as a background screen to hide an unwanted or untidy background. Courgettes, marrows, pumpkins and strawberries which grow on, or close to, the ground, can be photographed from overhead without the problems of confusing backgrounds, although it may be necessary to tie back any leaves which obscure the fruits or vegetables.

No consideration need be given to the background when close-ups of fruit and vegetables like raspberries or tomatoes and solitary blooms such as dahlias fill the frame with surrounding leaves. After pulling, root vegetables can be laid out on soil to be photographed. Make sure to take only perfect specimens, since any blemish caused by insect or fungal damage – however small – will be an irritating eye catcher in a picture, as

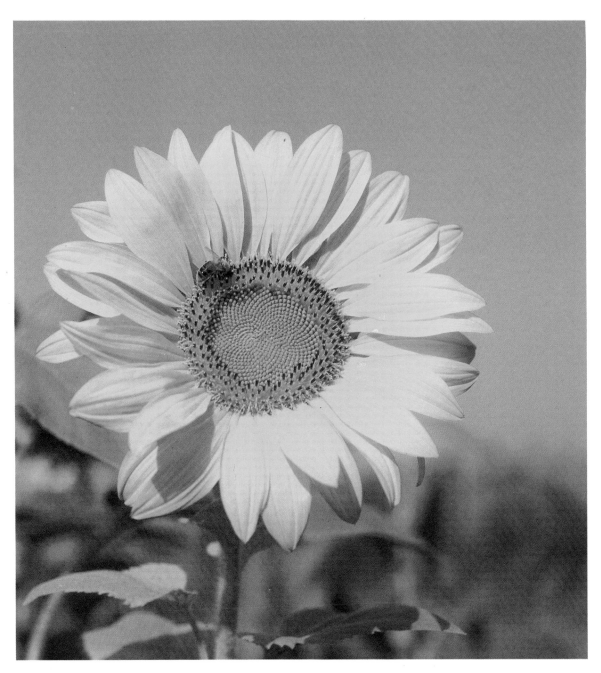

A low camera angle has isolated this sunflower, growing in an allotment, against the sky. The foraging bee was an additional bonus.

well as reflecting on the care and ability of the gardener. Chrysanthemums and other robust flowering plants, as well as climbers like sweet peas, can be photographed from a low angle looking up towards the sky.

Photographs of urban gardens are rarely featured in profusely illustrated garden books. Somehow they cannot be seen to compete with wider vistas and this is a pity, because town gardens have an intimate charm of their own. The close proximity of each part means that the interplay of contrasting textures becomes much more obvious and with the use of plants in containers the scene can so easily be dressed anew according to the season.

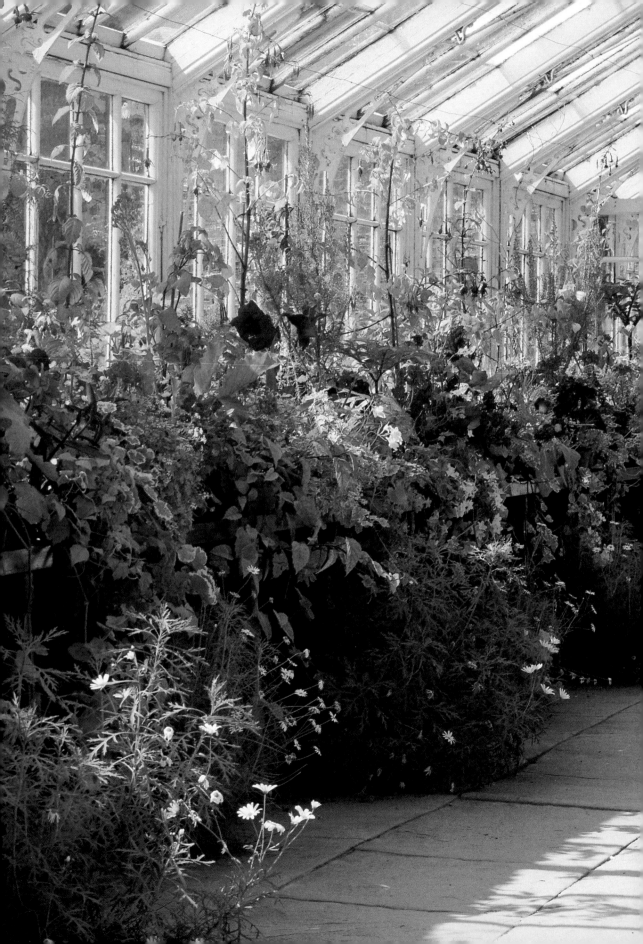

13 Under Glass

Today's modern glass-houses offer opportunities for taking pictures of exotic plants that are unable to survive out in the open. Unlike the original architectural glass-houses, they are functional but have little aesthetic appeal; possible exceptions being the extensive Exhibition Plant Houses opened in 1967 at the Royal Botanic Garden, Edinburgh and the three space-age geodesic domes of Mitchell Park Conservatory at Milwaukee in Wisconsin.

Heated glass-houses permit tropical and subtropical plants to be grown in cold climates and indigenous plants to be grown out of season, while cold ones allow temperate plants to be grown in the tropics. Glass-houses isolate plants and the photographer from the outside weather so come rain or shine they provide opportunities for photography. Larger glass-houses, attractively landscaped inside with rocks and water, are more photogenic than houses where potted plants are laid out on benches.

Glass-houses developed originally from moveable constructions used to protect citrus trees in winter and, because they housed these tender evergreens, came to be known as greenhouses. Gradually they were used more and more for propogating and growing the more delicate plants, for display in conservatories near the house.

Flaws in old thick glass tended to focus light, thereby causing scorch marks on plants, so that the production of thinner, better quality glass and the designs of houses featuring sloping glass roofs or walls greatly improved the efficiency of glass-houses at gathering warmth from the sun's rays. The repeal of the Glass Tax in 1845 (reducing the price by 85%) led to a boom in the construction of glass-houses and conservatories in Britain, some developing into winter gardens providing a complex of accommodation for pleasurable pursuits.

Glass-house exteriors

The most striking pictures of complete glass-houses from outside are those in which the glass is shown in maximum contrast to the framework, invariably painted white. The design of the framework can be much better appreciated when the glass panes are dark and none of the plants inside are discernible. Overcast days are therefore best for taking glass-house exteriors. Even then, take care to avoid camera angles which result in distracting reflections such as white clouds appearing in the glass. Pictures taken with a low-angled sun behind an all-round glass-house will reveal the plants as ghostly silhouettes. Free-standing glass-houses can be viewed from any angle, whereas orangeries or conservatories built along a wall can be photographed only from a limited number of angles.

Avoid tilting the camera up towards the sky otherwise the verticals will

Photographing the conservatory interior at Wallington in Northumberland was almost unbearable during the summer 1983 heatwave. Back-lit by sunlight shining through the plain glass, the container-grown plants on the staging grow down to meet the plants growing up from floor level.

137

converge (page 66). Notable examples of nineteenth-century glass-houses include the Great Palm House at Kew, and the huge Temperate House built during 1860 to 1899, and reconstructed in 1982. There is also Syon Park's Great Conservatory (1820–27) close to London's River Thames, the Curvilinear Range (1843–69) in the National Botanic Gardens at Glasnevin in Dublin and the Kibble Palace (1865–73) in Glasgow Botanic Gardens. The latter was designed and built by John Kibble as a conservatory to his house, but later moved to the Botanic Gardens and enlarged. Its aerodynamic shape has protected it against the gales which have badly damaged other glass-houses in the Gardens. Kibble was not only an engineer and botanist but also a photographer. He built a huge camera which took photographs measuring 90×110 cm.

Syon Park's Great Conservatory is an impressive building designed to combine an orangery with a conservatory. Built of gunmetal and Bath stone, measuring 116 metres long, and covering an area of 278 square metres, its type and size is unique. The huge frontage makes it difficult to photograph the complete structure without a wide angle lens.

Smaller conservatories which are easier to photograph as a whole, include the orangeries at Hampton Court and the Royal Botanic Gardens, Kew both of which combine stonework with glass panes in the front. However, the Bicton Park Palm House (originally an eighteenth-century orangery) is a much lighter domed structure built leaning up against a solid back wall, presenting attractive viewpoints from both outside and within. Avoid bright sunny days for taking a skyward view through the palms, for the extremes of the sky and plants will be too great to expose both correctly on colour film.

Cool houses

Small greenhouses in private gardens offer limited room for working, and often the only viewpoint will be from outside the door looking inwards. Their small size also means that it is difficult to avoid getting the walls in the picture, unless flowers or fruits are taken filling the frame. Large glass-houses allow scope for both general views and close-ups.

Permission may have to be sought in advance for working in any public glass-house; for example, the Royal Botanic Gardens, Kew allow photography inside houses on Friday afternoons and then by permit only.

There will usually be enough daylight for photography except on very dull days or where a lush vegetation canopy lines the entire glass roof, then it may be better to use flash. With no troublesome draughts to shake the plants, I usually prefer to use a long exposure without flash, often using a reflector beneath the subject to bounce back some of the overhead light. The diffused light of a slightly overcast day is best for photography in a glass-house because it does not cast strong shadows of the supporting structures. If the glass has been whitewashed to reduce the strength of sunlight, it acts like a diffuser and makes photography easy even on a sunny day.

Before taking close-ups, check that there are no unsightly blemishes on the leaves, caused either by evaporation of hard water or by an insecticide spray. As with outdoor plants, the ravages of pests and diseases can spoil a photograph unless it is specifically taken for identification. Many pests such as scale insects and red spider mites need to be photographed several

times larger than life size by using either extension tubes or bellows and preferably a flash.

Cool glass-houses such as vineries, alpine houses and unheated prop-ogating houses are used for growing a specific kind or group of plants. Vineries were often built leaning against the wall of a house and those which remain today offer much the same scope for working under glass as the conservatory (page 144).

Alpine houses provide wonderful opportunities for photography, espe-cially during the winter when the choice of garden subjects is limited. The traditional alpine house, with a central path between parallel flat-topped benches can be seen at Wisley and in the old alpine house at Kew, where plants are displayed in pots and pans on top of the staging. Such houses can provide a continuous attractive display, simply by frequently changing the exhibits. However, it is virtually impossible to take a photograph without the edge of a pot showing in the picture unless the flower fills the frame. In the alpine house at Harlow Car, the pots are buried in gravel which makes a much more attractive background for photography.

Opened in 1981, the new Alpine House at Kew is a revolutionary design resembling a pyramid built on top of vertical walls, surrounded by a water-filled moat. Inside, most of the plants are grown directly in a landscaped rock garden including a waterfall, pool and peat bed, but a special feature is a refrigerated bench divided into two sections. At one end, a temperature of 0–9°C and additional lighting are maintained from May to October during the growing period for Arctic-alpines. Come the winter, they are kept in a dark store at −6°C. The temperature at the other end of the bench is 5°C at night rising to 21°C by day, additional lighting extends the day length to 12 hours to simulate natural conditions for equatorial montane plants.

Popular greenhouse plants are begonias, fuchsias, pelargoniums and

Miniature cyclamens growing inside the Alpine House at Harlow Car Gardens, Yorkshire were photographed using available light, with the camera on a tripod.

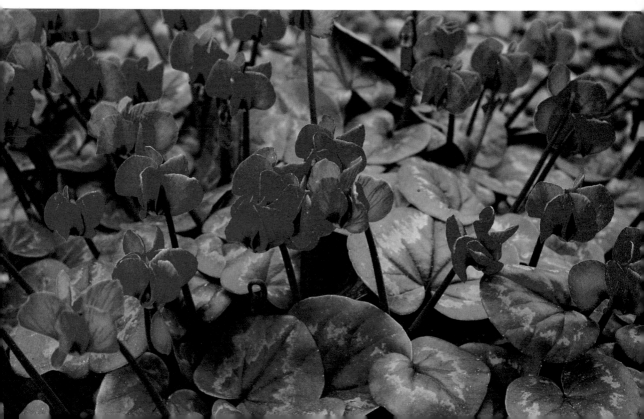

these, amongst others, are well-displayed in the spacious conservatory at Wallington. One of the fuchsias, 'Rose of Castile', dates back to 1908 and now has a thick, woody trunk. Flowers of other fuchsias were inaccessible so I used a long-focus lens with an extension tube to take them in close-up and exclude any distracting colours from the edges of the picture.

Glass ferneries became extremely popular in Britain during Victorian times and, although ferns are predominantly green, they are very photogenic, especially if a view can be found directly beneath the huge fronds of a tree fern radiating out from the central trunk. At Tatton Park, striking tree ferns *Dicksonia antarctica* reach the roof of the fernery and shelter smaller varieties beneath, and at Southport Botanic Garden ferns are planted amongst grottos, waterfalls and pools. Ferneries were also popular in Australia where they were known as shadehouses built with a timber lattice instead of glass. A huge fernery in the garden of Rippon Lea in Melbourne has now lost its wooden slats, but the iron framework remains.

In temperate regions, glass-houses are generally considered a means of protecting delicate plants from cold temperatures, but the prime function of the alpine house is to keep alpines dry in winter. In Singapore Botanic Gardens a cold house is used for growing temperate plants.

Heated houses

Houses in which a tropical heat is maintained might seem ideal places to work during a cold winter's day. However, a cold camera brought into a warm humid house quickly develops condensation on the lens and on the viewfinder. Any pictures taken through a steamed-up lens will look as though a soft focus filter has been used. Either the camera has to be allowed to warm up or, a warmed camera needs to be rushed inside. The problem will not arise on a hot summer's day, but I do not recommend photographing in tropical houses under these conditions, when the temperature is almost unbearable for any length of time. In modern greenhouses automatic sprinklers can create another problem by starting up without warning.

Tropical houses are well-worth visiting with a camera, to gain some insight of the rich diversity of tropical plants. Glass-houses, landscaped inside lend themselves to photography, such as the Tropical Peat and Rock Houses at the Royal Botanic Garden, Edinburgh where the paths weave around rocky outcrops enlivened with *Streptocarpus* and *Columnea*, and New Guinea rhododendrons and gingers. Trees and shrubs in the restored Temperate House at Kew Gardens can be seen at birds' eye level from the elevated walkway so the crowns of tree ferns and palms can be seen from above. There is also a raised walkway in Kew Palm House, but many of the palms are now so tall, they tower up to the roof.

There are large landscaped glass-houses in North America. In the spacious Azalea House at the Longwood Gardens in Pennsylvania, permanent trees and shrubs with pools and a waterfall are redressed each season when the beds are replanted; at Milwaukee on Lake Michigan the three glass domes separately maintain conditions simulating arid desert, tropical and temperate environments. The new tropical conservatory being built at Kew is an exciting futuristic glass-house where 10 different computer-controlled environments ranging from the Namib Desert, mangrove swamp, cloud forest and tropical pools will be housed.

Exotic close-ups

Among the many exciting subjects worth photographing in well-established tropical houses are orchids, aquatic plants, bizarre modified leaves of insectivorous plants, bromeliads and cacti. Whenever taking glass-house interiors always watch out for distracting backgrounds – windows, struts or even labels. A close-up of a large orchid bloom like Venus' slipper *Paphiopedilum* will provide more impact than a picture of a whole plant bearing a fine spray of flowers with a confusing background behind them. It is difficult to light the interior of deep-throated orchids unless they are front-lit by means of a ring flash mounted around the camera lens.

Many orchids live naturally by perching on the branches or in the forks of trees and when cultivated they are often bound onto branches or cork strips, so care must be taken to make sure there are no unsightly pieces of wire visible in the picture. These epiphytes do no harm to the trees, merely using them to gain a high-level site above the forest floor.

During the autumn of 1983, the orchid house at Wisley was re-opened after being completely re-organised. The rows of pot-grown orchids have

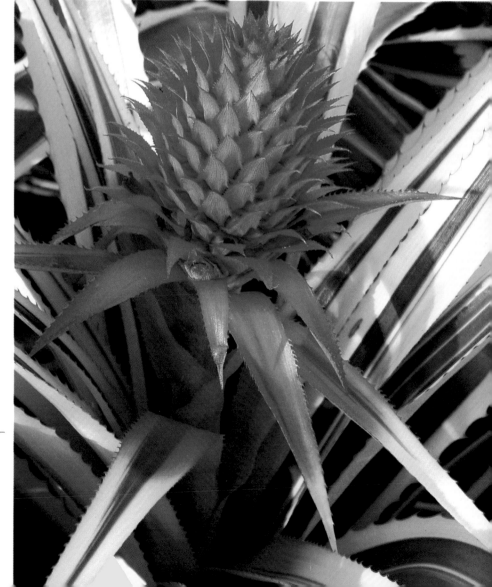

Ananas comosus 'Variegatus' – a spectacular relative of the pineapple – was taken inside a glass-house at the Royal Botanic Garden, Edinburgh. The variegated leaves offset the colourful flowering spike.

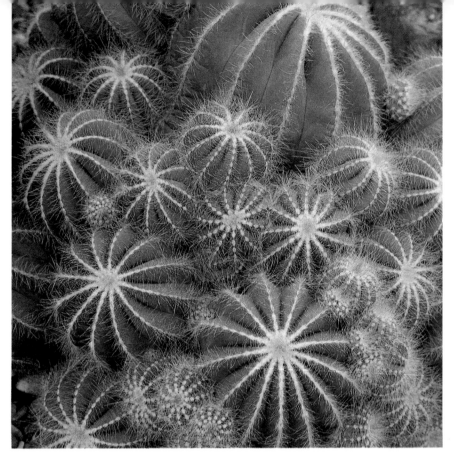

When a group of cacti, such as these *Nothocactus (Notocactus) magnificus* in Holly Gate Cactus Nursery, fill the frame, the background does not need to be considered.

been replaced with oak branches sunk into soil displaying the epiphytic orchids, while potted terrestrial orchids are now sunk into soil interspersed with ferns. A raised, fenced bridge winds through the glass-house allowing the epiphytic orchids to be viewed and photographed at eye level. The majority of orchids in the Wisley collection flower in mid-winter so that any time early in the year it is worth paying a visit with a camera.

Another interesting group of epiphytic plants are the bromeliads. Related to the pineapple, they perch on trees or rocks gaining moisture and nutrients from the air instead of the soil and many smaller varieties are marketed as airplants (page 144). Among the most attractive bromelaids are *Neoregelia* with colourful red bases to their leaf rosettes, while *Ananas comosus* 'Variegatus' produces a small red pineapple-shaped fruit in the centre of variegated leaves.

Other photogenic tropical plants include *Hibiscus* and the bizarre Bird of Paradise flower *Strelitzia reginae*. Both are best taken from the side to show all parts of the flower clearly. *Bougainvillea* produces tiny flowers in the centre of purple bracts – a difficult colour to reproduce accurately on colour film (page 39). Exquisite pendulous clusters of the wax flower, *Hoya*, need direct sunlight or flash to highlight their nectar drops.

All these flowers can be photographed with available light shining through a glass-house, but flowering vines which hang down beneath a dense leafy canopy may need flash not only to light them but also to stop persistent movement. The pair of pictures of the exquisite jade vine on page 28, shows how the whole mood of the picture can change by careful positioning of the flashes. The flashlit picture has also produced the more accurate colour rendering.

Insectivorous plants are always intriguing and displays are common in heated houses, including pitcher plants from both old world(*Nepenthes* spp) and new world (*Sarracenia* spp), sundews and the Venus' fly-trap. If pitcher plants are back-lit the level of water inside the leaf traps shows up as a darker area. Close-ups are needed to show the sticky hairs on a sundew leaf.

Glass-houses landscaped with cacti and succulents are always worthy of a picture, recently I have visited three contrasting ones, in Edinburgh, in Sussex and in Arizona. Within the Cactus and Succulent House at the Royal Botanic Garden, Edinburgh, plants from arid parts of the world are grouped according to their geographical region, and they range from large columnar cacti to succulents of all shapes and sizes. The low-angled winter sunlight back-lights the cacti beautifully, emphasising their spines. Small stone-like succulents (*Lithops*) need to be photographed from above and are best lit with either a high-angled sun or diffuse lighting. The subtle planting of these living stones or pebble plants makes it difficult to distinguish the plants from the stones! In their native South African deserts these pebble plants avoid browsing by herbivores not only by closely matching the surrounding stones but also by their mottled patterning disrupting their outlines. When photographing any subject – plant, or animal – which mimics its surroundings, natural light will give the most authentic pattern of light and shadow.

A much denser planting of cacti and succulents can be seen at the Holly Gate Cactus Nursery where 20,000 plants are landscaped beneath glass – too many to appreciate with just a single visit.

In the Desert Botanical Garden at Phoenix in Arizona, some cacti and succulents have to be displayed in shadehouses. The overhead slats used to restrict direct rays of the sun create regular shadow patterns preventing the taking of naturalistic pictures on a sunny day. This problem also arises in the Australian slatted shadehouses.

Birds and butterflies

In addition to plants, tropical birds housed in walk-through aviaries are an added attraction. They provide a rare opportunity for combining a flower with a bird in one photograph although reflexes must be quick if focus and exposure are achieved before a bird flies away. Chester Zoo is renowned for its botanical as well as animal collections. It has 70 species of free-flying birds in its tropical house opened in 1964, where sugarbirds, sunbirds, turacos and hummingbirds can be seen flying among lush tropical vegetation.

The London Butterfly House at Syon Park, opened in 1981, houses a permanent exhibition of free-flying butterflies from all over the world in landscaped tropical glass-houses. Food plants for both the larvae and the adults are grown and butterflies may be seen hatching from pupae laid out in the emerging cage, sipping nectar from flowers or basking on warm stonework. The butterflies seen on the wing constantly change throughout the year, so there are always new subjects worth photographing.

Many butterflies close their wings when they alight, but the beautiful South American heliconids display the patterned upper surface of their wings long enough to get a photograph. Providing the lens is at right angles to the outstretched or closed wings of a butterfly the complete wing

area should be in focus. Mating butterflies tend to rest more than solitary butterflies and so are easier to approach with a camera, particularly if a long focus lens with some extension tubes, or a 105mm macro lens, is used.

In the conservatory

A conservatory or sun-room is a useful place for photographing not only pot plants, but also detailed close-ups of individual blooms using either daylight, flash or artificial light (page 29). The pair of pictures on page 35 of a pot plant collection was taken in our south-facing sun-room, using reflectors to boost the natural light and black velvet as a background. Although black is unnatural, it is the best background for offsetting the shapes and colours of flowers and leaves. Sometimes I use a more naturalistic background by placing foliage behind the flowers or fruit being photographed, always avoiding anything shiny which will produce distracting highlights.

Airplants are easy to keep in the house and can look very attractive if displayed on a piece of driftwood or in a seashell. Fine-leaved forms in particular are good subjects for back-lighting against a dark background.

Conservatory-grown fruits, especially black grapes, will make a good picture if they are taken before the surface bloom is damaged. If the conservatory has a glass roof some of the overhead light can be reflected back onto the underside of a bunch of grapes or a ripe peach simply by holding a reflector beneath the fruit out of the field of view. With citrus plants it is often possible to include both flowers and fruits together in a single picture.

Another photographic use of a conservatory is for taking time-lapse pictures of seedlings germinating or of flowers opening. The camera must be mounted on a tripod and not moved during the series. The magnification will then remain constant so measurements can be made of the amount of growth between consecutive frames. When first setting up the camera remember to allow plenty of room in the field of view for a flower

Airplants *Tillandsia ionantha* and *T. caput-medusae* planted in barnacle 'shells' make an attractive conservatory display. These were photographed in my studio using two flashes, one to light the front and the other to back-light the larger plant.

A 'Duke of York' peach was photographed in a conservatory of a Yorkshire garden using a gold reflector to bounce back some of the natural light penetrating the overhead glass.

to open or a seedling to grow; if the frame is filled in the first picture, the subject will outgrow the field of view. Either a series of individual frames can be taken over a period of several hours or even days or multiple time-lapse exposures can be taken on a single frame, if you have a camera on which the shutter can be recocked without advancing the film. Using a Hasselblad camera I sketch the position of the subject on the viewfinder screen with a Chinagraph pencil to decide when the next picture is worth taking.

Wardian cases and bottle gardens

In 1829 Nathaniel Ward introduced his Wardian case, a miniature glass-house where plants favouring a warm and humid environment might be grown in dry or draughty rooms. They became extremely popular in Victorian times, particularly as fern containers. Some resembled small green-houses, while others were more ornate. These tiny glass-houses with straight sides allow attractive pictures of enclosed plants, unlike the curved sides of bottle gardens, much in evidence today, which distort plant shapes.

When photographing any plants contained within glass, make sure that the front pane is scrupulously clean. Reflections may appear in the front glass unless a mask of matt black card is attached to the front of the camera lens. Remember not to use a flash mounted on a camera when photo-graphing through glass (page 129) and spare some thought on where best to place a glass container so the background is harmonious.

Glass-houses are good places to try out a new camera in the winter months when the weather is not always conducive to outside photo-graphy. However, in all conditions and through every season gardens produce an endless supply of subjects for photography. From easy snaps to difficult set-ups, pictures provide pleasure in both the taking and the viewing – so why not go out today with a camera in the garden?

Appendices

1. Photographic Glossary

Angle of view Widest angle through which a lens can accept light to give a good quality picture over the whole frame. Compared with a standard lens, a telephoto lens has a narrow angle of view, while a wide angle lens covers a greater angle.

Aperture Iris diaphragm of lens which controls amount of light reaching film. Calibrated in f numbers or stops. A high f number (e.g. f16) denotes a small aperture.

Artificial light film Colour filmstock for use with tungsten lights, both domestic and photofloods.

ASA (American Standards Association) Numerical rating for a film's sensitivity to light. A high ASA number denotes a 'fast' or high speed film, a low number denotes a 'slow' film. See *Film speed*.

Bellows Variable extension inserted between the lens and the camera body for close-up photography, allowing magnifications of greater than life size (1:1).

Blur Unsharp image caused either by camera shake, by subject movement or by imprecise focusing.

Bounced lighting Indirect diffuse lighting obtained by deflecting the light off a white board, wall or umbrella, above or to one side of the subject.

Bracketing Taking several pictures of the same subject and viewpoint but varying each exposure by half a stop to ensure one will be correct.

Cable release Flexible cable attached to shutter release for triggering the shutter without shaking the camera.

Close-up lens Attached to front of camera lens for close-up photography.

Colour compensating filter (CC) Used with colour films to alter the overall colour balance.

Colour conversion filter Used with colour films to correct overall colour balance, e.g. blue Wratten 80B used with daylight colour films and photoflood lighting; and orange Wratten 85 used with artificial light colour films in daylight.

Complementary colours Used to describe the colours yellow, magenta and cyan which are complementary to the primary colours – blue, green and red. A primary colour and its complementary show maximum contrast.

Contre jour Lighting a subject by pointing the camera towards the direction of the light source, i.e. back-lighting.

Definition Sharpness of the negative, print or transparency, relates to lens quality, focus and film speed.

'Slow' films give a more sharply defined image than 'fast' films.

Depth of field Zone of sharp focus behind and in front of plane of focus. Increased by using a smaller aperture or by decreasing the image size. Particularly important in close-up work when depth of field is reduced.

Diaphragm Adjustable lens aperture which controls the amount of light passing through the lens.

Differential focus Isolation of a sharply focused subject from an out-of-focus background.

Diffuser A substance used to scatter light passing through it to give a soft even lighting.

Dioptre Strength of a close-up lens. A +2 (convex) lens magnifies twice as much as a +1 lens.

Emulsion Light sensitive layer on photographic films (or paper).

Exposure Correct combination of shutter speed and lens aperture used to produce a good negative or transparency for a given film at a particular light intensity. See *over-exposure* and *under-exposure*.

Extension tubes Inserted between the body of an SLR camera and lens for close-up photography.

Fill-in flash A flash used to light shadows cast by main light source (sun or flash).

Film speed Relative sensitivity of a film to light, expressed as an ASA, DIN or ISO rating. 'Slow' films have a low rating and require more light than 'fast' films.

Filter Transparent or translucent substance (glass or gelatin) which alters nature, colour or amount of light passing through it.

Flare Bright spots or patches formed by strong light reflections inside the lens, when the camera is pointed towards a light source. Flare can be reduced by using a lens hood or a multi-coated lens.

Flash An artificial short-duration light source balanced for use with daylight colour film. Flashbulbs are expendable. Electronic flash is reusable.

Focus Adjusting the lens-film distance so that the subject image appears sharp on the film plane.

Focusing screen Glass or plastic screen in a camera used for viewing and focusing the image.

Graduated filter Used to reduce the contrast between one

part of the picture and another e.g. an uncoloured sky and the rest of the scene, by adding colour to the sky.

Grazed lighting (Textured lighting). Extreme low angled oblique lighting used for emphasizing texture.

Ground spike Camera support for ground level subjects, the base of which is pushed into the ground.

Guide number (or flash factor) Denotes power of flash. Used to calculate aperture required for a given subject-to-flash distance.

Incident light Light falling on a subject. See *Reflected light*.

Infra-red light Long wavelengths invisible to the human eye, which can be recorded on special infra-red films.

Iris diaphragm See Diaphragm.

Lens hood Opaque metal or rubber tube attached to front of lens to prevent extraneous light striking the lens surface and thereby causing *flare*.

Long focus lens Has a focal length greater than the standard lens, so for the same image size, the camera-to-subject distance is increased.

Macro lens A lens with built-in extension allowing magnifications of up to XO.5 without using extension tubes or bellows.

Monopod A single-legged camera support.

Motor drive Automatic mechanism which winds on film and recocks shutter after each exposure. May be built into the camera, or attached as an accessory.

Open flash Way of using flash whereby camera shutter is opened, flash is fired (once or repeatedly) before shutter is closed.

Over-exposure Results from film being exposed to too much light, so slides appear pale, negatives dark.

Panning Horizontal movement of camera (hand-held or on a tripod) to view a scene or to keep a moving subject in the viewfinder.

Perspective correcting lens Special wide angle lens used for correcting converging verticals, by off-centring the lens.

Photomacrograph A close-up photograph obtained by using extension tubes or bellows or a macro lens. Often referred to as a macrophotograph.

Polarising filter Used to reduce distracting reflections from water and glass or wet and shiny surfaces. It also strengthens colour e.g. darkening a blue sky.

Reflected light Light reflected from the subject. See *Incident light*.

Reflector A surface used to reflect light onto the subject.

Reflex camera Has a mirror which reflects image onto focusing screen for critical composition and focusing. Twin lens reflex (TLR) cameras have two lenses, one for viewing and one for taking, while single lens reflex (SLR) cameras have one lens only.

Ring flash Electronic flash which encircles the camera lens. Provides shadowless frontal lighting for extreme close-ups.

Shutter speed Length of time a shutter remains open so the light reaches the film. Measured in seconds, and fractions of a second, each speed is half (or twice) the duration of the neighbouring one, e.g. 1, ½, ¼, ⅛, 1/15, 1/30, 1/60, 1/125, 1/250 and 1/500 sec.

Silhouette Solid subject viewed against a brightly lit background, such as sky, obtained by exposing for the sky.

Single lens reflex (SLR) See *Reflex camera*.

Slave Fires additional flashes (not connected to the camera) simultaneously with the flash linked to the camera which activates a photo-electric cell in the slave unit. May be an accessory or built into flash.

Soft focus lens Attached to camera lens to produce a soft, diffuse image.

Spotmeter Measures light from small area of subject. Some cameras and some hand-held meters have this facility.

Standard lens Has a focal length approximately equal to the diagonal of the negative or transparency, giving an angle of view of 45–50°.

Stop (f number) Aperture of lens *iris diaphragm* which controls the intensity of light reaching the film.

Stopping down Using a smaller lens aperture to reduce the amount of light passing through, and to increase the *depth of field*.

Table top tripod Miniature tripod used for table-top work and for low level photography outdoors.

Telephoto lens Long focal length lens giving a narrower angle of view (less than 50°) than a standard lens used from the same position. See *Long focus lens*.

Time-lapse photography Used to record gradual movements such as plant growth over a period of hours or even days as a series of images on separate frames or on a single frame (multiple time lapse).

Tripod Three-legged camera support with extendable legs usually with a centre column.

TTL (Through the lens) meter. Reflected light meter built into an SLR camera which measures the light passing through the lens.

Twin lens reflex (TLR) See *Reflex camera*.

Ultra-violet light Invisible short wavelengths which produce an image on monochrome or colour films, when all visible light rays are excluded with a filter.

Under-exposure Results from film being exposed to insufficient light so slides appear dark, negatives pale.

Viewfinder Used to view, compose and focus (on reflex cameras) the picture.

Wide angle lens Short focal length lens giving a wider angle of view (greater than 50°) than a standard lens used from the same position.

Working distance Distance between the camera and the subject.

Zoom lens Variable focal length lens, e.g. 80–200mm.

2. Choosing your Equipment

Cameras

For novices, *110 or disc cameras* are easy to use. Although some models have a built-in close-up lens and a flash, they are of limited use for taking close-ups, because the viewfinder does not see precisely what the camera takes. *35mm direct vision cameras* are more versatile, but tend to have fewer variable controls than a *single lens reflex (SLR) camera*. A built-in light meter allows either the photographer or the camera (on auto models) to set correct exposures. The lens is focused by a distance scale, by a range finder or by an auto-focus mechanism. However, since the viewfinder is to one side of the lens, it is impossible to view the effect of adding a filter or a close-up lens. Automatic metering and focusing is ideal for anyone who wants the camera to do the work. However, SLR cameras which show the precise framing in the viewfinder have the greatest versatility. Interchangeable lenses allow greater flexibility in choice of subject and are a must for close-up enthusiasts. 35mm SLR cameras have TTL metering, but this is an optional extra on 6 × 6cm SLR cameras. The range of *twin lens reflex (TLR) cameras* is limited, but because they use a large format film and are cheaper than a 6 × 6cm SLR, they are useful for taking garden views for reproduction in books and magazines.

Lenses

A standard 50mm lens is adequate for scenes, trees, shrubs and borders, and can be used for close-ups by adding either a close-up lens or extension tubes. Other useful lenses are wide angle (for working in confined spaces) and telephoto (for taking parts of trees, inaccessible plants or insects). A zoom lens with a range from 35–70mm can function as a wide angle (35mm), standard (50mm) and short telephoto lens (70mm). Such lenses are easy to use and weigh less than three separate lenses, but cheap zooms give poor picture definition.

Tripod

A tripod is unnecessary for taking views on a sunny day, but it is essential in shady parts and for close-ups. It must be sturdy enough to support the camera firmly – even on windy days. When using a tripod, also use a cable release so that the camera is not shaken as it is triggered.

Filters

A filter can be used with any camera, but the effect can be seen only when photographing with an SLR camera. A skylight filter reduces the bluish haze of colour pictures taken in open shade on a sunny day. Other useful filters are colour compensating, colour conversion, graduated and polarising (see Photographic glossary).

Close-up accessories

A close-up lens attached to the front of the camera lens magnifies the image. It is the cheapest way of taking close-ups with any camera. With an SLR, extension tubes or bellows inserted between the lens and the camera body can give much greater magnifications. A macro lens provides most flexibility for taking a wide range of close-ups. More details can be found in *The Book of Close-up Photography* (Ebury Press) which I wrote and illustrated.

Reflectors

Lightweight collapsible Lastolite reflectors are invaluable for filling in shadows. There are two sizes (20″ and 38″ diameter) and three finishes (gold, silver and white). The white reflector can also be used as a diffuser for softening harsh direct light.

Flashes

Electronic flash guns range in complexity from small manual to sophisticated automatic models with a range of accessories such as filters and reflectors. Before buying a flash consider how often it is likely to be used and for what subjects. A small flash will be quite adequate for taking close-up subjects. *The Handbook of Photographic Techniques* by Adrian Holloway (Pan Books) summarises types of flash guns as well as a wide range of photographic equipment.

3. Working in Monochrome

Throughout this book the emphasis has been on colour photography, however there is a need for black and white prints for publication. These are best made from original black and white negatives, but acceptable ones can be produced indirectly from good colour slides.

Thinking in black and white

When using monochrome film, many of the techniques are the same as for colour, but with the added problem of having only tonal variations with which to create the image. A red rose will come out the same tone as for green leaves unless a green filter is used to lighten the leaves and darken the flower. Any colour contrast filter will lighten the tone of objects of its own colour and darken those of its complementary colour (page 34). Thus, yellow and orange filters will darken a blue sky. A polarising filter will have the same effect as when used with colour films.

Black and white prints from colour slides

To make a black and white print from a colour slide copy it onto black and white negative film, using extension tubes or bellows on an SLR camera. The camera must be firmly supported on a tripod or an overhead copying stand, with the transparency either placed in a slide copier or laid flat on a light box. Any light source – daylight, artificial light or flash – can be used to illuminate the transparency with a diffuser of translucent plastic or tracing paper, placed between the light and the slide. A transparency can even be copied by taping it onto a clean window on an overcast day and using the sky as a background. Special slide-copying units with a built-in electronic flash, are available for copying on a large scale. The negative is then printed in the normal way.

4. Diagnosing the Fault

Fault	Cause	Remedy
Completely black	No exposure made (1) Lens hood left on non-reflex camera (2) Film not advancing through camera	(1) Remove lens hood (2) Check film wind-on mechanism
Too dark	*Under-exposure*	Check exposure meter or method of using it
Too pale	*Over-exposure*	Check exposure meter or method of using it
Pale colour over part of frame often in shape of lens *diaphragm*	*Flare* caused by photographing into the sun	Use lens hood (or hand) to shade lens and adjust camera angle
Image not sharp	(1) Imprecise focusing (2) Camera movement (3) Subject movement	(1) Focus more carefully and use a smaller aperture to increase *depth of field* (2) Use faster *shutter speed* or a *tripod* (3) Use faster shutter speed or wait for wind to ease
Yellow streaks	Film fogged by light	Load film in subdued light. If problem recurs, get camera checked for light leaks
Unnatural yellow cast to whole picture	Dayight colour film used with tungsten lighting	Use *artificial light colour film* or 80B filter
Dark corners	*Vignetting* – lens hood or filter mount too deep so edges impinge into picture	Use correct accessories for each lens
Double exposure	(1) Film put through camera twice (2) Faulty wind-on mechanism	(1) Clearly mark exposed film (2) Get camera checked

Problems with flash

Fault	Cause	Remedy
Too pale	*Over-exposure*	Flash too close to subject, aperture too large for non-auto flash or *ASA* speed set on auto flash too low
Too dark	*Under-exposure*	Flash not close enough to subject, aperture too small for non-auto flash or *ASA* speed set on auto flash too high
Only part of picture illuminated	Flash not synchronised with camera shutter	Check synchronisation M with flash bulbs X with electronic flash and correct shutter speed
Burnt out patch	Glare caused by flash being reflected off glass or water	Move flash off camera to one side

5. Organisations Concerned with Plants, Gardens and Photography

This list is by no means comprehensive. Additional specialist horticulture societies are listed in the RHS Gardener's Diary.

Alpine Garden Society, E.M. Upward, Lye End Link, St. John's, Woking, Surrey GU21 1SW.

Arboricultural Association, Ampfield House, Ampfield, Nr. Romsey, Hants SO5 9PA.

Botanical Society of the British Isles, c/o Dept. of Botany, British Museum (Natural History), Cromwell Road, London SW7 5BD.

Carnivorous Plant Society, C. Hynes, 4 Brook Way, Hartford, Northwich, Cheshire CW8 1RH.

Cottage Garden Society (Hon. Membership Secretary), 15 Faenol Avenue, Abergele, Clwyd.

Forestry Commission, 231 Corstorphine Road, Edinburgh EH2 7AT.

Gardeners' Royal Benevolent Society, Palace Gate, Hampton Court, East Molesey, Surrey KT8 9BN.

Gardeners' Sunday Organisation (Mrs. K. Collett), White Witches, 8 Mapstone Close, Glastonbury, Somerset.

Garden History Society (Hon. Membership Secretary), 66 Granville Park, London SE13 7DX.

Gardens for the Disabled Trust, Headcorn Manor, Headcorn, Kent TN27 9NP.

National Council for the Conservation of Plants and Gardens (NCCPG), Wisley Garden, Nr. Woking, Surrey GU23 6QB.

National Gardens Scheme, The, 57 Lower Belgrave Street, London SW1W 0LR.

National Trust, 36–38 Queen Anne's Gate, London SW1H 9AS.

National Trust for Scotland, 5 Charlotte Square, Edinburgh EH2 4DU.

National Vegetable Society, W. R. Hargreaves, 29 Revidge Road, Blackburn, Lancs BB2 6JB.

Northern Horticultural Society, Harlow Car Gardens, Harrogate HG3 1QB.

Orchid Society of Great Britain, L. E. Bowen, 28 Felday Road, Lewisham, London SE13 7HJ.

Royal Horticultural Society, The, Vincent Square, London SW1P 2PE.

Royal Horticultural Society of Ireland, Thomas Prior House, Merrion Road, Ballsbridge, Dublin 4.

Royal National Rose Society, The, Chiswell Green Lane, St. Albans, Herts AL2 3NR.

Royal Photographic Society, The, The Octagon, Milsom Street, Bath, Avon BA1 1DN.

Scotland Gardens Scheme, 26 Castle Terrace, Edinburgh EH1 2EL.

Scottish Rock Garden Club, Miss K. Gibb, 21 Merchiston Park, Edinburgh EH10 4PW.

Woodland Trust, Westgate, Grantham, Lincs NG31 6LL.

6. A Selected Bibliography

Angel, Heather *Photographing Nature: Flowers*, Fountain Press/ Argus Books, Kings Langley, 1975.

Angel, Heather *Photographing Nature: Trees*, Fountain Press/ Argus Books, Kings Langley, 1975.

Angel, Heather *The Book of Nature Photography*, Ebury Press, London, 1982.

Bailey, Adrian & John Holloway *The Book of Colour Photography*. Ebury Press, London, 1979.

Boddy, Frederick A. *Foliage Plants*, David & Charles, Newton Abbot, 1973.

Boniface, Priscilla *The Garden Room*, HMSO, London, 1982.

Brookes, John *The Small Garden*, Marshall Cavendish, London, 1977.

Buczacki, Stephen & Keith Harris *Collins Guide to the Pests, Diseases and Disorders of Garden Plants*, Collins, London, 1981.

Campbell, Craig S. *Water in Landscape Architecture*, Van Nostrand Reinhold, Wokingham, 1978.

Chatto, Beth *The Dry Garden*, Dent, London, 1978.

Chatto, Beth *The Damp Garden*, Dent, London, 1982.

Coats, Peter *Great Gardens of Britain*, Hamlyn, Feltham, 1970.

Fleming, Laurence & Alan Gore *The English Garden*, Michael Joseph, London, 1979.

Forsyth, Alastair *Yesterday's Gardens*, HMSO, London, 1983.

Grey-Wilson, Christopher & Victoria Matthews *Gardening on Walls*, Collins, London, 1983.

Hadfield, Miles *A History of British Gardening*, Hamlyn, Feltham, 1969.

Hadfield, Miles *Topiary and Ornamental Hedges*, Adam & Charles Black, London, 1971.

Hepper, F. Nigel (ed.) *Kew: Gardens for Science and Pleasure*, HMSO, London, 1982.

Heywood, V. H. (ed.) *Flowering Plants of the World*, Oxford University Press, Oxford, 1978.

Hicks, David *Garden Design*, Routledge & Kegan Paul, London, 1982.

Hix, John *The Glass House*, Phaidon, London, 1974.

Huxley, Anthony *An Illustrated History of Gardening*, Paddington Press, London, 1978.

Huxley, Anthony *The Penguin Encyclopaedia of Gardening*, Penguin Books, London, 1981.

Hyams, Edward & William MacQuitty *Great Gardens of the World*, Nelson, London, 1969

Jekyll, Gertrude *Wall and Water Gardens*, Country Life, London, 1901.

Jekyll, Gertrude *Colour Schemes for the Flower Garden* (rev. by Graham Stuart Thomas), Penguin Books, London, 1983.

Jones, Barbara *Follies and Grottoes*, Constable, London, 1974 (2nd edn.).

Lees-Milne, Alvilde & Rosemary Verey (eds) *The Englishwoman's Garden*, Chatto & Windus, London, 1980.

Nelson, Charles & Aidan Brady (eds) *Irish Gardening and Horticulture*, Royal Horticultural Society of Ireland, 1979.

Pearson, Robert (ed.) *The Wisley Book of Gardening*, Collingridge, Feltham, 1981.

Rothschild, Miriam & Clive Farrell *The Butterfly Gardener*, Michael Joseph/Rainbird, London, 1983.

Saneki, Kay *The Complete Book of Herbs*, Macdonald and Janes, London, 1974.

Thacker, Christopher *The History of Gardens*, Croom Helm, London, 1979.

The Royal Horticultural Society *Dictionary of Gardening*, 4 vols. and supplement, Oxford University Press, Oxford, 1956–1969.

Thomas, Graham Stuart *Colour in the Winter Garden*, Dent, London, 1967.

Thomas, Graham Stuart *Gardens of the National Trust*, The National Trust/Weidenfeld and Nicolson, London, 1979.

Thomas, Graham Stuart *Trees in the Landscape*, Cape, London, 1983.

White, J. E. Grant *Garden Art and Architecture*, Abelard Schuman, London, 1968.

7. Gardens to Visit

Great Britain and Ireland

A selection of gardens to visit with their notable features listed below have been compiled from questionnaires sent to gardens and are correct to the best of my knowledge. Full addresses and up-to-date times of opening can be found in annual lists such as *Gardens Open to the Public in England and Wales* (National Gardens Scheme), *Gardens to Visit* (The Gardeners' Sunday Organisation), *Historic Houses, Castles and Gardens in Great Britain and Ireland*, *Scotland's Gardens* (Scotland's Gardens Scheme), *Houses, Castles and Gardens* (Information Sheet No. 32 Irish Tourist Board). The English Tourist Board's 1984 publication *A Celebration of English Gardens* lists some 500 gardens to visit. The National Trust and the National Trust for Scotland each provide listings to members of their properties and gardens. Detailed descriptions of notable gardens are given in the excellent regional series entitled *The Gardens of Britain* published by Batsford.

☐	=	National Trust
☒	=	National Trust for Scotland
SG	—	Spring garden
R/A	—	Rhododendrons/azaleas
RG	—	Rock garden
R	—	Roses
HB	—	Herbaceous border
H	—	Heathers
TR	—	Trees
AC	—	Autumn colour
HG	—	Herb garden
WF	—	Water feature
F	—	Fountain
S	—	Statuary
GH	—	Glass-house
D	—	Suitable for disabled

ENGLAND

Garden	Description	SG	R/A	RG	R	HB	H	TR	AC	HG	WF	F	S	GH	D
AVON **Bath Botanic Garden**	Municipal garden.	•		•		•	•		•						
BEDFORDSHIRE **Luton Hoo**, Luton	Capability Brown landscape. Topiary.	•	•	•	•			•	•		•	•			•
Wrest Park, Silsoe	Variety of period styles. Formal canal garden.					•		•				•	•		
BERKSHIRE **Savill/Valley Gardens**, Windsor Great Park	20th century woodland garden underplanted with colourful shrubs. Dry garden, raised beds.	•	•		•	•		•	•						
BUCKINGHAMSHIRE **Ascott** ☐, Leighton Buzzard	Colourful garden. Architecture, trees/topiary.	•		•		•		•	•		•	•			
Cliveden ☐, Maidenhead	Vast garden. Temples, parterre and fountain.	•	•		•	•		•			•	•			•
Stowe, Buckingham	Landscaped garden with many temples.							•			•				
Waddesdon Manor ☐, Aylesbury	18th century-style aviary. Sculpture.	•		•				•			•	•			
West Wycombe Park ☐, High Wycombe	Landscaped garden with classical temples. Lake. Views of Chiltern hills and beechwoods.	•						•			•				
CAMBRIDGESHIRE **Angelsey Abbey** ☐, Lode	Vast garden. Flower borders, trees. Many ornaments.	•			•		•	•			•	•	•		
Cambridge University Botanic Garden	Winter garden, chronological bed, systematic beds, conservation area, East Anglian rarities.	•		•				•			•	•		•	•
CHESHIRE **Arley Hall**, Northwich	Herbaceous borders. Clipped holm oak avenue.		•		•	•		•		•				•	•
Ness Gardens, Wirral	University of Liverpool Botanic Gardens. Richly planted peninsula with native plant collection.		•	•	•	•	•	•		•	•				•
Tatton Park ☐, Knutsford	Repton garden. Fernery, parterre, topiary.	•	•		•			•	•		•			•	•
CORNWALL & SCILLY ISLES **Cotehele House** ☐, Calstock	Stream-side garden, terraces. Magnolias.	•	•		•	•		•			•				
Lanhydrock ☐, Bodmin	Formal garden with topiary. Magnolias, bluebells.	•	•			•		•							•
		SG	R/A	RG	R	HB	H	TR	AC	HG	WF	F	S	GH	D

Garden	Description	SG	R/A	RG	R	HB	H	TR	AC	HG	WF	F	S	GH	D
Pencarrow, Bodmin	Large formal gardens set in woodland. Conifers.	•		•				•			•	•			•
Trelissick □, Truro	Wooded park. Sub-tropical shrubs. Camellias.	•	•		•			•							•
Trengwainton □, Penzance	Walled gardens with rare sub-tropical plants. Magnolias.	•	•					•							•
Tresco Abbey Gardens, Isles of Scilly	Mediterranean-style terraced garden with sub-tropical southern hemisphere plants.			•							•		•		
Trewithen, Probus	Woodland/landscaped garden, Camellias, Magnolias.	•	•		•			•	•		•				•
CUMBRIA **Acorn Bank** □, Nr Penrith	Small walled garden with outstanding herbs.	•			•	•				•			•		•
Brockhole, Windermere	Formal terraced garden overlooking lake.	•	•	•	•			•	•		•				•
Dalemain, Penrith	Terrace, 17th century gazebo, knot garden.	•			•	•			•		•			•	•
Levens Hall, Kendal	Topiary garden (1692); woodland walk.				•	•									•
Muncaster, Ravenglass	Rhododendron garden in castle grounds.	•	•					•	•						
Sizergh Castle □, Kendal	Rock garden, waterfalls. Ferns, dwarf conifers.				•	•					•				
Stagshaw □, Ambleside	Woodland garden, magnolias, moss garden.	•	•												
DERBYSHIRE **Chatsworth**, Bakewell	Capability Brown landscape. Fountains, cascade.	•	•	•	•		•				•	•	•	•	•
Lea Gardens, Matlock	Specialist rhododendron garden in old quarry.	•	•	•			•								•
Melbourne Hall, Melbourne	Formal garden. Van Nost statues. Wrought ironwork.					•		•			•	•			•
DEVON **Bicton Park**, East Budleigh	Italian garden, American garden and pinetum.			•	•			•	•		•	•		•	•
Dartington Hall, Totnes	Terraced garden. Contemporary statuary.	•	•					•	•				•		
Killerton □, Exeter	Hillside woodland garden and large open lawns.	•	•	•				•	•						•
Knightshayes Court □, Tiverton	Garden in wood, spring bulbs. Terraces.	•	•					•	•		•	•		•	•
DORSET **Athelhampton**, Puddletown	6 different walled gardens, pools and fountains.					•		•			•	•	•	•	•
Compton Acres, Poole	Range of separate gardens.	•	•	•			•	•	•		•	•			•
Cranborne Manor, Cranborne	Various gardens with Elizabethan knot garden.	•			•					•		•			
EAST SUSSEX **Bateman's** □, Burwash	Kipling's riverside garden with pear alley.	•		•	•						•	•	•		
Great Dixter, Northiam	Lutyens garden planted by Christopher Lloyd.	•			•						•				
Sheffield Park Garden □, Uckfield	Cascades link 5 lakes which reflect bankside trees. Drifts of spring bulbs.	•	•					•	•		•				
ESSEX **Beth Chatto Gardens**, Elmstead Market	Modern garden with unusual plants. Sun-loving, shade plants. Mediterranean garden.						•	•	•		•				
Saling Hall, Great Saling	1698 walled garden. Notable trees, water gardens.							•			•				•
GLOUCESTERSHIRE **Barnsley House**, Nr. Cirencester	Special features: knot garden, potager, laburnum walk, vistas and garden buildings.	•			•	•		•	•	•					•
Batsford Park Arboretum, Moreton-in-Marsh	Over 1000 kinds of trees, also bamboos and oriental bronze statues.	•						•	•		•		•		
Hidcote □, Chipping Campden	Series of garden rooms enclosed by hedges.	•		•	•			•	•		•	•	•		•

Garden	Description	SG	R/A	RG	R	HB	H	TR	AC	HG	WF	F	S	GH	D
Sezincote Garden, Sezincote	Oriental water garden.							•	•		•	•	•	•	
Westonbirt Arboretum, Tetbury	Forestry Commission estate. Rare specimen trees.		•					•	•						•
HAMPSHIRE **Bramdean House**, Nr Alresford	Herbaceous borders, unusual plants within walls.	•			•	•		•				•			
Exbury, Fawley	200-acre woodland, rhododendrons, magnolias.	•	•	•	•		•	•	•		•				•
Gilbert White Museum (The Wakes), Selborne	Gilbert White's garden with original ha-ha, sundial. Garden with old roses.	•			•	•		•	•	•					•
Greatham Mill, Nr Liss	Mill stream garden with variety of plants.				•	•			•						•
Hillier Arboretum, Nr Romsey	100 acres trees and shrubs. Scree area.	•	•		•		•	•	•		•				•
Jenkyn Place, Bentley	Carefully designed garden with unusual plants.				•	•		•			•	•	•		
Mottisfont Abbey □, Romsey	Old and species roses in walled garden.				•			•							•
Sutton Manor Arts Centre, Sutton Scotney	Sculpture garden of major 20th century arts. Formal herb garden.				•	•		•		•	•	•	•	•	•
HEREFORD AND WORCESTER **Burford House Gardens**, Tenbury Wells	Noted for garden design and interesting plants. Clematis collection.	•		•	•			•			•				
Croft Castle □, Leominster	Secret garden with fragrant plants. Avenues.	•			•			•							•
HERTFORDSHIRE **The Gardens of the Rose**, St Albans	Landscaped display of 1000 plants of more than 900 varieties.				•							•			•
Hatfield House, Hatfield	Formal and informal gardens, knot garden.	•	•					•		•	•				•
St Paul's Walden Bury, Nr Hitchin	18th century formal woodland garden with temples, statues, lake and ponds.		•								•		•		
ISLE OF WIGHT **Barton Manor**, Cowes	Victorian grounds. Scented secret garden.	•	•		•	•		•	•		•	•			•
Ventnor Botanic Gardens	Mediterranean-type climate with exotic plants.				•			•							•
KENT **Bedgebury National Pinetum**, Nr. Goudhurst	Forestry Commission national collection of conifers.							•			•				
Chartwell □, Westerham	Terraced gardens, lake, lawns, golden rose garden.		•		•			•			•				•
Hall Place Garden, Bexley	Large lakeside garden. Topiary.	•	•	•	•		•	•		•	•			•	•
Hever Castle, Nr Edenbridge	Formal Italian garden, lake, maze, topiary.	•	•		•			•	•		•		•	•	•
Scotney Castle Garden □, Lamberhurst	Romantic landscaped garden with moated castle, Waterside vegetation.	•	•					•		•					•
Sissinghurst Castle Garden □, Sissinghurst	Famous 20th century garden displaying colour schemes in separate enclosures.	•	•		•				•	•					•
LEICESTERSHIRE **Belvoir Castle**, Grantham	Hillside garden with views of Vale of Belvoir.	•			•			•	•				•		•
Rockingham Castle, Corby	Wild and formal garden with 'elephant' hedge.	•			•			•	•						
LONDON AND GREATER LONDON **Chelsea Physic Garden**, Chelsea	Dates back to 1673. Then a physic garden, now used for research and education.		•					•		•	•			•	
		SG	R/A	RG	R	HB	H	TR	AC	HG	WF	F	S	GH	D

Garden	Description	SG	R/A	RG	R	HB	H	TR	AC	HG	WF	F	S	GH	D
Hampton Court Palace, East Molesey	Gardens and parkland on great scale, with maze and knot garden.	•	•		•			•	•			•	•		•
Royal Botanic Gardens, Kew	Extensive plant and tree collections. Lakes.	•	•	•	•	•	•	•	•	•	•	•	•	•	•
Syon Park Garden, Brentford	Capability Brown landscape. Great Conservatory.			•	•	•	•	•	•		•			•	•
MERSEYSIDE **Croxteth Hall and Country Park**, Liverpool	2-acre Victorian walled garden with old fruit trees trained as espaliers and goblets.					•		•		•	•		•		
Liverpool City Botanic Garden	Municipal botanic garden with largest collection of glasshouse plants in the North.		•		•	•		•	•	•	•			•	•
Windle Hall, St Helens	Walled garden, woodland. Tufa stone grotto.	•	•	•	•	•		•	•		•			•	•
NORFOLK **Blicking Hall** □, Aylsham	Formal garden. Temple, orangery and lake.	•	•		•	•		•	•		•	•	•	•	•
Bressingham Gardens, Diss	5 acres of hardy perennials. Island beds.					•	•	•							•
Felbrigg Hall □, Cromer	Walled garden with dovecote. Camellias.							•			•			•	•
Oxburgh Hall □, Oxburgh	French parterre garden (c. 1845) Formal orchard.	•			•	•		•							•
NORTHAMPTONSHIRE **Castle Ashby**, Northampton	Landscaped by Brown. Terraces and Italian garden.	•			•			•			•	•	•	•	•
Easton Neston, Towcester	Clipped yews, arboretum, walled kitchen garden.							•			•		•		
NORTHUMBERLAND **Cragside House** □, Rothbury	Country park with fine trees and rhododendrons.		•					•			•				
Wallington □, Cambo	Woodlands, walled terrace garden. Conservatory.	•			•			•	•		•		•	•	
NORTH YORKSHIRE **Castle Howard**, York	Landscaped park, architecture, cascade.		•		•			•			•	•	•		•
Fountains Abbey and Studley Royal □, Ripon	Georgian 'green garden'. Landscaped water garden, follies, temples. Fine vistas. Abbey ruins.							•	•		•				•
Harlow Car Gardens, Harrogate	Northern Horticultural Society's garden. Varied displays and trials. Natural woodland, stream.	•	•	•	•	•	•	•	•	•	•			•	•
Newby Hall, Ripon	Riverside garden. Interesting plants. Ornaments.	•	•	•	•	•		•	•				•		•
Rievaulx Terrace □, Helmsley	Grass terrace with 2 classical temples.							•	•						•
OXFORDSHIRE **Blenheim Palace**, Woodstock	Vanbrugh/Brown park. Water parterre. Cascade.	•	•		•			•	•		•	•	•		•
Greys Court □, Henley	Walled garden with recent maze.	•			•			•			•	•			
Oxford Botanic Gardens	Oldest botanic garden. Wall plants.			•		•		•		•	•			•	•
Pusey House, Faringdon	Circular tour reveals variety of attractions.					•	•	•	•		•		•		•
Rousham, Steeple Aston	Kent landscape garden. architecture and water.					•		•			•		•		
Waterperry Gardens, Wheatley	Spacious grounds with trees. Riverside walk.	•		•		•		•	•					•	
SOMERSET **Barrington Court** □, Ilminster	Jekyll design of planting in garden rooms.	•	•		•			•	•		•			•	•
Clapton Court Garden, Crewkerne	Beautiful garden with formal terraces and woodland garden.	•	•	•	•			•	•		•			•	
Hestercombe, Nr Taunton	Restored Lutyens/Jekyll garden. Fine pergola.					•					•			•	
Lytes Cary □, Ilchester	Hedged formal garden. Lily pool, topiary.	•				•					•				
Montacute □ Yeovil	Formal gardens with Elizabethan pavilions.				•	•		•			•		•	•	•
		SG	R/A	RG	R	HB	H	TR	AC	HG	WF	F	S	GH	D

Garden	Description	SG	R/A	RG	R	HB	H	TR	AC	HG	WF	F	S	GH	D
Tintinhull □, Yeovil	20th century garden in Jekyll tradition.											•	•		•
STAFFORDSHIRE **Alton Towers**, Cheadle	Multi-level garden. Pagoda fountain. Conservatory.		•	•	•		•	•	•		•	•	•	•	•
Dorothy Clive Garden, Willoughbridge	Alpine and rock plants, rare trees and shrubs. Woodland with fine rhododendron collection.	•	•	•	•			•	•		•				
Shugborough □, Great Haywood	Park with neo-classical monuments. Rose garden.	•	•		•		•				•	•	•		•
SUFFOLK **Euston Hall**, Thetford	Laid out by Evelyn and Kent. Modified by Brown.					•	•	•			•				•
Melford Hall □, Sudbury	Crinkle crankle wall. Gazebo. Topiary.	•			•			•		•	•	•			
Netherfield Herbs, Rougham	Award-winning herb garden.							•		•			•		
Somerleyton Hall, Lowestoft	Famous maze. Paxton glass-houses.		•					•					•	•	•
SURREY **Claremont Landscape Garden** □, Esher	Restored 18th century garden with turf amphitheatre and lake.		•					•	•		•				•
Polesden Lacey □, Dorking	Woodland grounds with lawns. Formal garden.			•	•	•		•					•		•
Winkworth Arboretum □, Nr Godalming	Hillside woodland with two lakes. Many rare trees and shrubs.	•	•					•	•		•				
Wisley, Ripley	Year-round interest in Royal Horticultural Society's garden. Trials area. Alpine house.	•	•	•	•	•	•	•	•	•	•	•		•	•
WARWICKSHIRE **Charlecote Park** □, Stratford-upon-Avon	Landscaped garden on river terrace with border of Shakespeare's flowers.												•	•	•
Packwood House □, Hockley Heath	Walled 17th century garden. Huge clipped yews. Sunken garden. Wall-mounted sundials.						•				•	•			
WEST MIDLANDS **Moseley Old Hall** □, Wolverhampton	Reproduction 17th century formal garden with parterre.	•			•			•		•					•
WEST SUSSEX **Denmans**, Fontwell	Walled gardens planted for all year interest.	•						•	•		•			•	•
Holly Gate Cactus Nursery, Ashington	Many cacti and succulents planted in landscaped glass-houses.													•	
Leonardslee, Horsham	Spectacular woodland valley garden with lakes.	•	•	•				•	•		•				
Nymans Garden □, Handcross	Worldwide collection of shrubs and trees.	•	•		•	•	•					•	•		•
Petworth House □, Petworth	Park landscaped by Brown. Woodland garden.	•	•					•	•		•				•
Wakehurst Place □, Haywards Heath	Large collection of exotic trees and shrubs managed by Royal Botanic Gardens, Kew.	•	•	•				•	•		•				•
WEST YORKSHIRE **Bradford Botanic Garden**	Plants illustrating wool trade and medicine.													•	
Bramham Park, Wetherby	French-style formal garden with grand vistas.	•	•		•			•	•		•				•
Lister Park, Bradford	Public park with Victorian bedding-out.			•			•	•			•				
York Gate, Adel	Small compartments full of interesting plants.				•		•	•	•	•	•	•	•		
		SG	R/A	RG	R	HB	H	TR	AC	HG	WF	F	S	GH	D

Garden	Description	SG	R/A	RG	R	HB	H	TR	AC	HG	WF	F	S	GH	D
WILTSHIRE															
Bowood, Calne	Capability Brown landscape with lake. Arboretum.	•	•		•			•		•		•		•	•
Corsham Court, Chippenham	Capability Brown and Repton landscape.	•			•			•	•	•	•				•
The Courts □, Holt	English formal garden. Wildflower reserve.	•						•	•	•				•	•
Stourhead □, Mere	18th century garden with fine trees. Temples.		•					•	•	•		•		•	•
Wilton House, Salisbury	Riverside grounds. Palladium bridge. Cedar trees.	•						•				•		•	•

SCOTLAND

Garden	Description	SG	R/A	RG	R	HB	H	TR	AC	HG	WF	F	S	GH	D
Branklyn Garden ⊠, Perth	Rock and scree gardens. Uncommon alpines.	•	•	•					•						
Brodick Castle ⊠, Arran	Woodland garden, semi-tropical plants/shrubs.	•	•	•						•					
Cawdor Castle , Nairn	Walled formal and informal gardens.	•	•	•	•	•		•	•	•	•				•
Crathes Castle ⊠, Banchory	8 separate gardens with distinctive plants.					•	•			•	•				
Culcreuch Castle, Fintry	Walled garden. Exotic 1842 pinetum.	•	•					•	•	•					•
Culzean Castle and Country Park ⊠, Maybole	Spacious gardens—fine trees, walled garden, fountain court, pagoda, camellia house.	•	•	•	•	•		•	•	•	•			•	•
Dawyck Arboretum, Peebles	Fine trees, original Dawyck beech. Daffodils.	•	•					•	•						
Drummond Castle, Crieff	Magnificent formal garden. Parterre. Statues.	•			•				•		•	•	•	•	
Edinburgh Botanic Garden, Edinburgh	Noted for Chinese/Himalayan plants—especially rhododendrons. Fine rock garden.	•	•	•	•	•	•	•	•	•	•		•	•	•
Edzell Castle, Edzell	Formal garden enclosed by ornate walls.	•		•	•										•
Falkland ⊠, Fife	Gardens laid out to original royal plans.					•	•		•	•				•	
Glasgow Botanic Gardens	Orchids, economic plants. Victorian conservatory.							•		•				•	•
Inveresk Lodge ⊠, Inveresk	Reconstructed 19th century garden. Alpines.					•		•	•	•	•			•	
Inverewe ⊠, Poolewe	Woodland garden. Rare and sub-tropical plants.	•	•	•	•			•	•	•	•			•	•
Kellie Castle ⊠, Fife	Victorian walled garden with fine old trees.					•		•	•	•					•
Leith Hall ⊠, Kennethmont	A small, personal garden in two sections.		•		•			•		•					•
Pitmedden ⊠, Udny	Reconstructed 17th century garden. 4 parterres.										•				•
St. Andrew's Botanic Garden	University botanic garden. Rock and peat gardens.	•	•	•				•	•	•				•	•
Tyninghame Gardens, East Linton	Walled garden, with fine views of Lammermuir Hills. Secret Garden. Parterre.					•		•				•	•		•
Younger Botanic Garden, Benmore	19th century garden with large areas of huge conifers.	•	•					•							•

WALES

Garden	Description	SG	R/A	RG	R	HB	H	TR	AC	HG	WF	F	S	GH	D
Bodnant Garden □, Colwyn Bay	Upper terraced garden. Fine shrubs and trees.	•	•	•	•			•	•	•					
Chirk Castle □, Nr Wrexham	Formal garden, clipped yews. Flowering shrubs.	•	•	•	•			•		•					
Plas Newydd □, Angelsey	Spring and early summer garden. Fine views.	•	•		•			•	•						
Powis Castle □, Welshpool	Impressive terraced gardens with topiary.	•	•		•			•		•			•	•	
St Fagans Castle, Cardiff	Formal garden, terraces, knot garden.					•		•		•	•				•
		SG	R/A	RG	R	HB	H	TR	AC	HG	WF	F	S	GH	D

IRELAND

Garden	Description	SG	R/A	RG	R	HB	H	TR	AC	HG	WF	F	S	GH	D
Birr Castle Demesne, Birr	Park with formal gardens, terraces, lake.	●				●		●	●		●		●		
Castlewellan Forest Park	National arboretum. Notable rare conifers.	●	●		●			●	●		●	●		●	●
Curraghmore Gardens, Portlaw	Landscaped garden. 1754 Shellhouse.	●	●					●			●				●
Dargle Cottage, Enniskerry	Glen garden with modern sculpture.	●	●		●			●	●			●			
Derreen, Lauragh	Woodland garden with tree fern avenue.		●	●										●	
Fernhill, Sandyford	Informal 19th century garden.	●	●	●	●	●	●	●	●	●	●				
Ilnacullen, Garinish Island	Formal Italian Peto garden. Good architecture.	●	●					●	●		●				
Killruddery, Bray	Early 17th century garden.				●			●	●		●	●	●		
Mount Stewart □, Newtownards	Colourful parterres, fine formal and informal vistas. Topiary.	●	●			●		●	●		●	●	●		●
Mount Usher Gardens, Ashford	Romantic riverside Robinson-style garden.	●	●					●	●						●
National Botanic Gardens	At Glasnevin. Founded 1790. Large glass-houses.					●	●	●	●		●	●		●	●
Powerscourt, Enniskerry	Magnificent formal garden. Waterfall.				●	●	●	●	●		●	●	●	●	●
Rowallane Garden □, Saintfield	Spring garden with rocky outcrops. Fine trees and shrubs. Walled garden.	●	●	●	●			●	●	●	●				●
		SG	R/A	RG	R	HB	H	TR	AC	HG	WF	F	S	GH	D

Gardens in Other Countries

A brief resumé of useful addresses and books for any reader wanting to visit and photograph gardens abroad.

Australia

Each state in Australia has its own National Trust responsible for the administration of notable houses and gardens. Botanic gardens also exist throughout Australia and Canberra Botanic Gardens are devoted exclusively to growing Australian native plants. For those interested in the historical aspects of gardens, information can be obtained from the Australian Garden History Society, P.O. Box 300, Edgecliff, NSW 2027. Further reading:

Tanner, Howard and Jane Begg *The Great Gardens of Australia*, Macmillan, Melbourne, 1983 (2nd edn.).
Polglase, Pamela *et al Australia the beautiful, great gardens*, Keven Weldon & Associates, McMahons Point, NSW, 1983.
Watts, Peter *Historic Gardens of Victoria*, Oxford University Press, Melbourne, 1983.

New Zealand

Auckland, Wellington, Christchurch and Dunedin each have a botanic garden. A large collection of New Zealand native plants and trees can be seen in the Waipahihi Botanical Reserve in Taupo, while the Otari Museum of Native Plants in Wellington shows how they can be used in the home garden. Further information available from: Royal New Zealand Institute of Horticulture, Box 12, Lincoln College, Canterbury. Further reading:

Matthews, Barbara *Gardens of New Zealand*, Lansdowne Press, Auckland, 1983.
Pope, Diana & Jeremy *Mobile New Zealand Travel Guide: North Island*, 4th edn., Reed, Wellington, 1979.
Pope, Diana & Jeremy *Mobile New Zealand Travel Guide: South Island and Stewart Island*, 3rd edn., Reed, Wellington, 1981.

USA

The multitude of gardens, as well as the extreme climatic variations experienced in the United States, make it impossible to select even a few gardens. However, information can be obtained from the American Horticultural Society, 7931 East Boulevard Drive, Alexandria, VA 22308 and the Garden Club of America, 598 Madison Avenue, New York, N.Y. 10022. Further reading:

Ray, Mary Helen & Robert P. Nicholls (eds) *A guide to significant and historic gardens of America*, Agee Publishers Inc., Athens, Georgia.
A guide to public gardens of the United States, The Garden Club of America, 1982 (rev. edn.).

Index

See separate index for list of gardens on page 160

Figures in **bold** refer to illustrations

Index to Gardens

Index to gardens mentioned in the text which are open to the public

For general index see page 158
Figures in **bold** refer to illustrations